Managing Multimedia Projects

Managing Multimedia Projects

Roy Strauss

Focal Press

Boston Oxford Johannesburg Melbourne New Delhi Singapore

Focal Press is an imprint of Butterworth-Heinemann.

Copyright © 1997 by Butterworth-Heinemann

ℛ A member of the Reed Elsevier group

∞ Recognizing the importance of preserving what has been written, Butterworth–Heinemann prints its books on acid-free paper whenever possible.

Library of Congress Cataloging-in-Publication Data

Strauss, Roy.
 Managing multimedia projects / Roy Strauss.
 p. cm.
 Includes bibliographical references and index.
 ISBN 0-240-80244-6 (pbk.)
 1. Multimedia systems. 2. Application software—Development.
I. Title.
QA76.575.S77 1997
006.7'6—dc21
 96-48504
 CIP

British Library Cataloguing-in-Publication Data
A catalogue record for this book is available from the British Library.

The publisher offers special discounts on bulk orders of this book.
For information, please contact:
Manager of Special Sales
Butterworth–Heinemann
313 Washington Street
Newton, MA 02158-1626
Tel: 617-928-2500
Fax: 617-928-2620

For information on all Focal Press publications available, contact our World Wide Web home page at: http://www.bh.com/fp

10 9 8 7 6 5 4 3 2 1

Printed in the United States of America

This book is dedicated to my wife, Melinda Eskin, whose love, encouragement, and support made this book possible.

Special thanks to the following people for reviewing this book and making so many helpful suggestions:

> Stuart Gilbert
> Dave Castlewitz
> Joel Shayman
> Patrick Hogan
> Robert Edgar

Thanks also to all the great people at Commodore, Encyclopaedia Britannica, and Rand McNally, from whom I've learned so much.

Table of Contents

Introduction

With the increased popularity of multimedia, more people—many with little, if any, experience in the field—are finding themselves involved in producing multimedia applications. Some come from production backgrounds in other media, such as video and print; others may have developed software for more traditional, nongraphical software applications. It is hoped that this book can shed some light on the multimedia development process for those who may be new to it and help guide them to increased success in developing high-quality applications on budget and on schedule.

WHAT IS MULTIMEDIA?

Multimedia is *software*. While the term *multimedia* refers to many different technologies and applications, in this book the term will be used to describe software that has an emphasis on presenting content with video, graphics, and sound, and that is designed to be the end product itself and to be run on a computer. Examples of multimedia applications include computer-based slide show presentations, computer-based training (CBT) applications, museum touch-screen kiosks, consumer CD-ROM titles, and World Wide Web sites on the Internet. All these programs are meant to present content using visuals and audio, and the final delivery system for all these products is a computer.

Since multimedia applications are software, developing a multimedia application requires a software development process. The occasional misconception that multimedia is simply an extension of other mediums, such as "interactive video" or "electronic books" may account for some of the problems that print publishers and video producers have had when attempting to develop multimedia applications. This misconception may also account for some of the serious design flaws found among the first "title wave" of CD-ROM applications that flooded the United States consumer market in the mid-1990s. Publishing a book or collection of video clips on a CD-ROM misses the essence of software, which is to do something that cannot be done in another medium. Imagine videotaping a stage play from a single camera angle and then claiming it is a movie. A real movie is full of editing, close-ups, transitions, fast-changing scenery—all things that cannot be done in the theater. Likewise, software allows a whole different range of possibilities for interaction that is completely unavailable on print or video.

While multimedia applications are a type of software, they constitute a definite category of software that places great emphasis on presentation, including video,

graphics, and audio. It is this emphasis on the visual and audio elements that gives multimedia its character and is why CD-ROMs are so well suited to multimedia. Multimedia's heavy reliance on visual and audio elements requires large storage space for the considerable amounts of data (such as digitized video), and CD-ROM is an economical way to reproduce and distribute such large amounts of data.

In coming years, the World Wide Web will compete with or even supplant the CD-ROM as the primary medium for distributing multimedia applications. However, a World Wide Web site is just as much a software application as a CD-ROM title, so the processes, techniques, and methods included in this book are as applicable to Web applications as to CD-ROM or floppy-diskette-based applications.

USES OF MULTIMEDIA

Retail (Consumer Titles)

This category refers to the most popular form of multimedia currently available in the mass market: CD-ROM software, available from software outlets, mail order catalogs, and many other channels. Often referred to as "titles," these applications include children's educational programs, electronic encyclopedias, and games, and are designed primarily for home use by consumers.

Education

Educational applications are multimedia programs developed and marketed primarily (or exclusively) for use in schools. Increasingly, schools are using multimedia to enhance traditional print and video-based curriculums. However, this is somewhat limited by the relatively low number of computers per student within most classrooms. Rarely does each student have his or her own computer. Usually, a given classroom will have only one or two—often aging machines, without the capability to run the latest multimedia applications. In addition, they may not even be the same type, with Macintosh and Windows platforms in the same classroom, some networked, some not. Therefore, multimedia is not usually the primary means of instruction and most often supplements existing print-based curriculums. A multimedia application used for a classroom presentation requires a display device of some sort, such as an LCD panel or computer projector, which may or may not be readily available in a given school.

Computer-Based Training (CBT)

Software has been used for corporate training for many years because of the economic advantages of automating the training process, including self-paced instruction, decreased travel time through on-site training, and convenience of use. Multimedia applications simply represent the continued evolution of traditional

CBT, and this use has continued to increase as prices for computer technology have decreased. Multimedia can be incorporated into training in a variety of ways, from electronic slideshow presentations to self-paced instruction to "virtual reality" simulations. With the advent of simplified programming and authoring tools, training instructors are often able to create their own presentation and course materials.

Sales and Marketing Presentations

Electronic slide shows are frequently created for sales and marketing presentations as speaker support materials, ranging from multimedia extravaganzas using racks of equipment to intimate one-on-one sales presentations delivered on a laptop computer. In addition, the major new method for presenting sales and marketing information is to establish a World Wide Web site, as evidenced by the explosive growth and use of the Internet for such applications.

Kiosk Displays

Kiosk displays are usually stand-alone applications, frequently used for museum displays, trade show exhibits, automated information centers in company lobbies, and in-store promotional devices. Typically, the equipment is enclosed in some sort of housing with only the monitor showing and is left unattended. The user interacts with such an application through a touch-screen monitor. Some of the benefits of such displays include making huge amounts of data available to the casual user, running video on demand to show a promotional piece about a product, and allowing potential customers to feel comfortable obtaining information without a salesperson.

ORGANIZATION OF THIS BOOK

While every multimedia project is unique in some way, all share significant similarities in how they are developed, including budgeting and scheduling, phases of development, and other project management and production issues. These similarities are the subject of this book and may help the reader see how the concepts discussed can be applied to specific cases.

The book is organized in two parts: Factors and Techniques, and The Development Process.

Part 1 focuses on issues of common concern to most managers of multimedia projects. Chapter 1 describes the project management triangle and how the three management parameters of time, task, and resources manifest themselves in multimedia projects. It provides some strategies and perspectives for addressing the inevitable tradeoffs among the three parameters. Chapter 2 discusses laying the foundation for the development schedule, using project management software, and other techniques for monitoring progress. Chapter 3 discusses the difference

between a cost estimate and a budget, gives some methods for estimating project costs, including hidden costs, and addresses the issue of accuracy in a given estimate. Chapter 4 reviews the benefits of using an integrated team approach and ways to implement and deal with such a product development team. Chapter 5 compares the advantages and disadvantages of using an external developer as opposed to internal staff, and describes the trade-offs worth considering when deciding whether to develop the product internally or externally. Chapter 6 provides a comprehensive overview of most of the currently available multimedia hardware and software technologies and underscores the rapidly evolving nature of computer technology in general and multimedia technology in particular.

Part 2 is a guide to the basic phases that most multimedia projects tend to move through, from initial analysis to final application. Chapter 7 provides an overview of the various phases and attempts to put them in context relative to one another. Chapters 8–14 examine in detail the milestones, processes, concerns, and other notable issues encompassed by each phase.

The reader may find the application examples at the end of each chapter of particular use in showing how each phase applies to projects of varying scope and complexity:

- The electronic slide show is a simple visual aid during a presentation to company management. It will simply display still-frame graphics and allow a linear progression from one slide to the next.
- The consumer multimedia CD-ROM is a single-topic encyclopedia containing text, illustrations, photos, video, and animation, along with a sophisticated search engine and various other features. Commercially available examples of this type of multimedia application include *Encyclopedia of Nature* (Dorling Kindersley Multimedia), *Ancient Lands* (Microsoft), and *Nile Passage to Egypt* (Discovery Channel).
- The trade show kiosk is a marketing application, designed to attract trade show attendees to a booth, occupy them until a salesperson is available, and serve as an information resource for company personnel.
- The World Wide Web site is a simple home-page-related site for a small to medium-sized company. The site will provide an on-line starting point for the company's customers and business partners to obtain general information about the company and specific information about its products, find out how to order those products, and communicate directly with the company through e-mail.

Managing software applications in general, and multimedia applications in particular, is often a complex task and a significant responsibility. It is hoped that this book will shed some light on the process and help the increasing numbers of people who are becoming involved in multimedia to manage their projects more successfully.

Factors and Techniques

Project Management in Three Dimensions

Managing complex projects, such as multimedia applications, often entails many conflicting issues and concerns. You may feel that there simply isn't enough time to accomplish the task, that the job is too complex, or that the budget isn't adequate. It is often difficult to determine the proper course of action. To deal with such situations, it is helpful to understand and consider the three general dimensions of project management: Time, Task, and Resources. Without an understanding of how these three factors interrelate, you can easily slip into a reactive mode, constantly responding to the crisis of the moment. Once these three factors are understood and appreciated, however, they become the reins of control by which you can effectively manage a complex multimedia project.

These three factors of time, task, and resources constantly interact in a multimedia project, changing priorities and fluctuating in importance as the project advances. Understanding how they interact gives you a valuable and objective perspective that goes a long way toward demystifying the development process. It is the project manager's job to juggle these factors and make decisions about trade-offs and compromises along the way.

In *Dynamics of Software Development*, Microsoft's Jim McCarthy writes, "As a development manager, you're working with only three things: resources (people and money), features (the product and its quality), and the schedule. This triangle of elements is all you work with. There's nothing else to be worked with." (p. 96)

These three factors can be represented as the three points of a triangle (see figure 1.1).

THE THREE PROJECT FACTORS

Time

For the purposes of a multimedia application, the amount of time required refers to the project schedule—specifically, the completion deadline. This date depends

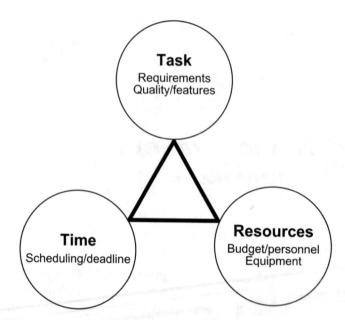

Figure 1.1 The project managment triangle: Task, Time, and Resources.

on the nature of the task (as designed) and the available resources (people and equipment). As a rule, the more resources available and the simpler the design, the faster the task can be accomplished, but only to a point. One might suppose that a project that takes a year with only one person working on it would take six months with two people and one month with twelve. In practice, however, adding more people does not reduce the amount of time at the same rate; a point of diminishing returns occurs when the overhead of communication and administration to co-ordinate all their activities negates the increased work actually being performed.

For example, during the development of a large educational CD-ROM on American history at Encyclopaedia Britannica, the project was burdened with an excessive number of consultants. These consultants were required to be part of the project team by the board of education in the state where we hoped to sell the product. The large number of influential consultants involved (each of whom had a unique opinion) kept the design in flux, which slowed the development process considerably. Since the project was originally scheduled to be delivered in one year, the budgeted amount for these consultants was spent after a year, and they were released from the project before it was finished. It was only after this had happened and the team size had decreased to a workable number that the project was able to gather momentum. It was finally released six months later.

You may also have experienced this same effect of more resources slowing down development when working on a project that has fallen severely behind schedule. Management, seeing a problem, decides to solve it by throwing more peo-

ple at it. This actually slows the project down further, at least temporarily, as the newcomers get equipped, trained, and worked into the process. Often, the work isn't speeded up appreciably even after these new recruits have been assimilated, because of the increased overhead for administration and communication within the team.

Some tasks, by their very nature, take longer, depending on the talent and experience of the individual doing the work. The best example of this is software programming, where the effectiveness of different programmers can vary by several orders of magnitude. A particular programming task may take one programmer a few days and another several months, depending on many factors, including each programmer's talent, experience, and tools. Even a particular individual's temperament may be more or less well suited for a particular task. In some situations, a programming task can be speeded up considerably by hiring the right programmer, or slowed down a similar amount by adding several inappropriate programmers. Occasionally, the fastest way to attain product release is not to change anything: even though it may seem to be going exceedingly slowly, the existing situation may be the most efficient of all.

Likewise, the task may dictate a greatly reduced or expanded schedule, depending on the feature set requirements (what the application is supposed to do). In many ways, the feature requirements (task) dictate the amount and kinds of resources and how soon the application can be developed (time). Given identical resources, an electronic presentation with twelve slides will take much less time than one with a hundred slides. A CD-ROM catalog that allows the user to conduct transactions on-line will take longer to develop than the same catalog without this feature. Only by closely examining the task and constantly questioning assumptions about the design can you strip the task down to its essentials. Multimedia projects require this constant pruning, because they tend to gather additional features as they are being developed. In fact, this accumulation of features and design enhancements during the development process is so widespread that it is commonly known as "feature creep," and you must beware of it to keep your projects running on schedule.

Task

The task refers to exactly *what it is* that is being built. This is the scope of the work to be performed: the magnitude and complexity of the final application. For a multimedia project, this consists of the requirements specification, the functional design, and the other materials that must be provided to accompany it, such as user manuals and promotional videos. This definition of the end product will determine the number of people necessary to produce the application, the skills they must have, the kind of equipment they will need, and how long it will take them to complete the project. For example, a simple electronic slide show to support a speaker for a five-minute presentation will take less time and fewer resources than a custom-designed and -programmed consumer CD-ROM application.

Resources

Resources basically refer to how much money is available to be spent on the project and how that money is applied in terms of people, materials, and equipment. In general, the more money available, the faster an application can be developed and the higher quality or more elaborate it can be. However, as noted earlier, if a project has fallen behind schedule, adding resources (people and money) does not always speed it up. Adding people to a project that's fallen behind schedule can cause it to fall even farther behind if the wrong resources are added or are added at the wrong time. The more highly skilled and specialized the resources needed, the better it is to add them early or not at all. For example, adding programmers early in the project can speed it up, but adding them toward the end may well delay it even further. According to Frederick Brooks in *The Mythical Man-Month*, "Adding manpower to a late software project makes it later" (p. 25).

Often, however, the limiting factor is resources (money/budget/personnel), leaving the time (schedule) and task (functional requirements) to fluctuate. If such a project runs into difficulty, the design will need to be simplified and/or the deadline will need to be adjusted.

For example, when working on an interactive employee benefits program for use as a demonstration/sales tool, our company had only a fixed amount of marketing funds to invest. When the project was cost-estimated, it became obvious that the initial project ideas could not be implemented for the budgeted amount. By taking a step back and repriortizing the features, we were able to design the program to meet the budget constraints. This also had a side benefit in narrowing the project focus. The final product came in on budget and was used successfully by the marketing staff for several years thereafter.

SEEING IT IN THREE DIMENSIONS

When a project is running, all three factors—time, task, and resources—can be viewed as ever-changing variables constantly interacting with one another. The job of the project manager is to constantly balance these three factors. If resources are removed (for example, if a key team member is reassigned to another project, access to equipment is restricted, or the budget is cut), the project will either take longer to complete (time factor changes), be less ambitious in scope (task definition changes), or both. Likewise, if the design is scaled back (features are dropped or simplified), the project can be finished faster or with fewer people. The main goal of project management is to constantly balance these factors during development of the product.

Whether or not you are conscious of the interplay of these three factors and can take action based on them will determine whether you are master of or slave to the development process. By manipulating these factors during the course of the project, you can exert considerable control. This helps you explain schedule delays, lets you

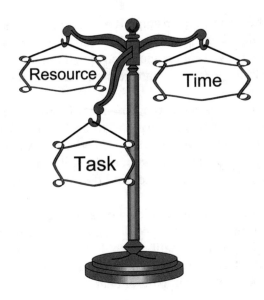

Figure 1.2 Balancing the three project factors.

"say no" to feature creep and design changes with good reason, and provides a rationale for increased personnel and equipment. By continually examining these three dimensions during the project, you can also find openings to improve the project dynamics. For example, if a complicated feature is dropped halfway through the project, this may well allow the project to pick up speed and be delivered sooner, or it may decrease the need for some resources (programming, data preparation, testing) and therefore increase the chances of hitting the targeted budget amount.

Only by examining these factors on an ongoing basis can problems be minimized. It is not sufficient merely to wait for a crisis and then start examining these factors to see how to extract yourself. If you watch these factors on a daily basis (project management software can be helpful in this respect) and make minor adjustments along the way, you can avoid crises before they develop.

In developing a Macintosh version of *Geopedia* (an educational CD-ROM on world geography) at Encyclopaedia Britannica, we had a one-year schedule. At the three-month mark, we found we were only about one-eighth done. The single programmer assigned to the task seemed satisfied that it would all get done "in time." This was not exactly reassuring.

If progress had continued at this rate, the programming would have taken twice as long as scheduled, which meant the application would probably have been finished a full year late. Not only would the product have been delivered late, but we would also have had to find something useful for the other project personnel to do in the meantime or else have been forced to lay them off and look for replacements when the time came. Fortunately, we recognized that this was the time to

"fine tune" one of the project dimensions. The situation presented various alternatives: 1) hire an additional programmer, to increase the speed of the programming; 2) redefine the product specification and remove half the features, so the programmer could finish on time; or 3) go to management and see if the delivery date could be moved back by a year.

For this particular product, management could not accept either a reduced feature set or a schedule change, so we had to find additional programming resources quickly. Fortunately, we found an experienced Macintosh programmer who had developed several previous geography applications. With his help, we were able to get the project back on track and deliver it within two months of the original delivery date.

A natural reaction in such a situation, however, is to start pressuring the original programmer. While this may improve appearances in the short term, it is usually not helpful over the long haul. Even if the programmer becomes more productive in the short term, people's personalities are difficult to change, and the programmer will probably lapse into his old habits before long. In addition, if it requires pressuring to change his behavior, you may have to maintain this pressure for the remainder of the project. As the programmer becomes numb to the pressure over time, you will need to become increasingly firm. This can create an uncommunicative, dysfunctional, and potentially explosive situation as the project grinds along. By the end of the project, if you make it that far, you may no longer be on speaking terms.

It is generally better to figure out what is really going wrong as early as possible, without blaming individuals, and try to fix it. You may realize (better late than never) that given the product specification it is really a two-person job, and without more money to hire an additional programmer, the specification needs to be changed. As Microsoft's Steve McConnell puts it in *Rapid Development*, "Cut the size of the software so you can build it within the time and effort planned." Or you may realize your programmer is not well suited to the task. Perhaps he has a mainframe programming background, without the necessary Windows experience to be effective on your project.

FIGURING OUT A SOLUTION

There is no single correct way to solve these kinds of problems, no rule book to determine when to adjust which factor. However, since budgets are usually fixed and extending the delivery date does not necessarily decrease the cost, the decision often boils down to changing the design specification. Obtaining more resources (money) is always a difficult proposition and is sometimes not possible. Increasing the schedule is a quadruple threat: 1) changing the timing of the product introduction can have all sorts of negative marketing and sales consequences; 2) it increases the amount of money needed, since people must be paid to work on the

project for a longer amount of time; 3) it allows more time to accumulate additional feature creep; and 4) it sometimes takes the pressure off the development staff, which can lessen the urgency they feel to complete the task.

The correct decision on how to adjust the three factors depends on the specific situation, and it is always best to discuss the options not only with members of the development team but also with others in the organization who may be affected by your decision. Very often the marketing, sales, and technical support people can be of great help in suggesting alternatives or pointing out where there might be leeway or options to explore. As the project manager, it is up to you to find a way to fix things through creative problem-solving and an intimate knowledge of the development process.

One common situation is when the project is taking longer than expected but there doesn't seem to be any slack to take up. In this case you may be tempted to ask people to work longer hours, and this may help a great deal in the short run. However, costs emerge in employee dissatisfaction and long-term quality of work. People working excessive hours tend to make more mistakes and usually do not work as fast as they normally would, so besides the added cost, the benefits of extending the workday are somewhat lessened. Asking team members to work longer hours is usually beneficial only at the very end of the project.

Tightening Up a Loose Project

By identifying bottlenecks in the development process and reassigning tasks so as to widen those bottlenecks, you can often tighten up a loose project. For example, imagine creating a training application that contains numerous input and multiple-choice questions for testing. The whole project may depend on a single programmer who is placing graphics, programming the test items, and performing his own software testing on those questions. This represents a substantial bottleneck. Perhaps another individual could be applied to create and place graphics, and another to test the questions once they are programmed, thereby widening the bottleneck from one person to three.

Crises

Multimedia projects tend to be prone to crises, because 1) they are software projects, and software projects always contain unknowns, due to the inherent invention/development process; 2) the necessary interaction and coordination between team members of different expertise—programmers, artists, video producers, and so on—can create miscommunication and other management difficulties; and 3) the large learning curve often required by many involved in the project can slow things down and produce mistakes.

Crises can usually be identified by a significant shortfall in two of the three project factors. For example, if your deadline is only a week away (time) and your programmer just quit (resources), the project is probably in a crisis—even with unlimited financial resources. Or if you have implemented only half the features (task) and the budget is all used up (resources), you have another kind of crisis on your hands.

The way to deal with a crisis is to break down the project factors, identify the main problem and how to fix it, then balance and readjust the three factors.

Breaking It Down

When a crisis develops, you need to separate the project factors and examine each to see what's wrong. Then, hopefully, they can be fixed and realigned.

For example, when Commodore was developing *AmigaVision* (one of the first icon-based authoring systems), the project hit a certain point when it seemed stalled in beta. We couldn't seem to move into the final testing phase. The original deadline came and went, development costs were starting to skyrocket, and management got ready to pull the plug. By breaking it down, we realized that 1) given the original product specification, our resources should have been adequate; 2) the original time estimate had been overly optimistic; and 3) the original design requirements had been superseded by numerous feature modifications and additions dictated by the marketing department, which was concerned about features thought to be under development in rival authoring systems. In other words, we were experiencing "feature creep."

In fact, it turned out that the continuous feature creep at work was responsible for our stalling out in beta. The obvious answer was to freeze the application with the existing features (which happened to considerably surpass the original feature set). We did this with senior management's approval and were then able to test, debug, and ship it in a few months.

In other situations, it may be that the original cost and time estimates are off significantly and all three factors must be adjusted. Another common situation is personal or interpersonal problems on the development team. All these fall under the category of resource problems. If a key programmer finds another job halfway through the project, you face a resource problem. If a squabble breaks out between the programming and testing personnel, you also have a resource problem: not that you don't have enough resources, but in this case, they cannot be used effectively because of the argument.

Unfortunately, no rule book or checklist spells out exactly what to do and when to do it, to avoid a crisis that has already developed. Each decision depends heavily on the specific situation and the subtleties of the priorities involved. However, by understanding how these three factors interact and by generating creative problem-solving alternatives, one's ability to cope with these minor crises is greatly increased. By paying close attention to the project schedule, one may even be able to avoid crises before they arise.

EXAMPLES

Electronic Slide Show

With an electronic presentation, the time factor is usually fixed, because the presentation has already been scheduled. Therefore, as soon as it starts looking problematic that a presentation may not be completed in time, you must immediately consider your options. The time factor cannot be changed, because the presentation date is set. Unless you can get the presentation rescheduled, the solution is to be found in either the task or the resources. The task should be closely examined. If the design can be simplified, it may allow enough time to get the project back on schedule. The resources may be another area to be examined, since theoretically, more resources help might well speed things up. While most electronic slide shows are developed by one person, another person might be able to set up the display equipment and handle logistics, like preparing paperwork to ship equipment or getting electrical and projection equipment set up ahead of time in the demonstration room.

Consumer Multimedia CD-ROM

Consumer titles are somewhat fixed in the task factor. Since they must compete in the open market, often against similar products, the visual design must be superb and the feature set comparable, if not superior, to competitive products. A consumer product that develops a poor reputation because of its design or feature set is difficult to market and faces an uncertain future. Therefore, since a weak or limited design can easily kill a product in the market, it is extremely important to maintain a high commitment to the full-featured design.

The time factor is often somewhat fixed as well by the cyclical buying pattern of the American public. Since the major selling season is Christmas, a new title not on the shelves in time will miss an opportunity to generate substantial revenue. Since a new title must be on the shelves by mid-fall, it must ship in early fall and be delivered by the development staff to manufacturing in late summer. Missing this window can have serious ramifications for the revenue generated by the product, and therefore the company funding the development.

Altering the resources (development budget) significantly can also pose some risks for the company financing the project, since it means either more units must be sold to break even or the price must be raised, which could affect sales. Yet, given the trade-offs, if it can be done early enough in the process, increasing the development resources can be the best alternative, simply because it is usually more important to ship the product on time than not to go over budget by an incremental amount. For every month a consumer product ships late, a month of sales revenue will be lost. The increased development costs can pale in comparison to a whole month of lost sales. In addition, when the high cost of marketing a consumer product is added to the original development cost, the combined total can mean millions of dollars on the line. Compared to costs of this magnitude, the

incremental cost of hiring a few more people for a few months to make sure the title ships on time can become nearly insignificant and may therefore be the best alternative under the circumstances.

Trade Show Kiosk

Developing a kiosk for a trade show is again a fixed time project. It is rare that a trade show can be rescheduled to allow you enough time to finish your kiosk. If the project looks problematic early enough, you can start correcting by working with the task and resource factors. Some options regarding task include decreasing the quantity of data that needs to be prepared, especially photos and video. Another approach is to use a more modular development approach—since kiosks are often a supplementary attraction in a trade show booth, it may be possible to implement a subset of the full application and plan to implement the remaining features for the next show. For example, if the design calls for an attraction module, a product demonstration module, and a lead generation module, perhaps the lead generation module can be postponed (and you can use the goldfish bowl to collect business cards one last time). If the other two modules are working well, they will still add significant value to the trade show exhibit.

If the requirements cannot be altered, the other option is to request more resources to apply to the project. If this is done early enough and the resources are granted quickly, it could have a dramatic effect on the development schedule. However, if you try to pile on people in the final development stages, it will probably have little positive effect on the overall schedule and may well backfire since the original staff who are still doing the bulk of the work, will now have to train the new recruits as well.

Web Site

World Wide Web home pages and company sites are generally more fluid and ever-changing than other multimedia applications. Since they exist in an on-line medium, not only can they change, but frequently they must be updated, reorganized, and even redesigned as company priorities change. Therefore the task factor is often a moving target. This makes it especially difficult to estimate the resource and time factors of the "final application," since, in a sense, the application is never really "final." The resources required generally consist of internal project management and data preparation staff, along with external Web developers who have the specialized and fast-changing technical knowledge required to maintain a reliable commercial Web site. For a simple Web site, actual programming time is often less a factor than the time required to design the site, especially when multiple departments within a single company are to be represented on the site and are all involved in making design decisions.

2

Planning and Scheduling

To schedule the workflow on a project, you need to identify as many of the individ-
ual tasks as possible, place them in a logical sequence, and identify the dependen-
cies (that is, which tasks are dependent on the completion of other tasks). Then you
can start scheduling those tasks. The resulting workplan should include as many of
the tasks as possible—not only software development tasks but the production of re-
lated print, audio, and video materials as well, since these are often interdependent
with the software process and will affect the availability and scheduling of project
resources.

While you should attempt to make the initial workplan as accurate as you
can, do not imagine it will remain unchanged for long. Such workplans are in a
constant state of flux and are never actually completed until the project itself is
done. Managing and updating the workplan to account for the reality of the proj-
ect workflow is an ongoing task and is in some ways the main function of the
project manager. Managing the workplan is intimately tied to current, sometimes
daily, developments on a project, and sometimes there is little time between the
planning and execution of tasks. In fact, sometimes scheduling and planning a
multimedia project in process has the feel of building a bobsled run just ahead of
the hurtling bobsled. For this reason it is essential that the team leader have some
measure of management control over the resources assigned to the project.

Scheduling corresponds to one of the three main project management factors
(time)—and depends on the other two factors: task and resources. If your access to
personnel and equipment (resources) is restricted, you may not be able to apply
them when they can be most efficiently utilized. This will probably delay the project
completion date. Likewise, if the task is overly ambitious, it may not be possible to
schedule or complete a project by the deadline, given a particular set of resources.

Personnel

One of the most important factors is the availability of the right personnel at the
right time. People develop these applications, and without the right people working

on the project at the right time, there is little chance of success. Not only must the right people be available for enough time, but the quality of that time is extremely important. A programmer available for half as much time as needed will only get half as much done as needed. However, even a person available for the full time, if constantly interrupted by non-project tasks, will find it difficult to maintain the schedule. The project manager must protect the staff from distractions and requests that interfere with the timely completion of assigned tasks.

The ideal way to manage the availability of staff is to have a full-time staff (a team) assigned to the project for the duration of the project. In this way, you can hopefully avoid the resource contention that often occurs in less optimal situations. This kind of full-time team arrangement has other benefits, including stable budgeting, decreased administrative time spent tracking hours on each project, and increased individual commitment to and "ownership" of an application. However, this full-time team assignment is an ideal situation that cannot always be arranged. The realities of business and production department workloads often limit the availability of key personnel, like skilled programmers and talented artists. In such situations, you can identify the risk to the schedule and quality of work and inform management of it.

DELIVERING ON TIME

When it becomes apparent that a project with a fixed deadline is running behind schedule, sometimes the only ways of getting it back on schedule are to add resources (people and equipment) or decrease the magnitude of the project itself (eliminate features and/or simplify the design). This decision should be made as early as possible to maximize the benefit. There is not much point in removing features if they have already been programmed and tested; in fact, removing features in the later stages may actually increase the amount of work to be performed. However, if a feature is yet to be programmed, data hasn't been prepared, and the feature doesn't affect any screen layouts or graphics, removing it from the design could reduce the workload significantly and help bring a project back on schedule. In fact, decreasing the quantity and complexity of features is one of the most effective means of achieving the schedule. This technique must be employed judiciously, however, to avoid impairing the basic usefulness of the application. You don't want to throw the baby out with the bathwater simply to get back on schedule. For example, removing a particularly complicated feature may put a project back on schedule; however, if it is a prime marketing feature, removing it might also make the resulting product less saleable.

Why the Date?

It is useful to investigate why a particular delivery date was chosen. Was the July 1st deadline a "drop-dead" date because the project is an electronic slide show and

that is the date of the conference presentation? Or was that date selected because the HR department wants to have a demonstration kiosk up and running in the lobby this spring to start making a good impression on new hires in the fall (in which case a week or two may not make much difference)? Was a turnover date to manufacturing assigned by someone with intimate knowledge of the manufacturing process who is trying to accommodate the multimedia development schedule? Or was it set by a junior accountant to make it easy to track cash flow in the production department? Your knowledge of the reason for a particular deadline may open up possibilities to adjust the schedule.

Importance of Deadlines

While deadlines can be onerous, they are also beneficial and are an important element in the development process. A significant effect of deadlines is that they force you to set dates for the completion of intermediate tasks (milestones), which then serve as a way to gauge and track progress. Besides, there is nothing like a deadline to motivate project staff. In addition, deadlines can be doubly important to the financial health of a company engaged in publishing a multimedia product for sale, since the sooner the product is completed, the sooner it can be sold, and the sooner you will start recovering revenue from the investment. While this consideration can be critical for companies offering products for sale, it is sometimes not apparent to production staff who may simply desire a more leisurely pace of development.

PROJECT MANAGEMENT SOFTWARE

One of the best ways to plan, schedule, and track projects is with project management software. Project management software packages such as Microsoft Project, Timeline, and MacProject provide useful, highly specialized project management tools like PERT (Program Evaluation and Review Technology) and Gantt charting capabilities, resource leveling, and cost reporting. These tools provide you with a bird's-eye view of the development plan and process, which is invaluable in tracking the organization, sequence, and completion of tasks and events necessary for a product to be delivered on time. This hopefully lets you identify and foresee potential crises ahead of time, so you can avoid them. With project management software, you can easily adjust the workplan to try different scenarios. When these workplans are shared with others on the development team, they become an excellent means of discussing the project and help keep team members informed of their tasks and the required completion dates.

Often, you will encounter individuals who believe project management software is necessary or useful only for large projects, like building a nuclear power plant or erecting a dam across the Colorado River. This is not true. Aside from small, simple projects of short duration, most multimedia applications can benefit

from project management software. In fact, many projects actually require it. Such software programs allow you to structure the workflow, delineate tasks, assign durations and dependencies, and show the ripple effects of delays at various points. They can also calculate the critical path of task dependencies and provide a variety of reports and charts to help you effectively focus your attention and energy.

Project management software programs typically offer multiple views of a project, the most common being PERT and Gantt charts. PERT charts are diagrams that show the individual project tasks, connected by arrows marking the dependencies between those tasks. Gantt charts show task durations organized on a timeline. Project management programs also provide various histograms and other reports. It is not necessary to use all the various display and output capabilities. Some views are essential, and others can be extremely helpful in a given situation. You can usually sort the tasks according to various criteria, such as grouping together those tasks to be done by a certain individual, listing the tasks that should have been started by a particular date, or highlighting individuals who are over-committed.

PERT Charts

One of the most powerful means of planning and scheduling a multimedia application is a PERT chart. This is a network of interconnected boxes, each of which represents a task or milestone in the development process. By identifying which tasks are prerequisites for other tasks, you can clearly see the interdependencies of the individuals at work on a project. This is helpful in exposing dependencies between tasks and bottlenecks in the workflow that may not otherwise be apparent. A PERT chart can be helpful when you are trying to figure out how to finish the project by the deadline date, because you can reorganize tasks and interdependencies and see the results on the schedule immediately. For example, you may originally have scheduled the user manual to be written at the end of the project. However, a PERT chart may make it apparent that this will make the project several weeks overdue. You might then decide to break up the user manual production into separate tasks (for example, outlining, writing, editing, and screen shots), which can be done simultaneously with software development, thereby shortening the overall time frame but increasing the need for more personnel earlier. A PERT chart can alert you to the probable schedule slippage points and let you find ways to overcome them.

Gantt Charts

Gantt charts are also powerful project management tools that are helpful in tracking whether tasks are progressing as scheduled and being completed on time. Gantt charts are a type of bar chart that graphically depict how long a task is scheduled to take, when it can be started, and when it must be finished. This graphical

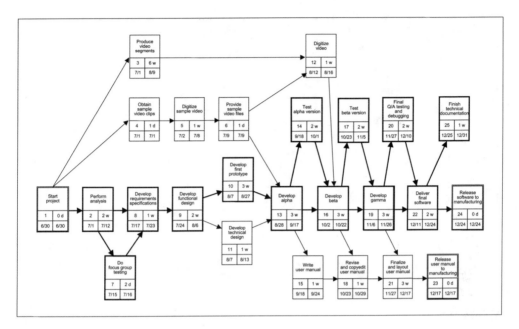

Figure 2.1 Sample PERT Chart.

representation also shows the relative magnitude of individual tasks and the percentage of each task completed to date. Gantt charts are an excellent way to measure the progress of individual tasks and a great way to show team members what they need to do and when they need to do it. Gantt charts can group tasks by individuals, to show what each person is responsible for; by date, to show the overall sequence of tasks; or in many other ways.

A Planning Method

It seems that almost everyone has a preferred method of planning and scheduling projects. One useful method is to create a "blue sky" PERT chart diagramming your preferred workflow for the project, including reasonable task durations without regard to schedule. Generally, this initial "blue sky" PERT chart will generate a projected release date well beyond the project deadline. The chart then becomes a tool that promotes creativity and research to identify ways to shorten the schedule and still get the work done. Once the PERT chart adequately and realistically reflects the development tasks and the sequence of events that must take place to achieve the deadline, you can use the Gantt chart to track the completion of these tasks. By using the PERT chart as the primary interface to schedule and adjust the workplan, from which the Gantt chart is derived for schedule tracking, you can maintain a global perspective on the project. It is easy to see the ripple effect of various plans, where scheduling conflicts arise, and where the critical path is at any given point.

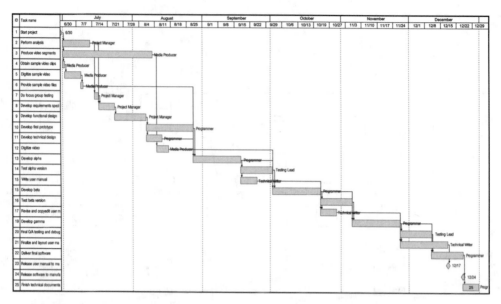

Figure 2.2 Sample Gantt Chart.

Some people, however, find it easier to work with the Gantt chart as the primary interface. Whatever method you feel most comfortable using to schedule tasks is probably the best way for you to operate.

Bells and Whistles: Diminishing Returns

New users of project management software sometimes find the sheer volume and complexity of features offered by these programs intimidating. In fact, this may actually account for the lack of acceptance that project management software has received by some project managers. These programs are often packed with advanced (and sometimes marginally useful) features. In addition to dozens of different kinds of reports and charts showing resource allocation conflicts, these features include the ability to incorporate subprojects and to track nearly every conceivable facet and variable a project has to offer. This proliferation of features is analogous to the "feature creep" associated with other software categories, like word processing software. While most people use only a small percentage of the features available in the typical consumer word processing program, (e.g. Microsoft Word) these applications require a glut of features because of the fierce competition among word processing programs. The same principle applies to project management software. Just because the program has all these features doesn't mean you have to use them all. By using features that are obviously helpful (like PERT and Gantt charts) and then finding and learning other features on an as-needed basis, you can avoid most of the learning overhead that dissuades some from using these incredibly useful project management tools.

Maintenance and Modification

When using project management software, someone (usually the project manager) must continually maintain and modify the workplan to account for the realities of the project. The various charts and reports should be viewed as works-in-process that are continually in flux and that change to accurately reflect the project. They are not meant to be some theoretical blueprint, cast in stone at the beginning of the project. Multimedia projects are subject to many unforeseen events and unpredictable progress, and the PERT and Gantt charts must be revised, modified, and updated regularly and continually to reflect the current state of affairs. The charts and reports are tools by which the project is accomplished. Once the project is finished, such charts are also helpful to review what really happened, so as to learn by experience and prepare for future projects.

RULES OF THUMB
Rule of Thirds

Many studies have been performed concerning the relative amount of time and resources invested in the various phases of software development projects. These studies are hampered in arriving at global conclusions by both the substantial differences in corporate development methodologies, and the various measurement techniques employed. Nevertheless, substantial similarities recur from one software project to another (including multimedia projects), which can be helpful in making generalizations and constructing rules of thumb.

One rule that seems to be of help is the "rule of thirds," which basically holds that the amount of time and effort spent in design, production, and testing are roughly equal within a particular application. An application that takes one year to develop will probably take roughly four months to design, four months to produce (program and data preparation), and four months to test (and debug). This may seem a disproportionately large percentage for design and testing, but in practice, this rough rule of thirds seems to hold across various applications, whether they are scheduled that way or not.

This rule is not a bad way to quickly estimate the overall time for project completion and set some useful parameters on the work to be performed. For example, if a product must be released in six months, you can plan to spend two months in design, two in development, and two more in testing. This means you have two months to design an application that can be developed in two months. This places some helpful limitations on the complexity of the design that can be accomplished in that time and, hopefully, on the complexity of the resulting application.

The validity of this time allowance is indicated by a common response from project personnel after a project has ended; namely, that more time should have been spent designing the application in detail up front. This includes thinking through the interface issues and doing more early screen design, focus groups, and

prototyping. The simple reason for spending more time on this before starting actual production is that this detailed design work will have to be done anyway, and if it isn't done in sufficient detail in the beginning, it will have to be done later, which creates larger problems and costs more. Additionally, if the design issues are being decided on the fly as the application is being programmed, programming efficiency is greatly decreased.

Another piece of anecdotal support for the "rule of thirds" comes in the form of a rude surprise in the sheer length of time necessary to test and debug most applications. Even those that are programmed efficiently and by experienced programmers must still go through a full quality assurance cycle, if only to certify that they are working correctly. Usually, this ideal scenario does not occur, especially when several programmers are working together on an application. Testing should start relatively early in the development process and usually continues well past the point where intensive coding has ended. This time and effort spent in testing can be extremely frustrating, especially if it hasn't been built into the schedule. In addition, because testing is the last step in the process, it always seems to catch the blame for schedule delays that in reality were caused by mistakes in design and coding that occurred much earlier. Like a relay race, where the success or failure of the last runner depends in large part on the efforts of those who came before, if code is delivered late and has been hacked together, testing personnel cannot be faulted for late delivery of the product simply because they test it and find problems that need to be fixed.

Testing Takes Longer

Not only does testing usually take longer than anticipated, it sometimes takes two or three times longer. There are several reasons for this, including the quantity and quality of the testers, the sophistication of the testing methods employed, and the responsiveness of the programmers to the test results. Testing is sometimes imagined and planned as if it were a simple certification process, when in reality it is a crucial and time-consuming development phase. It may take as many full-time testers working on the product as there are programmers, depending on the complexity of the code and the amount of data. Often this quantity of testers is not anticipated, much less budgeted. Therefore, if the testing resources allocated are inadequate, it will take much longer to accomplish the work. If a single individual is assigned to test a product that really requires two testers, testing will take twice as long; if the product is complex enough that it requires three testers and only one is assigned, testing will take three times as long. The quality of the testers themselves also makes a huge difference in the testing process. A single experienced quality assurance professional, working from a test plan and tracking findings in a well-designed database, can outperform a whole roomful of inexperienced interns or students who are asked to simply "try to break this program." The experienced tester knows what to look for, where to find it, how to report it, and how to check it later to see if it was fixed. Experienced software testers should be able to write a test plan, manage a software defect database, and perform regression

testing. A person of this caliber will be able to find more defects faster and will also speed up by an order of magnitude a programmer's ability to fix the defects. Therefore, when planning software development, the testing process and personnel must be planned with as much emphasis as that required for the design and programming processes, including the use of test plans and automated testing tools if appropriate.

Cool under Fire (Drills)

Multimedia projects tend to be subject to false crises, commonly called "fire drills." These "tempest in a teapot" situations, which arrive without a moment's notice, are quickly forgotten. To adequately manage these situations, it is important to keep a respectable mental distance from the problem, and above all, don't panic. The urgency of these episodes is often inversely related to their actual importance. For example, while working intently on attaining the beta release date for a new marketing application, you might receive an urgent message from the secretary of the vice president of marketing that you have to demonstrate the work-in-progress later that day. This is in effect a command performance with little or no advance warning. In this situation, you might have to drop everything to comply, knowing full well that the application is not really in a showable state. It is important to maintain your composure and quickly get to the source of the request (in this case, the VP), so as to find out exactly what is wanted and by when. Sometimes the individual didn't realize the amount of work the request entails or is actually looking for something different than what was conveyed by the messenger. If you react in a less controlled way, perhaps by succumbing to panic or by hastily packing up equipment for the impending demo, you may find yourself wasting time and emotional reserves. It can also be helpful to document the work interruption for future reference, in case you miss a project deliverable date as a result, and to check first with your own manager to validate the relative priority of the request.

MEASURING PROGRESS

Slippage

"Slippage" is one of those intangible factors in a project that seem to constitute an effect without a cause. Tasks usually slip because of events beyond your control or unforeseeable difficulties in implementation. However, just because slippage on an individual task is unpredictable does not mean that the overall slippage rate cannot be predicted. Slippage must be monitored closely from the beginning, because projects that start falling behind cannot easily catch up again.

By carefully measuring slippage in the beginning stages of a project, you can develop and apply a slippage factor across the full project and thereby improve the accuracy of your time estimate for completion of later stages. For example, if a twelve-week project has a four-week design phase scheduled and the actual

design takes five weeks, then the slippage is 20 percent. This means the end date for the project is probably closer to fifteen weeks than the original twelve, and not simply the thirteen weeks you might assume (the original twelve plus the one week the design phase was late). Early slippage is usually symptomatic of the general development conditions and as such is a useful indicator of factors likely to continue through the entire project. This initial slippage factor may also provide evidence for adding resources early in the process or for scaling back the design to meet the deadline.

Slippage graph

Measuring slippage can be enlightening, and there is an interesting way to use slippage and time estimates themselves to get a "slippage corrected" estimate for the most likely completion date. This technique simply involves recording your original time estimates and the date on which they were made. For example, imagine that at the beginning of January you estimate the application will take three months, giving it a completion date of March 31. At the beginning of February, a couple of focus groups have shown the need for some significant design changes, which will add work. You then revise your delivery date estimate to mid-April. In mid-February, a technical problem is encountered, and you must revise your estimated completion date again, this time to late April. At this point, you might well start to wonder, given the way things are going, when will the application *really* get done? Using the information cited above, you can easily create a data table, as in figure 2.3.

These points can be mapped on a graph, as in figure 2.4.

From this graph, you can see that given current progress, the project is actually headed for a release in mid-June. The graph also shows how easily even relatively small projects can miss deadlines by 100 percent or more, and hence the great necessity of getting a slipped project back on schedule quickly.

No Partially Done Tasks

One misconception that project managers sometimes have is that certain unpredictable and possibly nonquantifiable tasks can be accurately measured by the percentage of work completed. Some elements, like data preparation, can often

Date estimation was performed (on date...)	Estimated delivery (...I estimated the project would be done)	Development time remaining (weeks) (project length remaining)
January 1	March 31	12
February 1	April 15	10
February 15	April 21	9

Figure 2.3 Estimation/slippage table for the sample application.

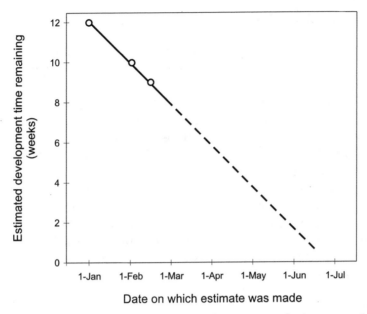

Figure 2.4 Estimation graph, showing data from figure 2.3 graphed to extrapolate most probable project completion date.

be measured quantifiably (if fifty out of a hundred photos have been digitized, it is fair to assume that the task is about half done). On the other hand, some tasks, like design, programming, and testing, are not done until they are done. In other words, the design process can continue ad infinitum, so it is sometimes meaningless to measure the percentage of the task completed. Likewise, programming may be finished, but testing results will require more programming to fix errors discovered. Testing itself is not done until the first product is released, and may even continue afterward. Therefore the precision of the scheduling and time estimation process has inherent limitations. Rather than try to quantify every task, it is sometimes wise to pay close attention to whether a task has been started or not, how it seems to be progressing, and if anything can be done to facilitate its completion. But to carefully tally the percentage of programming that has been completed based solely on a programmer's estimate is of little value and may well represent a waste of time or, worse, misinformation. When a programmer says a task is about 80 percent done, it may actually still require another 80 percent of the effort to finish the code and test and debug it. This is not to say that programmers are incapable of estimating accurately, but that project unknowns often make percentage-complete estimating inaccurate. Therefore, it is important to note when tasks are started and when they are completed, and use this information to manage a project, but percentages of task completion for design, programming, and testing may be of little value and should be taken with a grain of salt.

Function Point Analysis

The search for an accurate, analytical, quantitative method of measuring progress in software development has been viewed by many as the software development industry's search for the Holy Grail. However, at least one technique, Function Point Analysis (FPA), seems to be demonstrating progress in this regard. FPA attempts to quantify all the inputs, outputs, and file manipulations that must occur within a given software application, then uses the resulting number for a wealth of statistical measurements. Commonly called "software metrics," these measurements include the "real" percentage of a project completed, development cost per function point, accurate estimates of work to implement design changes, and other useful information. FPA appears to be useful in the beginning stages for cost and time estimates and to track progress and adjust schedules and expectations. However, to implement this technique requires the abilities of a fairly technical and skilled individual, usually with some programming background, who can understand and evaluate the underlying software architecture. It appears that for larger projects, when time and budgets allow, function point analysis can be an extremely valuable tool in monitoring progress.

No Shortcuts

When you are developing a multimedia application under tight deadlines, there is often a great temptation to cut corners, hoping that if you can just get *something* up and running to demonstrate progress, it can be fixed later. However, this is often precisely the wrong strategy and can sometimes cause more problems, and more difficult problems, than the original problems it was meant to fix. If you attempt a programming shortcut because of schedule pressure, three counterproductive effects become evident. First, schedule pressure itself rarely leaves time to adequately design the shortcut, meaning that the shortcut will have to be debugged, possibly to a greater extent than the original implementation. Second, schedule pressure still exists, and if the shortcut fails to work, the time invested in it is lost, thereby increasing the pressure. And finally, if the shortcut is meant to be a temporary fix, then the work will have to be redone the right way anyway in the future.

Concurrent Tasks

Finally, one of the most useful strategies at the project manager's disposal is to constantly try to maximize the amount of work that can be done concurrently on a project. If you are watchful and creative, it is often possible to find ways to get people started on tasks sooner than originally planned. For example, if you are asked to develop an electronic slide show but the presenter is out of the office, it may be possible to reach him or her by phone or fax to get a brief outline of topics and let you get started putting the basic structure together. By getting a running start like this, you can significantly cut the start-up time on a project. Likewise, a program-

mer who has been included early in the design process on a given project may know enough to start laying out the basic software architecture, even before a final functional design has been approved. Data preparation people can immediately start producing sample data to work out the details of their file conversion processes, rather than waiting for some arbitrary date to get started. Most projects present dozens of situations like this, and it is up to the project manager to identify them and use them creatively to keep a project running on schedule.

Planning and scheduling multimedia applications is as much art as science, requiring both intuition and analytical skills. If you can obtain the resources necessary to do the job and apply them efficiently, you will be well prepared to deliver high-quality products on time.

3

Cost Estimates and Budgeting

Multimedia projects are notoriously difficult to cost-estimate. Cost overruns are usually a result of the unknowns inherent in the software development process and changing design specifications during development. Nevertheless, figuring out how much a multimedia application will cost to develop and then getting the funds approved is key to multimedia development. Developing an application requires resources; it cannot be created out of thin air. Whether the application is developed with a generous budget in a well-furnished multimedia studio or is done as a skunk works project after hours, it requires people, equipment, time, and materials. Your ability to accurately estimate the cost of these resources is crucial to your success in managing multimedia projects.

Relationship to Project Factors

The cost of doing an application corresponds to one of the three project factors—resources—and depends on the other two: the task itself and the time available. To do a short, simple application (small task) will cost less (take fewer resources) than to do a large, complex one. In order to develop an accurate cost estimate, the task and time available must be predetermined. This interrelationship between the dimensions is a primary cause of confusion in determining how much a project will cost. Without setting two of the parameters, the third cannot be accurately derived.

Risk

Cost estimating and budgeting contains perhaps the largest inherent risk in the whole development process. Software projects usually go over budget because budgets are linked to inaccurate cost estimates done early in the project. This is when enthusiasm is high and foresight is low, and the combination can have disastrous implications for companies with significant resources committed to such a project. The higher the final cost, the more units that need to be sold to break even

and the lower the profit potential. Or if the project is to be used for training or marketing, the higher the development cost, and the more effective it must be to justify the increased cost.

COST ESTIMATES VERSUS BUDGETS

While cost estimates and budgets are closely related (both attempt to predict and control expenses), there are some significant differences between them. Cost estimates are predictions of how much the project will cost by the time it is finished; budgets are spending limits set within an organization, typically yearly. Cost estimates differ from budgets in various ways, including why they are created, who creates them, and whether they are static or dynamic.

Why They Are Created

Cost estimates are done to identify the size of an investment required or remaining until the application can be sold or used. This is needed to determine whether or not sufficient funds remain in the budget to pay for the remaining costs, and if not, whether it is worth getting more funds approved, so the application can be finished. Initial cost estimates are done to assess whether or not it is worthwhile even to do the application at all. Finally, identifying the remaining costs for the purpose of cost estimating is also helpful in planning for and allocating resources.

Budgets, however, are created to set spending limits for a company, based on revenues expected to be generated. Without a budget, individual departments in a company could not function efficiently, since they would not know their spending limits and therefore could not plan to obtain (or retain) the resources to fulfill their responsibilities. In addition, budgets identify the kinds of expenses that will be incurred, since various expenses are handled differently for accounting purposes. For example, rented equipment can be written off as a business expense in the current year, while purchased equipment must be depreciated over at least several years; personnel costs require a surcharge for taxes and benefits, and so forth.

Who Creates Them

The cost estimate for a multimedia application is generally done by the project manager in consultation with the development staff. Budgets are usually set by upper management as part of the ongoing fiscal year cycle. It is rare for the same person who does the cost estimate for a multimedia application to actually set and/or approve the budget for the project. This disparity can create problems. Not only can there be innocent misunderstanding and miscommunication between people, but the individuals' different responsibilities can create interdepartmental competition. For example, if the financial department is competing with the production department for visibility or control, budgeting can be a potent weapon in that struggle.

Dynamic versus Static

Accurate cost estimating is a dynamic, iterative process, with the first valid estimate being possible sometime during the latter part of the design process, increasing in accuracy as the project progresses. Without a fairly complete design specification, a cost estimate is mostly guesswork, simply because the product being estimated is undefined. The clearer the definition, the more accurate the estimate. As the design progresses, the estimate becomes more accurate.

Budgets, on the other hand, are usually set early in the development process, sometimes even as a precondition for project approval, and usually remain unchanged for the duration of the project. This creates an inherent contradiction, since the cost estimate can (and does) change, but the project budget is fixed. This often results in either going over budget or shaving features out of a product toward the end of the development process, in an effort to stay within budget.

OVERLOOKED COSTS

The costs of developing a multimedia application can be calculated in various ways; however, two areas often overlooked are the fixed costs inherent in developing an application, and the costs of maintaining the product over its anticipated lifetime.

Fixed Costs

Fixed costs refer to costs that will be incurred anyway, regardless of whether the multimedia project is done or not. Such costs include utilities (rent, heat, electric, telephone), salaries, benefits, overhead, software tools, rental equipment, and the like. They are easy to overlook (or even dismiss) for smaller applications such as presentations, but it is essential to include these costs, since they will be incurred anyway and will most likely be charged to the given project.

However, determining fixed costs may not be a simple matter. Many companies have Byzantine accounting methods for calculating overhead expenses. Hopefully, some standard amount, say 50 percent, can be added to an employee's salary to account for overhead (taxes and benefits). In this case, a staff employee being paid $25 per hour may actually cost the company $37.50 per hour ($25 x 1.5 = $37.50) and should be cost-estimated at that amount.

Cost to Maintain Product

The cost to maintain a product over its life cycle is a real cost that must be figured into the cost estimate and budget if the application is to have a viable future. This includes the cost to fix errors, modify the user interface, and other essential software maintenance tasks. Without estimating and budgeting for these items and

their associated costs up front, there is often little chance of obtaining the necessary funds later.

Other costs that should be noted but not necessarily included in the cost estimate include the cost to update the application to run on new versions of an operating system, to convert the program to a new operating system entirely, and to make additions and enhancements for a new version of the program. These costs should be viewed as separate projects that need to be budgeted anew.

ACCURACY OF PREDICTIONS

While it is important to attempt to estimate costs as accurately as possible, remember, there is inherent unpredictability in any new product development work and in software development in particular, simply because it is an activity of continuous learning and invention. This makes estimating software development a qualitatively different kind of activity from estimating the costs of other known activities, like manufacturing or marketing.

In fact, according to some researchers, most software projects are actually out of control from the beginning (Tom DeMarco, et al.), if only because the resources and skills to accurately measure the size and progress of the application are lacking in most situations. There is a real cost associated with simply measuring; but without accurate measurements, it is difficult to determine the true size and scope of development activity and actual progress being made. Without accurate measurements, you can only guess at how far along the development process really is.

For example, if the alpha version of an application was scheduled to be delivered one-third of the way through the development process and this has taken place, it might be natural to conclude that the project is one-third finished. However, the reality may be that only a small sample of the data has been prepared, the programming is full of errors with more being found every day, and design additions are being approved right and left. In this situation, the project may actually be only 10 percent done. Conversely, an electronic slide show in the beta testing stage with several days' work left may be thought of as only two-thirds done, but few, if any, modifications may remain.

Since it requires resources to accurately measure progress and those resources are rarely part of the development budget, most projects are in some sense unmonitored and hence more or less out of control. This accounts, at least in part, for the scale of estimate inaccuracy on many software projects and multimedia applications, where it is not uncommon for an application to run 100 percent (or more) over budget.

One way to increase the accuracy of a cost estimate is to provide a range within which the application is likely to fall. Providing a high (pessimistic) estimate and a low (optimistic) estimate greatly increases the chances of actually arriving within the estimate. This also provides management with a not-so-subtle

signal that the cost estimate is simply that—an estimate, not a price quote—and shows that some uncertainty is inherent in the situation. If management budgets an amount at the lower end of that range, they will have done so knowing they are choosing to be optimistic.

The Mythical Man-Month

One crucial consideration for most multimedia projects is the quality of the programmer(s). Not all programmers are created equal. Productivity between individuals can vary by a factor of ten or more, and it is extremely difficult to gauge relative productivity, even by other programmers who have worked together.

First, programming tasks themselves can vary in complexity by an order of magnitude, which makes it difficult to objectively compare the work of various programmers. In addition, programming is a solitary activity; the only way to observe it is to inspect the code itself, which can be costly, labor-intensive, and highly subjective. Another way to assess a programmer's performance—keeping meticulous records of the number of errors found through testing the code—requires a significant and ongoing investment.

In larger software projects that involve a dozen or more programmers, individual variations in productivity between programmers start canceling out toward an industry average. However, most multimedia applications are programmed by just a few individuals—usually six or fewer, and often just one or two. For this reason alone, the possibility of accurately estimating the cost and time necessary to develop an application is inherently limited. However, if you can maintain a stable programming staff rather than bringing in different programmers for each new project, at least you are dealing with a known entity, and the chances of estimating more accurately are better.

Accuracy Tolerances

In general, because of the inherent unpredictability of the software development process, initial cost estimates that fall within 15 percent of actual expenses must be considered to have been fairly good. Therefore it is important to include a safety factor of at least 15 percent in the initial estimate. This safety factor is important simply because the initial estimate is a total of all the costs you can foresee, but only those you can foresee, and there are always unforeseen expenses. Most overruns are caused by unforeseen items. Those who insist on clinging to precise estimates are generally schooled in areas where more predictable estimates are possible, and who may have little experience with new product development in general and software development and multimedia in particular.

Multimedia cost estimates can be even more problematic than generic software cost estimating because of all the content licenses, rights, and availability issues that abound. The rights to use photos, for example, may be free in some cases and may have to be purchased for hundreds of dollars apiece in others, and it is

almost impossible at the beginning of the project to determine how many of each will be needed. This may amount to a huge difference when an application needs hundreds of such photos.

METHODS OF COST ESTIMATING

Cost estimates are simply predictions of the final costs that will be incurred in developing an application. Since estimates become more accurate as the number of factors decreases, estimates done at the beginning of the project are generally significantly less accurate and reliable than those done as the application progresses. The more work that has been done on the project, the less work that remains and the more accurate the estimate will be. Unfortunately, cost estimates are frequently required at the beginning of the development process, budgets are then established, and projects are expected to fall within those budget limits. Sometimes cost estimates are requested by management even before the design has been done!

There are at least two cost-estimating situations: 1) budget-first (setting the budget ahead of time and designing the application to meet the budget), and 2) design-first (designing the application and then developing a cost estimate based on the design). While the latter is usually perceived as the "correct" way to develop an application, in the real business world, the former is at least as common. A sales department may have budgeted $50,000 for an interactive application and then presents this as the first parameter ("What can you produce for fifty thousand dollars?").

It is important to know which situation you are really dealing with, to avoid making incorrect assumptions. Quite frequently, after designing an application and providing a cost estimate, you learn that the cost estimate is "too high." This usually means that there is already an acceptable budgetary figure, and if you can learn that amount, an application can be designed to fit it.

Budget-First Estimating

If you are given a budget within which the application is expected to fall, the design parameters for that application must be very flexible. If management assigns a fixed budget amount, it is essentially limiting the resources available to the project, which fixes one of the three project factors. Usually there is some implicit schedule expectation as well, which sets a second project factor (time), leaving the task as the only remaining variable. In such a situation, be extremely conservative in your choice of features and functionality. This may be difficult because of the creative nature of most developers and the high expectations held by senior management. However, every additional feature tends to increase the cost of the application not linearly but exponentially. Every new feature must be designed, programmed, and data prepared. The new feature must be integrated into the application, tested, debugged, and documented in such vehicles

as printed documentation and on-line help files. The later these features are added, the more they will cost.

In fact, if the budget target is important enough, it is not unreasonable to choose a design estimated at only half the target budget. Not only will this overly conservative estimate allow you to obtain and allocate resources with relative certainty and to incorporate the 15 percent safety factor, it might allow you the option of adding features to the design later if the opportunity arises.

Design-First Estimating

Design-first estimating assumes that the design itself is created first, as a basis for the cost estimate. To approach some degree of accuracy, it also requires thorough and detailed cost measurements to have been taken during previous projects and that those previous projects were directly comparable to the proposed project. This requires a significant investment and commitment by the organization to the process of measuring development costs. The process of collecting such information is an actual expense.

For example, comparing the cost of creating a small electronic presentation done in-house in PowerPoint is of little value when it comes to estimating the cost of doing a full-blown transactional marketing kiosk system in C++, including original video production, using an outside development house. However, after having completed and measured the cost of doing one electronic presentation, you might be able to estimate with a fair degree of accuracy the cost of producing another one with more screens and better artwork. After measuring the cost of doing the second presentation, estimating the third presentation will be even more accurate. At some point, a worksheet might be developed to assist in such estimates.

Accurate cost estimates can be promoted by performing a post-mortem on completed projects. This helps uncover hidden costs charged to a project (overhead, materials, equipment rental, administrative costs), which can amount to a significant portion of the total development expense.

Once the design has been approved, there are several ways of estimating the overall cost. Three common strategies are time and materials, feature and data costing, and contractor proposals. By developing two or more of these estimates simultaneously and comparing them to each other and to the cost of similar projects in the past, you can often obtain a relatively accurate range of the costs required to develop a given application.

Time and Materials
Sometimes considered a "wet-finger-in-the-wind" estimate, this method is not always precise. However, it can be useful in quickly sizing up a project and providing a baseline from which to start comparing other estimates, and also to plan for the resources necessary to complete the project.

With a thorough knowledge of the design and a good idea of how many and what kinds of individuals will be necessary to carry it out, you can estimate the

cost of employing those individuals for the specified time, the cost of required equipment, and the cost of services and outside contractors (for example, video production, digitizing, CD-recordable discs). Overhead, testing, and administrative support must be considered, as well as any other probable costs. The total should then be multiplied by some safety factor (say 15 percent) and added as a buffer against unknown expenses that are sure to occur.

This method of estimating is not really precise, but it has great benefit in being quick and is not easily dismissed. Such a quick estimate will quickly show whether the application as designed will cost closer to $5,000, $50,000, or $500,000. It is frequently surprising to see how fast the costs add up. Another significant benefit to this method is to help gauge the scope of the effort necessary to complete the application, including the number of people needed, their skills, and the length of time they will be working on the project (which has implications for equipment rental, software purchases, and other resource issues).

Imagine you have completed the design for a multimedia kiosk that in addition to some fairly sophisticated interactive software will include at least fifteen minutes of video and several dozen photos and illustrations. It is to be displayed in a corporate lobby and is due six months from now. Will it cost $5,000, $50,000 or $500,000? A quick estimate might look like the one in the trade show kiosk example at the end of the chapter: $315,000. This may appear outrageously expensive, and indeed, it could easily be off by 25 percent or more. That means the project would likely come in somewhere between $235,000 and $440,000—a huge range, but still useful in setting expectations and within which we can start refining our accuracy.

Feature and Data Costing

The second method of cost-estimating a multimedia application is based on a detailed examination of the design and the individual features. While this method can be much more accurate than the previous quick estimate, it requires more time to analyze the design and relies on your organization having had a history of developing similar applications and having kept statistical data about those projects, to apply to the proposed project.

Analyzing the design is itself a significant undertaking. However, it should be pointed out that this analysis should be performed anyway, as part of the normal development process. The criteria you choose to measure will depend somewhat on the application and the development environment. For example, the estimate for a simple electronic slide show using PowerPoint may consist of a count of the screens, average lines of text per screen, and the number and complexity of any illustrations that might be needed. By keeping track of such statistics across several projects, the development group can start developing a formula by which to estimate future presentations. There will most likely be a minimum cost to develop even the simplest presentation, which corresponds to the fixed costs of consulting with the client, getting the presentation structure defined and set up, loading the presentation onto a display machine, and setting up the equip-

ment. In addition are project-specific costs, which increase in a linear fashion (number of screens, amount of text), and other costs, which might have a nonlinear relationship (ability to incorporate audio or video, payment for software licenses).

For other, more complex applications, like a marketing kiosk created with an authoring system, the measurement criteria and analysis can be significantly more complicated. For example, you might find it necessary to track not only the number of screens, but user interface points on each screen (buttons, list boxes, menu items), complexity of each interface element, quality of original artwork, quantity of photos, minutes of video, and other pertinent items. Again, the accuracy of such an estimate will depend on the quality of the analysis and measurements taken, the history of previous projects that were similarly analyzed, and the stability of the design. (Adding features later in the development process will increase costs and time disproportionately.) Previous projects used for comparison should be those developed with the same authoring system and preferably of similar complexity. If the design is still in flux or if much opportunity for design changes occurs during development, the initial estimates may be off by a wide margin. Hence the need to perform ongoing cost estimates.

For complex, custom-programmed applications, the risk is higher still, simply because the investment is usually greater. The design must be analyzed at a finer and more highly technical level. Factors to consider include the complexity and artistic quality of the user interface, production and preparation of multimedia elements, the number and complexity of software modules and submodules, and other items that can be measured only after a detailed technical design has been produced. Again, the quality of any individual estimate will depend on the similarity of the application to previously developed and measured applications and the stability of the design.

Contractor Proposals

The third method of cost-estimating a multimedia application is to solicit bids from potential contract developers, sometimes called "fixed-bid estimating." This method should be used only if you are really planning to contract out the development. It is extremely unethical to solicit proposals for an application if you have no real intention of letting the contract. Preparing a serious proposal takes significant time and effort, which most developers will undertake if there is a reasonable chance of actually getting the contract. But to offer them a fake opportunity for the purpose of getting a free cost estimate is stealing their time and energy, and for most small interactive developers, their time and energy is the only thing they have to sell. In addition, the very process of requesting proposals and comparing bids is too costly to pursue unless you are actually going to let the contract.

In many situations, independent developers will quote a fixed price to develop the whole application. This effectively sets an upper limit on the amount that would be spent to develop the application (in contrast to an in-house development effort, which exposes the project to the risk of cost overruns that must be paid for

by your company.) By signing a development contract specifying payments based on milestones, the developer is assuming the risk of potential cost overruns. However, this can be a double-edged sword, since changes or modifications made to the original design must be renegotiated with the developer during the development process, and when an independent developer is halfway through programming your application, you do not have much leverage to negotiate. If you really want particular changes, you have no alternative but to pay the price, because there is little chance you'll take the work elsewhere at that point.

It may appear simple to obtain a cost estimate from several developers. In reality, however, obtaining reliable and high-quality proposals takes a significant investment of your own time and energy. The quality of the developer's proposal and estimate will depend in large part on the quality of the information supplied (the design requirements). The more thorough and well-specified those requirements, the more accurate of a cost estimate you will be able to obtain. Creating high-quality design requirements takes time and expense, and even the most complete document will often leave many issues unresolved. A good developer will try to get as much information as possible, which will often require significant amounts of your time to answer questions, discuss options and responsibilities, and, in effect, work with the developer to create a feasible proposal. Soliciting such a proposal from several developers simultaneously can become a full-time job.

EXAMPLES

The following are time-and-materials cost estimates for the four sample applications.

Electronic Slide Show

This estimate is for a slide show expected to take two weeks to produce. Included are the fully loaded labor costs for a full-time developer to actually produce the application, supported by a staff artist working on it half time. It is assumed that the development and display computers and presentation software (such as Power-Point) are available in-house and that an LCD display device must be rented for the actual presentation.

Consumer Multimedia CD-ROM

Figure 3.2 shows a sample cost estimate for a basic CD-ROM electronic encyclopedia consumer title that would take one year to develop and be competitive with existing CD-ROM applications available for purchase in a retail environment. It is assumed that computers for temporary workers would need to be rented and that some new development software (compilers, graphics programs, and so forth) would need to be purchased.

	Weeks	Hours	Hourly rate	Overhead (@ 50%)	Totals
Personnel					
Developer	2	80	$30	$15	$3,600
Artist	2	40	$30	$15	$1,800
Materials					
Equipment rental					
Display device (LCD panel)				1 week @ $300	$ 300
Subtotal					$5,700
Safety factor (15%)					$ 855
Total					$6,555

Figure 3.1 Sample time-and-materials cost estimate: electronic slide show.

This is not meant to be an actual budget for a specific application but, rather, a general estimate for the kinds of tasks and resources necessary to develop an application that is competitive in this environment. This represents only development costs and does not include any marketing or promotional costs, which can equal or exceed development costs for such an application. The high start-up costs for equipment and software as well as development and marketing for such applications helps explain why this market is not easily penetrated by small independent developers working alone, and why software development companies have such an advantage over traditional print publishers for such titles.

Trade Show Kiosk

Figure 3.3 assumes the development of a multimedia application to be housed in a kiosk for a trade show booth. The application will take six months to develop and is to contain newly created video as well as text content and photos derived from existing promotional materials. It is assumed that everyone is on staff, so the labor costs are fully loaded, and that all development equipment is already owned and available. Some new software will need to be purchased, as will the display machine and kiosk housing. It is also assumed that the application will be developed to run on a single platform only.

Web Site

The primary difference in cost-estimating between Web sites and other kinds of multimedia is the additional cost of maintaining and modifying the site once the initial pages have been created. In addition, the ease with which a Web site can be changed and enhanced mid-process can make "feature creep" a real consideration on an ongoing basis.

	% of year	Yearly salary	Loaded salary	Project total	
Personnel					
Project manager	100	$65,000	$97,500	$97,500	
User interface designer	80	60,000	90,000	72,000	
Artist/animator	60	50,000	75,000	45,000	
Lead programmer	100	65,000	97,500	97,500	
Junior programmer #1	100	50,000	75,000	75,000	
Junior programmer #2	100	50,000	75,000	75,000	
Lead test engineer	100	50,000	75,000	75,000	
Software tester	80	40,000	60,000	48,000	
Data analyst #1	100	40,000	60,000	60,000	
Editorial (text content)	75	45,000	67,500	50,625	
Editorial assistant	75	35,000	52,500	39,375	
Personnel subtotal				735,000	$735,000
Materials					
Hardware					
Rental machines		6			
Cost per month		350			
No. of months (combined)		57.6			
Rental subtotal		120960		120,960	
Peripherals		15,000		15,000	
(external drives, CD-recordable drive, etc.)					
Software:					
Average cost per rental machine		1,000		6,000	
Special (coding languages, etc.)		10,000		10,000	
Content production and rights					
Stock video footage	10 minutes			10,000	
Stock photo rights	100 @ 100 each			10,000	
Music	3 minutes			600	
Print encyclopedia (text content)				50,000	
Materials and equipment subtotal				222,560	222,560
Outside services					
Video digitizing				1,000	
External testing				50,000	
Desktop publishing					
Manual and packaging				25,000	
Subject matter experts				10,000	
Miscellaneous				5,000	
Outside services subtotal				91,000	91,000
Project subtotal					1,048,560
Safety factor (15%)					157,284
Total					$1,205,844

Figure 3.2 Sample time-and-materials cost estimate: consumer multimedia CD-ROM.

	Months	Hours	Hourly rate	Overhead (50%)	Loaded rate	Totals	
Personnel							
Project manager	6	840	40	20	60	$50,400	
Programmer	6	840	35	17.5	52.5	44,100	
Designer/artist	4	560	30	15	45	25,200	
Data analyst	4	560	30	15	45	25,200	
Tester/documentation	4	560	25	12.5	37.5	21,000	
Writer	3	420	30	15	45	18,900	
Personnel subtotal						184,800	$184,800
Materials							
Display computer w/touchscreen							
Software tools (6 people @ $1000)						6,000	
Miscellaneous computer peripherals (removable hard drive)						1,000	
Outside services							
Video production (15 minutes @ $2,000)						30,000	
One-off CDs (10 @ $100)						1,000	
Usability testing						5,000	
Generic kiosk housing						1,500	
Equipment and services subtotal						44,500	44,500
Subtotal							229,300
Safety Factor (15%)							34,395
Total							$263,695

Figure 3.3 Sample time-and-materials cost estimate: trade show kiosk.

The following estimate, figure 3.4, assumes a small Web site to provide a company with a basic and respectable on-line presence. The site would contain a home page from which the user can choose between several areas, such as the company's on-line brochure, a catalog of products and services, a method to send e-mail directly to the company's "webmaster," and employment opportunities. It would *not* currently include on-line ordering and purchasing of products (but would contain a toll-free telephone number for customers to place orders).

Many such web projects are executed by an external developer who then maintains the site for the client company. The company generally provides a project manager to communicate with that external developer. The company may also provide other resources, such as art direction, data and content preparation, and even testing.

	Months	Hours	Hourly rate ($/hr)	Overhead (50%) ($/hr)	Loaded rate ($/hr)	Totals $	
Personnel							
Internal							
Project manager	6	840	$40/hr.	$20	$60	$50,400	
Art director	1	140	$40	$20	$60	8,400	
Data/content preparer	4	560	$30	$15	$45	25,200	
Tester/documentation	1	140	$25	$12.5	$37.5	5,250	
External							
(using external billing rates for personnel)							
Project manager	3	420	$40	$20	$90	37,800	
Web programmer	2	280	$65	$32.5	$100	28,000	
Designer/artist	2	280	$30	$15	$75	21,000	
System administrator	1	140	$65	$32.5	$100	14,000	
			Personnel subtotal			190,050	
Infrastructure costs							
(connection, domain, server space, etc.)						5,000	
			Start-up total			195,050	$195,050

One-year maintenance and updating

	Monthly cost					Yearly cost	
Server space and access	$1,000					$12,000	
Project management (internal)	7,000					84,000	
Project management (external)	3,500					42,000	
Data and content preparation	2,800					33,600	
Programming and system administration	8,000					96,000	
Monthly total	22,300		Yearly total			267,600	267,600
			Project subtotal				462,650
			Safety factor (15%)				69,398
			One-year project total				$532,048

Figure 3.4 Sample time-and-materials cost estimage: Web site.

4

The Team Approach

Multimedia applications can be complicated undertakings, requiring the efforts of multitalented individuals and those with specialized skills. How these people work together is an important consideration in the development process. There tend to be two ways to develop new products (including software or multimedia products): 1) the functional area approach, and 2) the team approach. While they are not mutually exclusive, one or the other tends to dominate in most new product development processes. Industrial manufacturing has historically favored the functional area (assembly line) approach, but the team approach is generally better suited to multimedia development.

The Functional Area Approach

In the functional area approach, the work product moves through functional areas or departments in a supposedly "automatic" fashion, where specialists can apply their skills in the most time-efficient manner. For example, on the traditional auto assembly line, the workpiece (a car in the making) moves along from station to station, with specialists at each station applying their skills. The car stops in front of the windshield installer, then moves off to get its headlights installed, while the next car arrives to have a windshield installed.

The Team Approach

The team approach is fundamentally different, because an integrated team is responsible for taking a product from the beginning to the end of the development cycle. When building a car with the team approach, the car does not move down an assembly line. Instead, it stays in place, and a stable team of multiskilled people work together to build the car. One person installs the windshield, then goes on to install the headlights, and then perhaps helps another team member maneuver the engine into the engine compartment.

Although the functional area approach and team approach are fundamentally different methods of building products, a particular development process may incorporate elements of both. After a team builds a car, the car may go to a testing shop. Since that testing shop does nothing but test cars, it can be considered a functional area. Different product development and production situations favor different approaches, including hybrid processes—like a team approach that uses some assembly line elements, or vice versa.

When to Use Which Approach

The functional area approach is well suited to a situation where many similar or identical products need to be produced and a minimum of design work is needed. Each specialist can apply his or her trade as efficiently as possible, with a minimum of interaction between specialists.

The team approach is better suited when a small number of different products need to be developed, especially when a significant amount of design work is involved. For new products, in which a lot of interaction between specialists is required, a team approach is better suited. The more products and the more similar they are, the better suited is the assembly line. The fewer products and the more different they are, the better suited is the team approach. It will be seen that multimedia product development usually benefits strongly from the team approach.

The team approach may seem counterintuitive to those previously experienced in producing other kinds of media, like video or print. Typically, a video production moves from the scriptwriter to the director to a shooting crew to a post-production facility, all under the watchful eye of the producer, whose responsibility it is to make sure the project comes in on budget and schedule. Often the video is one of several (or many) similar videos being produced, perhaps as part of a video series or as an installment in an ongoing effort, such as a video magazine. A series of twenty videotapes can be produced by setting up an assembly line and then moving the work through the process in a steady stream. This type of product can move easily and efficiently through the functional-area production process, because each step is well defined and the current product varies little in form and format from previous products.

Likewise, print production lends itself well to a functional area approach because the work must proceed by a well-defined linear path (writing, editing, copyediting, proofing, layout). Everyone is a specialist and can do his or her job in turn; in addition, the current product—whether book, magazine, or brochure—is usually similar to previous products.

THE TEAM APPROACH TO DEVELOPING MULTIMEDIA APPLICATIONS

Software in general, and multimedia in particular, is unlike other media in this respect. Generally, a given multimedia application is one of only a few projects in

development (if that many), they are substantially different products from each other, and each requires significant design activity. Setting up an assembly line will usually result in loss of communication, inefficiencies, extra cost, and, most important, diminished product quality. Multimedia software development requires a wide variety of skills, from artwork to programming to writing documentation to testing; yet it also requires that these people applying these skills be in almost constant communication. Therefore, most successful multimedia applications are developed by small teams of individuals, working pretty much full time on a given project: the team approach.

Advantages to the Team Approach

Better Communication

To make appropriate decisions quickly during the multimedia development process, you need to keep a tremendous amount of detail in mind so you can evaluate the ripple effects of various decisions. For example, how will adding a particular feature affect other features? How will it affect the user interface and data preparation? How will it affect the print manual? Will adding digitized photos affect the palette? If so, will that change the system requirements of the target platform? To make intelligent decisions, you need to know quite a bit about the project in general and the product design specifically. The team needs a well-rounded representation of the various disciplines (programming, testing, design, and so on) and free and open communication.

If you try to produce a multimedia application with an assembly line approach, people on the assembly line doing the work need a huge amount of information about the work to be performed, and that information must move along with the work itself. In fact, the information about the product itself that must travel along with it is such a large overhead that it greatly slows down the project. With so many hands to pass through, it also opens up a large opportunity for miscommunication and mistakes.

Since a multimedia project moves from the analysis phase through the design phase, prototyping, alpha, beta, and final code, it is tempting to set up an assembly line approach, starting with a designer, who passes the design to a programmer, who then passes it to a software tester, who then approves it for manufacturing. In reality, however, these phases cannot be so cleanly separated. The design of the product will greatly affect the testing and programming procedures. A software tester involved in the project from the beginning can start writing test specifications early, from the design specification. Otherwise, the test specifications need to be written once the program has been coded, which is much more time-consuming. Likewise, a programmer involved early in the design phase can caution regarding proposed features that may be difficult or impossible to implement and offer alternatives that may be faster to code and require less testing. Having the programmer involved early also gives him or her a head start on the technical design and hence the implementation, even before the design is

approved. It is therefore important that as many team members as possible be involved from the beginning.

Concurrent Tasks

Another important reason for taking the team approach is the large number of concurrent tasks that can and must be performed to develop a multimedia product in a reasonable time frame. Imagine if a football team, which must be highly synchronized, were to use the assembly line approach. The center hikes the ball. Then the quarterback fades back to pass. Then the receiver starts to run. About five seconds later he is in position and waits for the pass. Then the quarterback passes the ball. The receiver catches it. Then he runs for the end zone. This play works fine with no opposing team and no time limit. However, in the real game, such a team would never score a point because the defense is operating simultaneously. When a football team runs a play, everything happens at once, with each team member anticipating the others' moves. Likewise, during a multimedia project, all team members are working simultaneously on various aspects of the project and need to be in constant communication. If they are working on the project full time, it greatly facilitates this communication and team integration.

Commitment among Team Members

Success in developing new software is usually tied to inventiveness; that is, a piece of software is usually successful because it can do something in a different, easier, more interesting, or more powerful way than was previously available. Most applications undertake to do this, so most projects are, by definition, attempting something new. Invention is at the heart of the process, and invention is characterized by continuous problem-solving, which takes time and dedicated people. You can get people to become dedicated to a project only if they are assigned to it more or less full time, not just doing it as part of an assembly line workflow. With a development team, the team becomes committed to a product, and they identify with it because it is a direct manifestation of their efforts.

A programmer who is part of an assembly line process rarely becomes dedicated or committed to a given program; he may never have seen it before and will probably never see it again. However, as part of a development team, that same programmer will be involved in a product through its development cycle and can actually become emotionally attached to it. He will often work extra hours of his own volition, to maintain high quality standards and because the other members of the team are counting on him.

This is not a magical, manipulative, or meaningless "warm, fuzzy" approach. It is simply an effective way of setting up group dynamics to address one of the essential elements of a successful multimedia development process: the bonding between members of the development team. They become dependent on each other and feel compelled to support each other in the development effort. The team can take on a wide variety of tasks, and team members can apply their individual strengths and cover for each others' weaknesses. In this way, a

team begins to identify with the successful completion of a product, and the team identity becomes dependent upon such a success.

Team Dynamics

A team is composed of individuals, and each individual has a unique personality and identity that must be respected and, hopefully, utilized. Creating teams out of collections of individuals is a delicate process. While it is difficult to predict in advance which individuals will work together well, it is helpful if team members can have some input into the composition of their group. On the other hand, it may not always be possible for the project manager to handpick the team members. However, one important consideration in team composition is the variety of personality types on the team. According to Alesandra et al. (1987), there are four basic personality types, including "socializers," "directors," "thinkers," and "relators." It is helpful to have a healthy mixture of all four types on your team. This variety helps balance the team dynamics. A team with too many directors is a team with too many chiefs and not enough Indians. A team without a relator may have trouble maintaining internal cohesion.

Finally, individuals may be assigned to projects, but real, cohesive, mutually supportive teams do not form instantly. It takes time for individuals to come together and start performing as a team. Both the psychological issues and the division of work and responsibilities need time to be sorted out before a team can work together effectively. In fact, according to Bruce W. Tuckman, a psychologist who wrote in the 1970s, a team in the making typically passes through four stages before it becomes a unified team: Form, Storm, Norm, and Perform. Form, the formative stage, is the time during which team members are chosen and are starting their work together. The storm comes next, when they are sorting out issues of responsibility, dominance, and informal communication. The norm period is when the team has settled down into a normal working pattern. The perform phase is when that established working pattern has taken hold and been optimized and the team is operating at peak capacity.

TEAM MEMBERS AND FUNCTIONS

Choosing the right team members and determining the right positions for the project is essential in the team approach. What are the right positions for a multimedia project team? The answer naturally depends on the specifics of the project. A short electronic presentation using PowerPoint may take only one person working a day or two. A large, multifaceted educational application to teach mathematics to fifth graders may take a team composed of half a dozen members working a year or more. However, the following roles must be covered, whether some individuals have responsibility for more than one role, or work with others to fulfill a single responsibility.

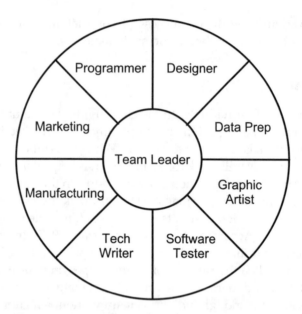

Figure 4.1 Team members and functions.

Team Leader/Project Manager

First and foremost is the team leader, usually the project manager. This person has ultimate responsibility for the outcome of the project. Administrative responsibilities will vary, depending on the person's rank within the organization. However, on a daily basis, this person must function as a first among equals, not strictly as a manager. While the team leader coordinates the efforts of team members, he or she is often not the direct administrative manager of those on the team. Therefore, the team leader must endeavor to gain the respect of the team members rather than managing them by administrative decree.

There is a huge difference between managing people and leading a project. Managers usually assume they know what to do and give orders to their subordinates, who then perform the appropriate tasks. Leading a project is different—a leader needs others to help figure out what to do and then coordinates the efforts of self-motivated team members. You can manage by decree but cannot lead by decree. On a true development team, the team leader must obtain the team members' cooperation by gaining their respect, not by coercion, intimidation, threat, or pulling rank. You can be appointed project manager but can truly lead a team only by gaining the respect and trust of the team members.

This is sometimes a difficult concept for traditional managers to understand and accept. In many companies, employees are viewed and treated as soldiers, whose job is to execute orders from their superiors. However, a true team approach is very different. A team approach does not rely on the chain of command; what it

relies on is the intelligence and internal motivation of the team members. The good news is that employees usually identify with their work, do the best-quality work they can, and want to make suggestions and have them taken seriously. Unfortunately, the intelligent, innovative employee who voices concerns about established methods is often viewed as a troublemaker by management.

The position of team leader or project manager requires a special person, conversant in all areas of multimedia development, from user interface design and programming to testing and documentation. While no one individual will be an expert in all these fields, the team leader needs enough background in each area to understand the issues involved. Otherwise, he or she will find it difficult to promote intelligent decisions and will thereby lose the respect of the team members. No one likes to be led by someone he thinks is incompetent. It is the team leader's responsibility to set the schedule, manage resources, and define the tasks to be accomplished. However, this can be done effectively only with the voluntary support of the other team members, which requires the team leader to cultivate good personal relationships with each of them. Therefore, in addition to the necessary technical knowledge, one of the most important requirements for an effective team leader is good interpersonal skills.

User Interface Designer

The main responsibility of the user interface designer is to plan out and maintain the functional specification. This includes describing the user interface through whatever means are appropriate, including screen drawings, text descriptions, and flowcharts. This must be done while considering the resources and time available to implement the design, which requires a good aesthetic sense as well as a creative approach to how features will operate. It is up to the user interface designer to figure out the details of how all the screens and dialog boxes are interrelated and flow together, which buttons do what, what happens in the various situations, and all the permutations of those situations. This must be planned so it will be aesthetically pleasing and user-friendly. This requires an individual with a wide variety of skills.

The designer should be schooled in the appropriate communications design, depending on the application, including instructional design and/or graphic arts when necessary, as well as the appropriate psychological disciplines, such as ergonomics. The designer should also be able to use graphics programs and authoring systems, in order to convey ideas to other team members as well as to potential users and management decision-makers. This person needs to be familiar with competitive products, if any, and should also understand both the paper and electronic prototyping process. He or she must be open to design changes from others on the team as well as changes based on focus groups and usability testing, which calls for a collaborative personality type.

The role of the user interface designer is crucial in developing a high-quality multimedia application. The amount of screen layout changes, feature

modifications, and shifting requirements, all of which must be designed and documented, make this position a fundamental and often full-time role on any significant multimedia project.

Graphic Artist

The graphic artist's job is to create the visual elements specified by the designer. These elements include screen layouts and designs, illustrations, button designs, and any other visual elements accessed by the user. There are dozens of ways to do this, from hand-drawn illustrations to computer-generated artwork, and combinations of the two. Therefore, the artist must be able to work proficiently with a variety of computer graphics and art programs. He or she must also have the technical ability to scan (digitize) slides and printed artwork and manipulate the resulting images as necessary. The artist will need to work in a visual style consistent with the intent of the application and provide feedback and alternatives to the user interface designer, giving options and examples from which to choose. This person must also be able to discipline his or her own personal style to the needs of the application, as determined by the designer

Programmer/Software Engineer

The programmer is responsible for designing the software architecture and writing the code at the heart of the multimedia application. The person's skills should correspond to the needs of the project. For example, a small PowerPoint slide show requires little, if any, actual programming. The programmer's job is therefore limited to selecting options from within PowerPoint. On the other hand, a new, original CD-ROM with innovative features and a variety of data formats might require the efforts of several programmers working together in C++, using utilities and routines written in other languages as well.

Regardless of how simple or complex the programmer's job on any given application, since multimedia is software, programming is at the heart of the multimedia development process. The programmer sits at the hub of the process and can be seen as the central destination of the other product development work. Artists create visual elements and pass them on to the programmer to incorporate; software testers test the code and provide feedback to the programmer about software errors to be fixed; the team leader relies on the programmer as the main gate in the development process.

The programmer should have previous experience working in the project's development environment, if possible. The learning curve can be quite steep for some development environments; it may be inefficient to have a mainframe database programmer who has never worked on a Macintosh assigned to develop a Macintosh application.

Programming is a task requiring the utmost concentration, which has ramifications for how the project is managed. It is beneficial to physically separate programmers from the rest of the development team—each in an individual office, if possible. The efficiency of a programmer subjected to frequent and uncontrolled visits by other team members will suffer greatly. Programmers must also be protected, to some extent, from the administrative and managerial demands of the project, because these also represent significant distractions. This does not mean programmers should be treated either like prima donnas or slaves, but merely that it is wise to keep distractions to a minimum to allow them the needed concentration, so they can meet their deadlines and avoid making costly mistakes.

In addition, it is advantageous for the programmer to be included as early as possible in the development process and not simply tossed a product specification and be expected to build it. If included early in the process, the programmer may bring many useful insights and suggestions to the functional design and can help the team avoid many pitfalls while it is still early enough in the process to have a beneficial effect. The programmer can propose creative alternatives to solve design problems early and can even be actively working on the software architecture much earlier than is often imagined.

Data Analyst

The area of data preparation refers to a wide variety of tasks, from graphics manipulation to video production to text mark-up and file formatting. Therefore, the skills needed by a data analyst will depend on the needs of the project. Such a person needs to be able to prepare the content used in the program (text, graphics, photos, video, and sound) in a file format specified by the programmer. Once prepared, the data is handed off to the programmer to be incorporated into the application.

There are two sides to data preparation: the creation of original source material (commonly called "content") and the processing of that content into the correct file format(s) for use in the program.

For example, if the data to be prepared is text, then that text needs to be created (written and edited) and then processed (formatted and archived) as needed by the programmer. If the data is video, it must be created (scripted, produced, and edited), then prepared through digitizing into the correct file format, such as Quicktime or Video for Windows. Multimedia projects often depend on content created for another purpose, such as a promotional video or print catalog. In such cases, the data analyst is mostly concerned with processing the existing data into the right file formats.

For example, to create a CD-ROM catalog, you may simply be able to extract text and photos from a print catalog and format it into the necessary database for the application. You may also be able to take video clips from previously produced promotional videos. The video footage must be selected and then digitized in the

appropriate format. Other common kinds of data preparation include HTML text conversion, picture file format conversion, and audio digitizing.

Another element of the data analyst's job is to control and oversee the data. He or she will need to archive data, follow and enforce file naming conventions, and update new versions of data. On a large project, this responsibility can become quite a significant task and requires an individual with good organizational abilities.

Referring to video and text as "content" and "data" may annoy some video producers and writers, but these terms bespeak a software-centric perspective of the multimedia development process that is essential for managing a multimedia project—which is, after all, a software project. While you may think in these terms to expedite the development process, in actual conversation with video producers, text authors, and so on, it may be more tactful to avoid referring to their work as "content" or "data" to avoid belittling their creative efforts.

Lead Software Tester

Software testing is crucial and can be a complex task. It requires exceptional attention to detail and a high level of creativity to find and isolate defects and errors that may be quite mysterious in their occurrence and effects. Software testing can most conveniently be assigned to a single individual, the lead software tester. At any given time, various team members may be performing testing, especially toward the end of the project. However, a single, knowledgeable lead software tester must coordinate their efforts and, usually, perform a sizable amount of testing him/herself. This person writes test plans (based on the design specifications) and implements them with the assistance of others on the project team and/or outside testing personnel. The lead tester is responsible for finding and documenting all fatal and nonfatal errors, including both programmatic errors (defects) and data errors (incorrect content).

All products must be tested, from a ten-screen slide show to a complex consumer title. The larger and more complex the program, the more testing will be required. It's often beneficial to have several people involved in the testing process, since different people tend to use a program differently, and in so doing find different kinds of errors.

Technical Writer

While needs will vary depending on the application, most multimedia applications require some sort of hard-copy component, from a simple page of installation instructions, to screen-shot handouts for a presentation, to a thick, well-composed user manual for a consumer application. Often, what is necessary is a modest-sized booklet describing the basic program function with some screen shots to clarify the text. This task, depending on the scope, often requires a good technical writer and print editor who can put such a booklet together, including developing the outline, writing the text, specifying images and screen shots,

designing the booklet, and sometimes even using a desktop publishing program to do page composition.

Others

Team members may need to assume many other roles when this is appropriate to the project. For example, quite often a marketing person is needed to coordinate development activities with marketing needs and look out for the interests of the marketing department. Likewise, depending on the complexity of the components, someone from manufacturing may well be necessary to coordinate development with manufacturing needs and schedules. Other areas of expertise that are often useful are sales and customer satisfaction.

TEAM MEMBERS AND ROLES

The team members and their roles described above are general guidelines, meant to be modified according to the needs of the project or application. It is certainly not recommended to use exactly seven people, in exactly those roles described, on every multimedia project you do. Multimedia projects can require the efforts of anywhere from a single person to dozens of people organized into teams and sub-teams. In addition, since the work is done over time as part of an ever-changing process, the workload and type of work for a particular team member will fluctuate, so it is key for team members to have overlapping skills and be easily trainable. If so, they will be able to help each other and smooth out the variations as the workload ebbs and flows among different specialties.

When team members can work on various aspects of the project, it gives them a more well-rounded knowledge of the product as a whole and promotes better communication within the team. These are two significant advantages in the product development. Together, these two advantages can raise overall team performance to a higher level. The result is relatively shorter development time and better product quality.

Another benefit of having people work in areas outside their specialties is that it maintains their interest level by letting them work on new tasks and develop new skills. This keeps them mentally sharp and also helps them develop a wider repertoire of skills for this and other projects.

For example, during a temporary lull in the testing workload, a software tester may need to assist in data preparation. This overlap is beneficial. In performing data preparation, the tester may learn valuable information about this area specifically and the project in general, which will ultimately help in testing and benefit the team as a whole. In addition, it necessitates interaction between the tester and the data preparation staff, hopefully promoting communication between the two. Finally, it gives the tester the opportunity to support another party on the team, increasing the bonding between team members.

EXAMPLES

Electronic Slide Show

Often, a single individual is assigned the task of creating an electronic slide show for a higher-level manager, based on an outline or script. In this case, there is no team to speak of. The individual is responsible for doing all the work. Although this individual must be multitalented, he or she may need assistance in particular areas, such as proofreading and technical support. This can be difficult because of the myriad of seemingly trivial issues, any one of which can derail the project. For example, presentations are often created for display on the road and entail special considerations for packing and shipping the machine, working out display device compatibility, and cabling, all of which are seemingly trivial but crucial. The presentation you created may be spectacular, but if the boss gets there and his computer hasn't arrived, or if it doesn't have the right cables to connect it to the hotel's LCD panel, it may be worse than if the presentation had never been scheduled in the first place. For this reason, the individual doing the development must be a jack-of-all-trades, technical as well as artistic, creative as well as detail-oriented.

Consumer Multimedia CD-ROM

Developing a competitive consumer multimedia title is a significant undertaking. The seven-person team described above is usually the bare minimum and is often supplemented with additional programmers, software testers, and external service providers. Also, the marketing and package-design needs are crucial, so individuals often work full time on these tasks and on coordinating throughput with manufacturing. In addition, a great deal of emphasis is usually placed on the visual appeal of the product, so additional artwork is often contracted for with freelancers. Altogether, the product development team for a consumer product can easily consume the resources of a dozen people working full time for six to twelve months.

With such a large team, the project manager is usually kept busy simply coordinating the actions of the various team members, with little time to do much actual hands-on design work. Also, given the volume of testing required, it is not infrequent for testing to be coordinated by the lead software tester but to be performed in large part by external vendors of software testing services.

Trade Show Kiosk

For a trade show kiosk, the heaviest responsibilities tend to fall on the project manager (who may double as the designer), the graphic artist (who may also do data preparation), and the programmer. It is also extremely beneficial to include representatives from marketing and manufacturing to assist in determining the physi-

cal kiosk structure, help obtain the equipment, and design its integration into the trade show booth. Hopefully, as design work tapers off, the project manager and others can perform testing, Although testing may not need to be as stringent as for other applications, a trade show kiosk still needs to be well tested before being placed for public use.

Web Site

On a World Wide Web project, the development team often includes external personnel who have the specialized knowledge to design and maintain a Web site. The external personnel often include a "webmaster," who maintains the server from which the site is hosted, and a programmer to write code necessary to provide special features within the HTML pages. These may well be the same person. A good graphic designer is also key to producing a high-quality Web site, and data preparation staff play a key role as well. The project manager often runs such a team in addition to other work responsibilities.

The ongoing nature of the project gives the team a different character than on most other projects. On a small to medium-sized site, team members may not have enough production work to occupy them full time. If they perform other work that pulls them away from the Web site for long periods of time, it may be difficult to establish an integrated and well-functioning team that identifies with the product. To offset this, the team should be kept as small as possible while maintaining redundancy of skills, in case an essential member leaves.

5

External versus Internal Development

Multimedia applications can be developed in-house (internally), out-of-house (externally), or using a hybrid approach. With in-house development, a company chooses, funds, and builds an application using primarily its own internal resources. Out-of-house development is when a company goes outside and hires another company to build the application, in a client/vendor relationship. In out-of-house development, one's perception of the project may differ greatly, depending on whether one is the client company or the outside developer. In actual practice, most projects are accomplished with a hybrid approach. While many who work inside large and medium-sized companies would like to do all the development in-house, few companies have the staff necessary for all the work involved in a significant application. Either they lack sufficient resources or their staff does not possess all the necessary skills.

Typically, the client provides content and conceptual design input and the vendor provides technical design and production. So, for example, design may take place inside, while programming is done outside. Data preparation may be handled by internal company employees, but graphic artwork and testing may be contracted out. Generally speaking, the more design work, software architecture, and programming being done outside, the more it is considered an external development effort. This mixed approach is probably the healthiest method, because it keeps vendors competitive, helps educate internal staff, and gives the company itself a wider choice of production alternatives. The larger the project, however, the more time and effort necessary to coordinate the workflow and communication between internal and external personnel. Whether you are the vendor or the client, you must be careful with whom you choose to do business, by making sure the other party is creditworthy, and that the relationship can be managed toward mutual benefit.

Long-Term Relationship

Once an application has been developed, the natural course of events is to have the original developer maintain and update that application. The original developer

will already understand the program code, data formats, workflow, and so on, and will have the best ability to make whatever changes are necessary. For this reason, original developers and their clients tend to develop special relationships. When common conflicts arise, such as personality clashes, business concerns, and miscommunication, which in some other businesses would cause the client to change vendors, with software this is not so easily done, for the reasons mentioned. This creates a situation with significant potential for built-in conflict. Sometimes clients can feel they are in an inescapable relationship with a developer and are being taken advantage of. On the other hand, developers may feel an unappreciative client is not fairly compensating them for their creative efforts.

DECIDING WHETHER TO GO INTERNAL OR EXTERNAL

If you have the luxury to decide whether to do a project internally or externally, it is an important decision. A company getting ready to do its first multimedia application will probably do it with external support, to some degree. While many production personnel would like to do all work internally, few companies have this option. Often, this decision is already made by the nature of the situation. For example, it may take only one person working alone a day or two to put together a short PowerPoint presentation. But if you have a CD-ROM to create and no internal programming or design staff to do it, it is obvious an outside developer will have to be brought in at some point.

One erroneous assumption that is sometimes made is that working with an outside company will somehow relieve one of project management responsibilities. After all, isn't that why the developer was hired? Oddly enough, outside developers can require just as much management supervision as internal staff, if not more, and the notion of a truly "turnkey" multimedia developer is somewhat unrealistic. Too many internal decisions, discussions, and judgment calls must be made to allow an outside developer to be truly independent.

Another erroneous and widespread notion is that it is always less expensive to do the development internally. First, the final cost depends on many factors specific to a given project. Second, whether a project is done internally or externally, similar resources must be applied to achieve the same result, so when management and overhead are counted, costs should be comparable. Finally, the larger the company doing the development work, the more expensive it will generally be, whether internal or external, simply because of the increased management overhead that must be supported.

Whether you are already committed to internal or external product development or you have the choice to make, it is helpful to be aware of the following advantages and disadvantages of the two approaches:

Control and Communications

By doing the development in-house, you have the maximum control over how the project is executed. The development personnel work for the company directly and

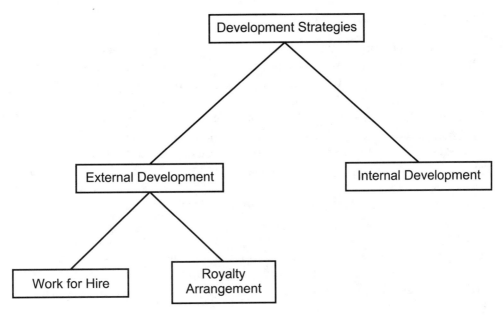

Figure 5.1 Internal versus external development arrangements.

can be monitored closely, if necessary. You have great flexibility in how resources are applied. In addition, if the development is done in-house, presumably the maintenance can be done in-house as well. In a situation in which the project has great strategic importance, in-house maintenance is the safest method, and less expensive as well. Also, if the team is composed of company employees, you can better monitor and encourage the commitment and loyalty of the development team.

When working with an external developer, you relinquish some degree of control over the project. An external developer, by definition, works off-site and is therefore a relatively independent entity. This means that many of the methods this party uses will not be within your means to stipulate. If you object to the procedures, dress code, working environment, or any other factor for some reason, you can usually do little about it. If you feel the need to control these sorts of factors, working with an external developer could be a frustrating experience.

Another mundane but very real issue is geographical distance. An external developer may be located across the country (sometimes even in a foreign country). In such a situation it is difficult to hold face-to-face meetings, which are generally an important way to build and maintain rapport between team members. Distance can also become a significant inconvenience because of time zone changes. Given the large number of development houses located on the West Coast, this time zone change can make a big difference for companies located in eastern states, since the three-hour time difference leaves three fewer hours during the working day for phone calls. Sometimes this communication gap can be eased with e-mail and voice mail, but it can still affect communications.

Development Cost

While the cost of a project will not necessarily be less if done in-house, it is potentially the least expensive method, since theoretically you pay only for the true cost of developing the application; presumably no profit is built in. While your department may be required to "pay" other departments for their resources and personnel, these costs are typically less than would be required by outside developers. In addition, sometimes internal staff are exceptionally talented, especially if they are already familiar with aspects of the work because of their normal job responsibilities. For example, if a project requires data preparation using internal company source files, internal personnel will probably be faster and more experienced at converting or reformatting the data than an external developer, who would be working with the data for the first time.

In addition, external developers can become more expensive once a project is underway (if they are not working on a fixed bid) or after the first version of a product has been released and it is time to develop an updated version. Since the most convenient way to produce an update is to go back to the original developer, the developer can charge a premium for its project-specific experience and knowledge (although this is usually worth every dollar of it).

On the other hand, external developers can be less expensive in some situations, such as when internal personnel do not have the skill or experience to do the job efficiently, or when the corporate structure is not conducive to such product development and thereby creates administrative bottlenecks and inefficiencies.

Teamwork and Agendas

One especially good aspect to doing work in-house is that portions can often be offered to other departments in the company, which they will sometimes eagerly accept. For example, multimedia art preparation work could be done by an internal art and design department. This gives them an opportunity to increase their own visibility within the company and may help them justify increased staff and equipment to perform the work. In addition, many people simply appreciate the opportunity to work on an interesting new multimedia project. This shared experience can also increase the sense of teamwork between departments, which benefits the company as a whole.

If you are working with an external developer, by definition you are working with a different organization, with potentially different objectives. In fact, in the most basic arrangement, where the developer is doing the project as a work-for-hire and getting paid fixed lump sums based on milestones, the objectives are fundamentally different. The client wants as much design flexibility, functionality, and timeliness of deliverables as possible. The developer wants fixed design specifications to avoid rework, minimal functionality to avoid cost overruns, and schedule flexibility to allow more convenience in scheduling resources.

Some situations present even more hidden and conflicting agendas. Developers have been known to work on applications for impressive, well-known

companies for little compensation simply to put that company's name on their client list. Applications done for this reason may never get finished, and those that do get finished tend to be of little use, given the minimal functionality afforded by the often minimal investment made by the developer. On the other hand, client companies are sometimes guilty of "stringing along" small developers with promises of work to keep their options open in the future and sometimes to even get de facto free consulting services from an eager independent developer.

Expertise

Another consideration in doing the work in-house is the added experience and expertise that will be gained by the development staff (although this is not without a real cost). The talents and skills of its employees are a very real and valuable asset to a company. The work experience gained by developing a multimedia project is often applicable to other tasks within a company and could be of great use in the future, especially if other multimedia projects are approved. However, if the appropriate staff does not exist internally and an application is attempted anyway, the results can be disastrous. While it is feasible for internal people to learn some tasks on the job, such as basic software testing or documenting design changes, other tasks (like C++ programming) are not so easily learned in a short time.

When working with an experienced outside developer, you get the benefit of the firm's experience and learning on other projects. This is one of the main reasons you might consider an outside developer and why it is sometimes less expensive in the long run. If a project has a high risk factor and must be completed on time, it might be wise to use an external developer with a proven track record of producing such applications, rather than trying to do the work internally and learning along the way. For example, if your company needs a Web site developed but has little Internet experience, it might be wise to look to an external Web site developer who has developed and currently maintains other Web sites you can view. Ideally, however, internal people can be included in the development process to prepare them to take on more active roles in the future.

Sharing the Rewards

Virtually everyone wants to take satisfaction in a job well done, and this is especially true for those in the product development arena. By allowing internal staff to develop a multimedia application, you give them the opportunity to take part in interesting work that can broaden their skills and to gain a sense of accomplishment when the project is completed. Not only does this benefit the individual, it also benefits the company, by raising the interest level. This can have a beneficial effect on morale, with a ripple effect even among those not participating directly in the project.

On the other hand, an external developer is a specialist and can often do a much better job on a project than if the project were developed in-house. This

will greatly benefit the project and those associated with it. In addition, an application developed by a well-known developer can even increase a commercial program's salability.

Logistics and Expediency

The main disadvantages in proceeding with multimedia development work internally relate to managing the resources, personnel, and support structure to build an application. If the application development is beyond the normal workflow, new staff must be recruited, hired, and managed. One must also arrange for equipment, working space, software tools, and communications infrastructure to allow these people to be most productive. This often includes internal LAN connections and access to the Internet. These resource and logistical issues can consume a great deal of managerial, administrative, and technical support time that, while not directly related to running the project itself, drives up general operating expenses.

One of the most significant benefits to working with an external developer is that it can be much more expedient than trying to set up or coordinate in-house development. There is much less administrative work, in the form of reports, meetings, approvals, performance reviews, job descriptions to justify new staff, and so on. The external developer can just go off and do the work. The equipment, communications, and staffing issues are generally the responsibility of the external developer; you don't have to arrange for rental computers or write up endless justifications and paperwork to purchase equipment. You can adopt much more the convenient role of consumer, purchasing development services as needed, rather than dealing with the time-consuming logistics and details required to directly manage a large staff.

Personnel and Resources

After hiring individuals to work internally, even on a freelance or project basis, you may find that a subconscious commitment develops among in-house staff to keep them employed once the project has ended. This applies, even if the individual is hired as a simple freelancer. It is only natural that after working closely with a person for a length of time and participating in the trials and tribulations of developing a new product, you may be concerned about that person's well-being at the end of the project. It is natural to feel a commitment to keep such people employed even after the project has ended. In time this can cause budgetary difficulties. Using an external developer helps avoid such situations.

Sometimes an external developer can offer you a great deal of flexibility, letting you speed up and slow down the project at will (depending on contractual arrangements). If the work is being done on an hourly basis, you can have as much or as little work done as needed. An external developer can typically get projects started (and stopped, if necessary) faster and can often change directions faster during the project as well.

Priorities

A potential problem with in-house personnel is that often these people are part of an existing department not under your control. Usually these individuals retain at least some of their existing responsibilities in those departments while working on your project "part time." This situation can cause problems with priorities and with commitment to the project goals. For example, suppose a trade show kiosk needs to be developed, and you intend to use existing company resources. Perhaps the programmer is from the corporate MIS department and, although assigned to help on your project, may still retain some of his or her usual responsibilities. Work on your project may suffer, and development time can evaporate quickly in such a situation. Besides this, internal personnel are sometimes less easily motivated. They are usually on staff and will get a paycheck anyway, regardless of when the product is finished.

In an external development arrangement, the resources are essentially guaranteed to you by the developer, so there should be no conflicts of interest or reprioritizing of your application. When payments are made based on milestones, pressure can be easily (sometimes too easily) applied, and the developer motivated, simply by withholding payment if necessary until a milestone is reached. Since many small developers run their businesses virtually from payment to payment, withholding a payment if necessary will usually motivate them sufficiently to meet the milestone dates and specifications to the best of their abilities.

INTERNAL DEVELOPMENT CONSIDERATIONS

If you decide to do development internally, there are some important issues to be aware of:

Resources

The decision to develop an application internally is frequently motivated by a desire to save money. It is sometimes imagined that if done internally, a given project can be done at a fraction of the external cost. This is rarely the case, and starting a large project based on this assumption can be a recipe for disaster. Often, a project bid received from an external developer is significantly higher than expected. At this point, individuals in the production department may start to imagine that they themselves can do the work internally for the amount originally envisioned (without reexamining whether the original sum was realistic), and the project is approved by management under this scenario. Three months later, instead of being released, the project is still in the early beta stage, with another three months to go before completion, and management starts to realize its mistake. This situation benefits no one, least of all the production personnel who may have lobbied to do the work internally.

If you start a project without adequate resources being budgeted, it will require additional unbudgeted resources to complete, which can quickly escalate into a serious situation. For this reason, projects to be done internally should be estimated very conservatively.

Overpromising

Try to avoid promising too many features in the initial design. While it is often easier to win approval for a more feature-rich application that solves multiple needs than for a simpler, more focused application, the feature-rich application may actually be orders of magnitude more costly and time-consuming to produce. Difficult as it may be to win approval for such a mega-project, it is usually even more difficult to actually develop it. Therefore, it is important to propose the simplest, most well-focused application possible. As the saying goes, "Underpromise and over-deliver."

Expectations

Not only does developing a project in-house entail more administrative overhead than developing it out-of-house, but in-house development may also cause a number of hidden expectations. Internal clients will often expect you to drop everything and demonstrate the project at a moment's notice, they may expect to be able to change the design at the end of the project, and they may even try to cut the project budget halfway through development. In short, internal clients will often feel free to make demands of an internal production staff that they would never attempt with an external developer. The fact that the project is being done internally makes it much more vulnerable to internal political maneuvering and scrutiny.

Likewise, obtaining the cooperation of internal subject matter experts may, paradoxically, be more difficult for an internal developer. Sometimes subject matter experts take internal developers for granted, compared to an external developer. Internal political situations may come into play as well.

However, with reasonable foresight and political sensitivity, multimedia projects can be developed internally with significant efficiency. And developing applications in-house can be a rewarding experience, both in terms of job satisfaction and career advancement. If you get the opportunity to develop a product in-house, make the most of it!

EXTERNAL DEVELOPMENT CONSIDERATIONS

Working with an external software developer is reminiscent of a marriage relationship; it requires commitment, hard work, and dedication to make the relationship function smoothly, and it tends to be a long-term relationship as well. In addition,

it can bring mutual benefits to the partners, which are unachievable by the partners working alone.

Selecting an Outside Developer

While a complete discussion of how to select an external developer would require more space than is practical here, a few points bear mentioning. First, while developers who want business will attempt to quote a competitive price, some unscrupulous developers have been known to quote extremely low prices simply to get the job, believing that once the application is sufficiently underway, they can ask for more money as it proceeds. Other unprincipled developers might quote an unrealistically low price and stick to it, knowing they will deliver a low-quality product. Some developers have even been known to quote low in order to "hook" a new client—that is, intentionally take a loss on one application so as to get in the door and hopefully obtain future work at a much higher price. None of these scenarios is healthy, encourages a good working relationship, or lends itself to the delivery of a high-quality product.

When selecting a developer, try to avoid lowballers and those with hidden agendas. But how do you select a high-quality developer? Many factors enter the picture, including review of work for other clients, talking with other clients, and cost comparisons. If cost is an important factor, consider the old method of getting three bids and accepting the middle bid, under the reasoning that the lowest bid will be a lowball or low-quality bid, the highest will be the one with the most built-in profit, and by default the middle bid is probably best. This is obviously a somewhat arbitrary approach, but it is much better than picking the lowest bid because it is the cheapest or the highest bid because you are subconsciously impressed by such a high-ticket developer.

A much better method than simply comparing bids based on price is to request in a prospective developer's proposal a detailed analysis of how the firm will accomplish the task, including tools, personnel, equipment, and testing. Sometimes it is even appropriate to pay a developer a small sum to help defray the costs of developing such a detailed proposal. Generally, the better and more well thought out the proposal, the higher the quality of the developer and the more seriously the firm is considering the proposed application.

"Do" Diligence

The best way to assess the capabilities of a developer is to view samples of previous work. A reasonably well-qualified developer should have at least a few sample projects to show, hopefully of the same type as yours (for example, a presentation, kiosk, or training application). If the work is a different kind of application or isn't of high quality, there is little need to continue the discussion. If the work looks good, try to find out what parts of it this developer did, since most projects are a collaborative effort. (Did the firm do the programming, the graphics, the design, or a combination?)

Another way to check out the developer is to talk with previous clients. Any reputable developer will let you contact satisfied clients (unless a project was done under nondisclosure for some reason). If a developer has no satisfied clients as references, let that be a warning.

Visit the Company
There is no substitute for actually visiting the developer's worksite itself. First impressions may not be one hundred percent accurate, but they are often more correct than not. Everything from the layout of the offices, cleanliness of the environment, disposition of the employees, technical resources, decorative taste, and company rules and policies can contribute to an informed impression of the developer.

Meet the Principals
One of the best indications of the quality and character of the development company is to meet the individual(s) who actually run and/or own the company. A company's tone is set at the top, and meeting the people who run and own the company can provide an important insight into the company's work mode and ethic. This is especially true with most multimedia developers, because they tend to be smaller companies where the owners run the company hands-on and are closely involved in the work. In fact, the company is often a direct reflection of the owner. If the owner seems to have a strong work ethic and is flexible, accommodating, and technically knowledgeable, this is a good sign. An owner who turns out to be an investor with more interest in fancy dining and expensive cars than in technology might not be viewed as favorably.

Size of Developer
The size of the independent developer(s) you choose should be appropriate to the size of the project. Generally, the larger the project, the larger the developer needed. The developer should be large enough to absorb fluctuations in the workload but not so large as to be too expensive or unresponsive to your needs. A single individual working as a freelance developer might be fine for a small project, like an electronic presentation. For a full-blown consumer CD-ROM to be sold at retail, a mature development house with other projects and clients might be more suitable. Such a developer can absorb your workload fluctuations, and the other jobs provide the developer with a depth of experience that can benefit your project as well.

However, a developer who is too large for your project may not be as responsive as a smaller one. If a large developer falls behind schedule on someone else's million-dollar job and yours is only a fifty-thousand-dollar project, the manager may be tempted to pull resources off your project to get the larger one back on track.

Make Valid Comparisons
When comparing developers and development proposals, try to make sure you compare them fairly and are not comparing "apples to oranges." One developer's fifty-thousand-dollar bid may be very different from another's. One developer

may include CD-ROM mastering, subject matter consulting, or even quality assurance testing in the bid, while another may not. These are real costs that can make a huge difference in the final project expense.

Limit the Number of Vendors

If a project is being done out-of-house, try not to work with too many external developers and vendors. When a lot of work is to be done externally, it is tempting to want to spread it around to a number of different developers. On the face of it this seems fair, and even a means of comparing the performance of different developers. However, each external developer requires a significant amount of internal project management time and coordination. As the number of vendors increases, the effort to keep them all working together in sync increases exponentially. Conflicts inevitably arise between different external developers working on the same project: finger-pointing starts for missed deadlines, software defects, and the like; jealousy over the amount of business being done with one or the other; and issues of confidentiality between potential competitors. In addition, it takes time and effort to develop a good working relationship with a developer, to the point that the external firm understands your company (expectations, priorities, structure) and you understand theirs. It is often wise to focus more work on fewer developers than to try give more developers smaller pieces.

Working Arrangements

To encourage a successful project outcome, working arrangements between a client and an external multimedia developer must be mutually beneficial. Without a "win-win" situation, both parties will likely lose in the long term. If one partner feels it is being taken advantage of, the personnel involved may reserve their best efforts.

Relationships between Publisher and Developer

A client who intends to sell the final application is considered the publisher. What follows is a brief overview of a complex subject: the relationship between a publisher and a developer. In such a situation, there are two basic working relationships: work-for-hire and royalty. These two relationships represent the ends of a spectrum. In an extreme, or "pure," work-for-hire arrangement, the developer is simply paid for the work, including graphics, source code, design ideas, and documentation, and the publisher retains all rights and ownership to that work, without any additional obligations. In a pure royalty arrangement, the developer is paid little or nothing for the work but receives a substantial percentage of the sales revenue and retains full rights and ownership to the work.

There are many intermediate and hybrid arrangements between these two extremes. For example, a developer might be paid an "advance against royalties" (the client funds the project in advance but deducts that amount from the eventual royalty payments due the developer). Another hybrid approach is for the

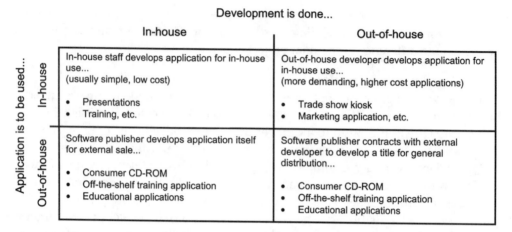

Figure 5.2 Comparison of where the development is done versus where the application is to be used: various scenarios.

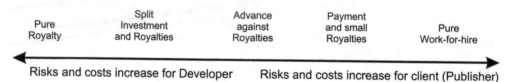

Figure 5.3 Risks and costs as a function of royalty versus work-for-hire.

client to both pay for the development and give an immediate reduced royalty. Another method is for both companies to fund the development equally and split the revenue generated. In another arrangement, the developer partially funds the project and receives distribution rights in a particular market or geographic region (such as overseas).

These deals can be structured in an infinite number of ways, depending on the parties involved and their financial and strategic goals. However, the basic formula is that the higher the royalty percentage to the developer, the more the developer will be committed to the success of the product. In fact, the amount of royalty determines the relative risk for each partner. The higher the up-front investment one party incurs based on expected future payments (royalties), the higher the risk they are assuming. The lower the up-front investment for one party, the lower their risk.

This risk assessment is an important consideration when negotiating financial arrangements between a publisher and a potential developer. While it may cost more up front to work with a developer in a work-for-hire arrangement, it may also be more expedient, requiring less negotiation. On the other hand, while it may cost

less up front to have a royalty arrangement, the developer may expect significant decision-making in the product design, since they are counting on a royalty once the product starts to sell, and hope to maximize sales through the product design.

Projects for In-House Use

Projects not destined for sale, such as electronic presentations or in-house training applications, are usually done as works-for-hire, since no royalty payment is involved. Sometimes the developer even wants to retain rights to the software and perhaps even the content as well, in which case payments by the client serve as a sort of license to use the final application. That is, the developer is paid to develop the program and allow the client free use, but still retains ownership of the product, to reuse goods or resell the program in the future.

These represent some of the more common arrangements between clients and external developers. The details will vary, depending on the aims and resources of the parties.

Development Contracts

When working with an external developer, it is necessary to have some written agreement defining the work to be performed and the amount and terms of compensation. While doing business on a handshake may be convenient at first, the flexible and ever-changing nature of software development make attempting any significant multimedia project without a written agreement an extremely risky proposition. This written agreement might range from a simple, single-page letter of agreement to a complete software development contract. The specifics of the agreement will depend on the situation and parties involved.

Without such an agreement, both parties put themselves at significant risk, proportional to the amount of time and effort that will be invested. A developer working without a contract is like a tightrope walker working without a net. They can easily find expected payments delayed or even withheld on minor pretenses, and themself without legal recourse. A client who asks for work to be performed without a contract not only risks investing significant time and energy without a guarantee of product delivery, but also litigation if disagreement arises over payment.

For projects of smaller scope and shorter duration, usually done as a simple work-for-hire at an hourly rate, a basic letter of agreement will often suffice. Such a letter generally includes a description of the work to be performed, intended delivery dates, hourly rate/compensation, and so on. This can be a single-page document signed by both parties.

For larger jobs, a software development contract may be necessary, a subject too large to be treated fully in this chapter.

- For more information on this subject, see Appendix A in this book.

Software contracts come in many different styles, but all attempt to detail the working relationship between the two parties. They describe which party is

responsible for what elements of the development, including payments and schedules, rights of ownership, distribution rights, maintenance and support issues, and much more.

Contract Milestones Many agreements are structured so the developer is paid a predetermined sum by the client at specific milestones, such as delivery of the design specification, the alpha version, the beta version, and the final version. Definitions of these deliverables are contained in the contract to provide objective criteria regarding when a particular milestone has been reached. As often as not, some disagreement about this occurs between the parties, such as whether a version submitted as beta by the developer is accepted as beta by the client. For this reason, the definition of the deliverables is an important section of the contract. Other items often contained in development contracts include maintenance and support responsibilities, warranties and indemnity, conditions of termination, and many other details specific to the given project.

When working with external developers, it is important to make every attempt to deliver timely payments. Small developers are usually very dependent upon their individual clients, and if a corporation withholds or delays payment, intentionally or inadvertently, it can have a serious and magnified effect on a small developer. This is sometimes difficult to appreciate by those within the corporate confines. A single delayed payment of sufficient size could cause a small developer credit problems, morale problems if the developer cannot make payroll, and even the temporary or permanent layoff of staff. In addition, these effects will certainly be counterproductive to the project under development.

Unfortunately, ensuring that payments to a developer are made in a timely fashion may be a project all its own for the project manager in a large company. Many companies routinely hold invoices until the very last moment for payment (sometimes even longer, for good measure). Invoices can easily get lost on the desks of busy executives whose signature is required for approval, or they can get lost in the accounting department while being processed for payment. Sometimes the approval process even gets changed while the invoice is in process, requiring it to start through the process anew. Meanwhile, the developer is anxiously awaiting payment and wondering whether to continue investing time and resources in the project.

Another effect of the software development process can add insult to injury for a small developer: the prerogative of the client to determine when a milestone has been reached and, hence, when payment will be approved.

For example, imagine that a developer is scheduled to deliver the alpha version on January 1, with a term of thirty days for the payment. The developer, assuming the payment will take two weeks to process (which is how long it might take in his own small company), expects and plans to receive payment in mid-January. In this case, though, the client takes a week to evaluate the alpha version and determines that it does not qualify as alpha. The developer takes two weeks to correct it, by which time it is the end of January. The milestone is

approved a few days later, and the invoice is submitted for payment. It takes a week to amass the correct signatures and finally arrives in the accounting department. It is now mid-February, and the accounting department may hold the invoice for several weeks, according to their general policy. The developer finally receives payment in mid-March, two months later than planned.

The paradox is that the client is acting as the judge and jury, since the company must pay an amount when a milestone is reached but is free to determine when that milestone is reached. Delayed payment will increase development costs for the developer.

The Old Stash-the-Payment Trick In the event that a more officially sanctioned method is not available, a corporate maneuver can minimize the payment delay problem described above. It works like this: the developer can be instructed to invoice for the payment at the earliest appropriate date. The project manager can then approve the invoice and submit it for approval and payment, regardless of whether the deliverable has actually been approved, with one qualification: *the check is to be routed to the project manager* rather than automatically mailed to the developer. Then the project manager can hold the check and send it out immediately upon approval of the milestone for payment. This allows plenty of time for the invoice to be processed, and it lets the project manager pay the developer immediately upon approval.

When using this method, it is best to be discreet. Your accounting department may not approve of it. Likewise, a developer who knows the check has been cut and is available may feel payment is being deliberately withheld and may become quite insistent that payment be made immediately (regardless of whether the deliverable has been approved).

Main Causes of Problems

In order to establish and maintain a good working relationship with an external developer, it is helpful to know about some frequent sources of conflict.

Compatibility

One of the most common reasons for problems between a client and a developer is that the client company chooses the wrong developer in the first place. The developer may be inexperienced in developing this kind of application, culturally incompatible, or just plain incompetent. The client may have chosen the developer based solely on price or on image. Whatever the reason, the close working relationship necessary between the client and developer will flush out even the smallest incompatibilities before long. It is therefore important for a client to be extremely careful when choosing a developer.

One common reason for such incompatibility is cultural differences between the two organizations. Every company has its own procedures, attitudes, and codes of behavior and dress, collectively referred to as the "corporate culture."

This is as true for small multimedia developers as for large corporations, and these "cultural" differences may be great. Sometimes they can be pronounced enough, and the individuals sensitive enough to them, to impair the working relationships. For example, imagine a conservative banking institution that requires a high-gloss marketing CD-ROM version of its annual report. If the chosen developer has a laid-back, creative atmosphere in which casual, offbeat clothing is encouraged, keeps odd work hours, and treats clients informally, the interaction between personnel in the two organizations might be somewhat strained and impair the project. A multimedia development house with a more conservative atmosphere might have been a better choice, even if the work produced is not quite as stylish.

Desire for Control

Another common reason for client/developer problems is the desire of either party to exclusively control the project. If the client treats the developer as a true partner with valid ideas and valuable knowledge, the independent developer will often put forth effort beyond your expectations. The developer who tries to control the project exclusively will often stifle an efficient development process. The desire to control a project (or an aspect of the project) accounts for many of the so-called "personality conflicts" that arise during development.

Design Changes

Another potential trouble spot, and probably the most common source of friction between a client and a multimedia developer, is when the client insists on making significant design changes throughout the development process, especially in the later stages of development such as Beta. This is a major source of conflict because of how often it occurs, and because of the severe ramifications it has on development and the developer's ability to finish the project in a timely fashion.

Design changes can happen for many reasons: the client may be unable to envision the final application until it is up and running, at which time they may want to change the design; or the requirements themselves may change during the project because of competitive issues or new ideas. Whatever the reason, requesting significant design changes in the later stages of development can create a massive amount of additional work for the developer, along with the resulting schedule and workflow problems. A competent and realistic developer will request more time and money to implement such changes, and clients are rarely pleased to hear this.

Hidden Costs

Finally, you should be aware that there are plenty of hidden internal costs when working with an outside developer. Simply because a contract has been signed to have development work performed doesn't mean you can just sit back and wait for it to be done. If your company is paying for it, it is your responsibility to make sure it is run and completed correctly. The outside developer must be managed,

and usually needs access to internal personnel and resources. For example, if an outside developer will be digitizing a promotional video that was created for another purpose, the master videotape must be located and duplicated, all of which takes time and money. If a publishing company contracts with an external developer, the packaging, manual, and other elements are usually the responsibility of the publisher, as are testing and maintenance costs, not to mention any marketing, duplication, and warehousing costs.

DEVELOPER'S CORNER

Dancing with the Elephant: Don't Get Stepped On.

Those employed by a small multimedia development company should understand some important concepts involved in working with large corporate clients. First, companies can move very slowly. The larger the company, the slower it typically moves. In a small multimedia development shop, the environment is completely different: decisions can often be made by one or two individuals and implemented almost immediately. By contrast, a large company may require several levels of approval, and each may be harder to obtain than the previous level. The chain of command and approval can be difficult to understand, even for those subject to them within the company, much less for a small, independent multimedia developer waiting for a "go" or "no-go" decision on a project. The developer's in-house contact may have little or no decision-making authority or even input into the approval process.

Large companies frequently operate in the "hurry up and wait" mode. They may require a developer to perform a large amount of work in a hurry (such as to write a proposal by the end of the week), then wait an indeterminate length of time for a complicated approval process to grind to completion. By the time the project is finally approved (assuming it does get approved), there may not be enough time left in the schedule to actually develop the application described in the proposal. Often the best thing a small developer can do is to maintain polite persistence, perhaps by checking in by telephone once a week, while looking for other project opportunities in case the project under discussion does not materialize or is delayed.

Most important, when awaiting project approval, do not assume that large companies are rational, logical entities; they frequently are not. They often pursue courses of action that appear to be (and actually may be) counterproductive and even self-destructive to their apparent business interests.

Quoting the Job

When working with a company for the first time, beware of quoting a project by the job; it is safer to quote an hourly rate and estimate the total time that will be required. If you quote the project on a fixed bid, it is difficult to come out ahead when a new client starts requesting design changes just prior to release. A client

who has to pay incrementally for those changes becomes sensitized to the costs involved in changing the specifications. This can be helpful in setting a precedent for future work (as long as the client doesn't feel it is being "nickeled-and-dimed" at the end of the project for every little thing).

False Starts

Often, after some great initial discussions, your contact in the company will mention that the project is "virtually approved." Don't be deceived. This phrase is usually meant to simply lend reassurance as the approval process grinds along. Project approval can vary tremendously from company to company and even within the same company. Usually a project really must obtain written and/or verbal approval by several individuals, including departmental managers, senior management, and the financial department. And just because you have negotiated a contract does not mean the project has been approved. It's not approved until you have a contract in hand, signed by both parties.

It is helpful for a developer to view the signed contract as the first milestone. Until the contract is signed, the project has not really started, and contract negotiations and approvals have a way of dragging out well beyond our most conservative expectations. These delays represent lost development time as well (unless you are willing to take a real risk and start the project early, before the contract is signed, in an attempt to actually deliver on time).

Using a Letter of Agreement

One way to speed the process and allow development to start quickly while waiting for a contract to be signed is to propose that the client provide a short letter of agreement as an interim step. The letter specifies a cap on the amount of work that can be performed (or invoiced to the client). This amount is then deducted from the payments specified in the contract once the final development contract is negotiated and signed. This letter is a stopgap measure that lets the developer begin in a timely manner under a written agreement, allows the company to commit to substantially less investment initially, and often requires a lower level of approval than a full-blown contract. Best of all, it starts the project rolling. Once these initial funds have been spent on a project, the company may become more committed to negotiating and signing a final contract.

Unrealistic Expectations

Clients may easily underestimate the cost and effort of developing a multimedia application, sometimes by an order of magnitude. It is a natural tendency for an inexperienced client to compare multimedia (software) to other types of media, like video and print. As a developer you can be sensitive to this tendency, but remain realistic regarding the true cost of development. You may easily underestimate the cost out of sheer optimism, pressure by the client, or simply because of the inherent unknowns in doing a software development project. In addition to the

risk of losing money on a project, a low price can set an unfortunate precedent that could inhibit you from billing the client at more profitable rates in the future.

Feature Creep

Probably the most dangerous and common problem to be aware of in dealing with a corporate client is that of "feature creep"—the addition of new features and design changes late in the development cycle. This occurs for many reasons, notably the inherent difficulty of completely envisioning software before it is actually up and running. Once it is running, all sorts of suggestions for improvements come to mind. Improvements attempted must be limited to a manageable level without compromising product quality.

Feature creep can often be effectively addressed by simply assigning a realistic cost and time factor based on the newly proposed changes. Another option is to add the new features or changes to the "wish list" for the next version of the application.

Late Content

In many projects, the developer is charged with creating an application based on content material provided by the client. However, sometimes it is difficult to obtain the content from the client in time to keep to the schedule (a schedule established by the client in the first place). This can cause increased development costs and delayed milestone payments.

It then falls to the developer to manage this process and either obtain the necessary materials in time from the client or make sure the client is well informed of the effects of delivering content late. Sometimes you can help with simple matters, like getting photos digitized or text input—with compensation, of course.

In addition, some developers have been known to charge an overtime fee if late delivery of content by the client forces the developer to work extra or unusual hours. Not only does the developer benefit from this overtime rate, but getting charged such a rate because of late content will often sensitize the client to the issue for the next project.

Indecisive Companies

Finally, one of the most frustrating situations involves overly bureaucratic companies where people cannot make even the smallest decision without endless meetings, committees, and layer upon layer of approvals. This means that few individuals are empowered to actually make real decisions and the company must reach a consensus for any decision of significance, including the decision to actually sign a multimedia development contract. If you start feeling that the decision-making process is taking much too long (and assuming there are no outstanding invoices), it may be time to look for other work opportunities while the client sorts things out internally. Check back by phone once every week or two to see how things are going. Patient persistence can be effective.

Collecting Payments

Sometimes obtaining a signed contract is only the first step; collecting payments can also present its own set of problems. Companies can be extremely slow in paying bills—sometimes by accident, such as when an invoice gets lost; sometimes deliberately, to improve their own cash flow. If the company you are doing business with is slow in paying, here are a couple ideas to consider:

Early Invoicing This refers to the previously mentioned technique of submitting invoices ahead of time. If you have good rapport with the internal project manager, he or she might let you submit an invoice early, put it through for processing, and hold the check personally until the milestone is approved. In this way, the time between milestone approval and receipt of payment can be minimized.

The Old Discount-for-Quick-Payment Trick One method that may get the attention and motivation of a corporate accounting department is to actually offer a discount for quick payment. If you can afford to offer such a discount, many otherwise lethargic accounting departments will jump through hoops to get the check out within the specified time. If the invoice shows a clear notice that the company can take a 2.5 percent discount for payment within ten days, many companies will process such an invoice at lightning speed.

Talking Directly with Accounting Finally, if the payment is "stuck in the accounting department" (according to your contact at the company), it may be worthwhile to talk directly with someone in that accounting department. This can sometimes shed light on who internally is responsible for the late payment and often provides useful information about internal corporate procedures. Trivial items, like including your corporate identification number or social security number directly on the invoice, may make a significant difference. However, if you decide to contact the accounting department directly, be careful to first obtain permission from your company contact; otherwise, you risk alienating people inside the company.

6

Multimedia Technologies and Tools

If there is one defining characteristic in the explosive growth of the computer industry over the last decade, it is the rapid pace of changing technology. Such change is the hallmark of the computer industry. In fact, the rate of change itself seems almost to be accelerating. According to Moore's Law (expressed by Gordon Moore, of Intel), the effective speed and power of processor chips doubles every eighteen months. Operating systems are continually evolving as well. Not only are new versions of existing operating systems being released, but new operating systems themselves are being released. We can therefore proceed under the assumption that this continuous change and evolution is likely to continue for the foreseeable future, despite the many industry-wide attempts and calls for "standardization." Change is the very lifeblood of the computer industry.

It sometimes seems that keeping up with all these changes is impossible. So many companies and individuals are working on new and improved technologies that it is impossible to keep up with all of them. However, it isn't really necessary to keep up with every new development and new product announcement by every new company, because given the sheer volume of new developments in the computer industry, the vast majority of technological developments are irrelevant to the work you are doing. However, it is important to understand the general technological issues at play, because they may affect the work you are involved in on a daily basis. For example, the inner working of ISDN lines may be of little direct relevance to you, but the increased bandwidth they allow may have a significant impact on the usability of a World Wide Web site you may be developing.

Planning and running multimedia projects often requires decisions on the kind of technology and development tools to use for particular application. Often there are several choices, none of which offers a clearly superior solution. Choosing the right hardware, software, and media can have a significant effect on the success or failure of an application. On the other hand, sometimes there isn't much choice. For example, in the case of a consumer title sold at retail that requires significant amounts of digitized video, a CD-ROM is usually the most appropriate choice. However, some situations are not so obvious, such as a marketing kiosk

where you may need to decide between a Mac or a PC, or between running the program from the computer's internal hard drive, from an external hard drive, or from a CD-ROM. In addition, the choice of software development tool is crucial.

Platforms Change

The gradual improvement and rising computing power available at lower cost ensures that developers and end-users alike will continue to obtain new and different machines. Systems that were unavailable at any price a few years ago are now being sold for casual home use. These changes range from CPU power to memory size to data storage capabilities (CD-ROMs and the Internet) to new technology and inventions still waiting to make their debut.

In addition to the gradual evolution of the successful platforms, like Windows and Macintosh, other platforms have had limited success for a relatively short period. A good example of this is the category of "set-top boxes" that in the late 1980s was thought to hold tremendous potential, including such incarnations as CD-I (by Phillips), CDTV (by Commodore), and VIS (by Tandy). Fierce competition was fought in the press between the champions of these formats, but ironically, none sold well enough to sustain itself as a viable widespread platform. (CD-I was still in existence in the mid-nineties, although its use has been relegated mostly to internal training or promotional applications.) Those developers who invested in developing a CD-I, CDTV, or VIS application were essentially investing in the success of that platform and were consequently disappointed when it went by the wayside.

Like these set-top boxes of old, other new platforms are being introduced in the form of dedicated home Internet terminals and non-Macintosh PowerPC-based computer architectures, and other inventions are poised to attempt a coup in one market niche or another. Only time will tell which are successful, to what degree, and for how long. For the developer or project manager trying to decide how to implement an application, this platform decision can represent real risk to the success of an application.

New Storage Formats

A new format is always just around the bend. In the mid-seventies, the new format was audiocassette tape for data storage; in the late seventies it was 8-inch floppy diskettes; in the early eighties it was 5 1/4-inch floppy diskettes; and in the mid- to late eighties it was 3 1/2 inch-floppies. In the nineties, the leading format to emerge was CD-ROM. This evolution is likely to continue. In fact, the Internet represents yet another format, which represents a whole paradigm shift for data storage and access, since it is on-line, remote storage.

And yet, sometimes the development process can be somewhat independent of the specific format on which the final application is delivered. Just as the same video program can be provided in various formats (broadcast television, VHS

videotape, 1-inch videotape, videodisc) that do not affect the production process, to some extent the same software application can be provided in the format of choice (CD-ROM, hard disk, network file server). While the basic multimedia application remains the same, the code may need to be optimized for various distribution mediums, such as CD-ROM or Internet transmission.

Continuous Change

The continuous change in hardware and software platforms will persist because the hardware and software companies that manufacture and sell these products need to constantly sell new products to stay in business. Without the endless evolution in power and sophistication of the products, the market would eventually fill up with computers, and sales of new computers would slow to a trickle. Therefore, computer manufacturers must continually introduce more powerful equipment for less cost in order to drive enough sales to stay in business. This creates a situation in which the price points remain roughly similar from year to year, while the power and quality of the equipment that can be purchased at that price continually improve. For example, for entry-level home computers, the price point has been around $2000 for a number of years. However, the power and capabilities of the equipment available for this price has increased by several orders of magnitude in that time.

As increased computing power becomes available, customers expect more of their new computers, which increases the demand for more sophisticated software to exploit this powerful new hardware. This means that software has to be continually updated and new applications invented to take full advantage of all the new hardware. Therein lies the beauty of the software industry: there is no end to the work to be done. As long as there are computers, people will be writing, rewriting, and developing new applications.

PICKING A PLATFORM

The proper choice of platforms for development and target systems depends on the application and its intended use. In the mid- to late nineties, three main platforms were available for most consumer multimedia applications (aside from video game machines): Windows, Macintosh, and the Internet/World Wide Web. In the case of Windows and the Macintosh, the operating system determines the kind of hardware system, although not necessarily the detailed specifications for the target machine. On the Internet, the target platform is more often defined by the capabilities of various HTML browsers.

Software Platform

Of the various operating systems available, the choice is often predetermined by existing factors. For example, if you were to start creating a brand-new consumer

multimedia CD-ROM in the mid- to late nineties, you would clearly need to consider Windows '95, because it was the dominant operating system in use by home computer users. Representing the largest target market, applications written for Windows '95 had the best sales potential.

For an in-house presentation, the choice could be much more arbitrary, and the correct decision might well be in favor of the Macintosh, since it is used heavily in many corporate art and design departments, where such a presentation is likely to be developed. Windows NT, OS-2, or even the "NeXT" operating system might be a good choice for a particular application in a specialized business environment where that operating system happens to be in use. For an Internet Web site, you may want to create HTML pages on a Windows or Macintosh machine and then load them onto a UNIX server. For each operating system, there are at least several development environments (authoring systems and programming languages) to choose from. The intended use of the application will determine the software platform.

Hardware Platform

The choice of an operating system determines, in most cases, the basic hardware platform. In 1996, the Macintosh operating system ran only on Apple Macintosh computers (including a few Macintosh clones). The Windows operating systems (3.1 and '95) ran on Intel and Intel-compatible computers (those with Intel 80486 and Pentium processors or compatibles). The Internet spanned most of the various hardware platforms, from mainframes and minicomputers to workstations and personal computers.

Target Platform

Once the choice of a hardware system is made, the target system's minimum hardware requirements can be specified, which will depend on your application. In general, the wider the distribution intended for your application, the less powerful the minimum system specification should be, and vice versa. If you are developing an electronic presentation for a single person to use and that person happens to have a Pentium notebook computer with thirty-two megabytes of RAM, sixteen million colors, and twenty megabytes of free hard disk space, that would be the right machine to target (or "specify"). On the other hand, if you are building an application for the consumer market, a lower-end target machine will allow the application to run on as many computers as possible and therefore obtain the widest possible target market. For a training application to be distributed to perhaps a few dozen people, a middle ground might be possible, in the form of a target system powerful enough to run the applications adequately but also likely to be found among the users' existing computers, and not expensive enough to put it out of range for an individual to purchase, if necessary. You often have to make a compromise between the "least-common denominator" system, and one with enough capabilities to deliver the features you desire.

MEDIA CHOICES

Each choice of storage technology has inherent limitations and advantages, which determine its suitability for a particular application. In addition, the storage techniques are not mutually exclusive. For example, most CD-ROM applications must be installed on a user's hard drive. Some CD-ROMs are even supporting Internet links directly, thereby extending the application's functionality in that direction.

CD-ROM

CD-ROMs have the advantages of being able to hold relatively large amounts of data and of being unerasable, inexpensive to manufacture, and convenient to ship and handle. On the other hand, they are relatively slow in accessing and transferring data and cannot be directly modified like magnetic media (hard drives and floppy diskettes). Therefore, CD-ROMs are an ideal medium for publishing final, unalterable multimedia applications. The large storage capacity is ideal for large data files, like video, graphics, and audio. Being unerasable, they are a durable medium that can be handled by casual users without problems. Being light and compact, they are inexpensive to ship and keep in inventory. On the other hand, this same compactness can diminish their perceived value to a potential customer (especially if they are compared to lower-priced audio CDs). For this reason, CD-ROMs are often packaged in colorful, oversized boxes, which help convey the impression of heightened value. (Often the manufacturing cost for the box, manual, and other packaging that accompanies a consumer CD-ROM is two or three times the manufacturing cost of the CD-ROM itself.)

3½-inch Floppy Diskette

Floppy diskettes are another means of distributing multimedia applications. The advantages they offer are that they are low cost and the format is ubiquitous. Virtually anyone with a computer has a floppy disk drive. Disadvantages include the small data storage capacity, the fragility of the medium, and the slowness in transferring data. Usually, therefore, floppy diskettes are used for applications that require relatively small amounts of data and/or are being created for small-scale distribution, where the diskettes can be duplicated individually or in small batches over a period of time. For example, floppy diskettes might well be appropriate for distributing a small slide-show presentation to sales representatives. Being a magnetic medium, the diskettes could be altered and customized for individual clients.

Hard Drive (Internal/Fixed)

Internal hard drives have the advantage of being able to hold relatively large quantities of data (one to two gigabytes or more), which can be erased and modified, and they have fast access and transfer rates. On the other hand, they are very expensive

compared to CD-ROMs, and there is always a potential for mechanical failure, resulting in the loss or corruption of data. Hard drives are most frequently used for dedicated presentation machines, such as a computer in a kiosk that must store large amounts of video and/or audio data, and where the display requirements should not be compromised, and it may need to be updated from time to time. This does not mean that the application should actually be distributed by shipping out internal hard drives full of data; rather, it could be loaded from a CD-ROM in its entirety and then run off the hard drive, without needing to access the CD-ROM again.

Hard Drive (External/Removable)

External and removable hard drives (such as the Zip and Jaz drives by Iomega and the EX 135 by Syquest) have many of the same advantages and disadvantages as internal hard drives. However, since they can be easily removed, they can sometimes offer convenience as a distribution medium. However, they can be fragile and more prone to data corruption and mechanical failure than internal hard drives, since they are more exposed than internal hard drives and are subjected to handling (sometimes by people with less-than-experienced hands). While the expense may be relatively high, the convenience is also high and may outweigh other factors, depending on the application.

Internet

The Internet, in the form of the World Wide Web, is not only a relatively recent phenomenon but represents a unique distribution medium as well. It represents a completely different paradigm from other storage mediums and is a strong platform for the future. The advantages of the Web are that data storage capabilities are virtually limitless and it offers easily modifiable data. It is also extremely mobile, since applications can be accessed from virtually anywhere; all you need is a phone line and a computer with a modem. One disadvantage is the slowness of data transfer compared to CD-ROMs or hard drives. Another disadvantage is the unpredictability of operation, because of the many dependent telecommunication links necessary to move data from the host computer (server) to the client (end user). In addition, Internet communications can sometimes be somewhat less than secure, so privacy may be an issue as well. The World Wide Web is an ever-changing environment where information that existed in one place yesterday may have moved to another location, been substituted by something else, or even removed entirely.

Videodisc

Interactive videodiscs (analog laserdiscs) were in the vanguard of the first wave of interactive multimedia applications. However, their use has been largely superseded by CD-ROM and hard disk technologies. Advantages of videodiscs include

high-quality, full-screen video and flexible control over and use of that video (such as still frame, reverse, and fast random access to individual frames). Disadvantages include the small installed base of computer-controllable videodisc players and difficulty connecting them to computers (inconvenient cabling and extra equipment to install in the computer). Currently, videodiscs are used mostly in specialized applications that require little in the way of interactivity and much in the way of video, often simply as a more durable way to play linear video than videotape offers. Examples include educational videos and high-fidelity playback of fine, classic movies (*Fantasia, Citizen Kane*). Another convenient use of a videodisc is for video programs that need to replay continuously, such as in-store promotional videos. Videodiscs are excellent for use without computers in continuously playing noninteractive museum exhibits or noninteractive trade show displays, where a videotape might eventually wear out and the interactivity of a computer is not needed.

DISPLAY CHOICES

Every multimedia application requires some sort of visual display. The most prevalent method is the standard computer monitor. Other display devices are used occasionally, including LCD (Liquid Crystal Display) panels, computer/video projectors, professional-quality video monitors, and even garden-variety televisions. In addition, touchscreen monitors are often used for kiosk and other public-access applications.

LCD Panels and Computer/Video Projectors

When presenting an application to more than a half-dozen people, some sort of projection display device is usually needed, either an LCD panel with an overhead projector or a video projector. An LCD panel acts essentially like a flat, transparent computer monitor that, when positioned on top of an overhead projector, projects the computer's display on a large screen or a wall. Video projectors, on the other hand, can be plugged directly into a computer and project the image, much like a movie projector. Some of the new computer/video projectors are quite small and portable, making them ideal display devices for multimedia presentations. The projection device you choose usually depends on what is available or affordable. LCD panels are generally less expensive, and the required overhead projector can often be obtained at the presentation site. Computer/video projectors are more convenient and the display usually looks better, but they are also more expensive to either buy or rent.

Video Monitor and Television

Occasionally, multimedia applications have to be shown on television sets or other video monitors. A projector device may not be available, or perhaps the application is designed for some sort of set-top box or video game machine. In designing such

an application, you must take into consideration the difference in display technologies (interlaced versus noninterlaced).

Display characteristics of computer monitors are substantially different from most television/video displays. Computers display at least 640 lines of resolution vertically (and sometimes much higher) and the display is *noninterlaced*. ("Noninterlaced" means the whole video frame is drawn all at once, usually 60 times a second, as with a standard computer monitor). Televisions generally have at least 512 lines of resolution, but it is *interlaced* ("Interlaced" means that each frame of video is drawn in two passes. On the first pass, the even-numbered lines are drawn—lines 2, 4, 6, and so on. On the second pass, the odd-numbered lines are drawn.) This means that when creating graphics for an interlaced (television) display, in order to get a stable image without flicker, effective screen resolution is halved, to 256 horizontal lines.

On the other hand, as analog display devices, televisions can accommodate virtually any color palette, while some computers may display only 256 colors. When using a computer to create graphics destined for display on a video monitor, detailed graphics and text must be much larger than necessary for a computer monitor, to compensate for the lower resolution. However, the palette does not have to be limited. The resulting design parameters are clearly illustrated in the graphics most often seen on television. You often see beautiful graphics with a tremendous depth and variety of color, but they are rarely small and detailed. Flying logos—with beautiful graphical backgrounds and radiant camera-shot scenery—are commonly seen, but you almost never see long, narrow columns of small text (as you do on a computer monitor). This difference is especially evident in the weather segment on the nightly news programs, where they have to deal with showing small text and numbers on a video display. By watching this segment closely, you can get a good idea of the parameters involved. Watch, for example, the thin text and horizontal lines where high-contrast colors meet and you will see the "flicker" that signifies an interlaced display.

When planning to connect a computer to a video monitor or television set, be aware of the differences in signals and connectors. Some high-end video monitors accept computer signals directly. These are generally called "multi-sync" monitors and will usually have the correct input ports on the back of the set to accept computer signals, as well as some way to select the computer input through manual controls. If such a monitor is unavailable and the computer must be output to a standard television, its signal must be converted to a composite video signal so the television can display it. This is done either with a board installed in the computer or with an external signal conversion mechanism (a "black box"). The set-top boxes and video game devices incorporate this signal conversion circuitry as a built-in feature.

DEVELOPMENT TOOLS

When planning and developing a multimedia application, the choice of a development tool will generally have a significant impact on the design and how it is

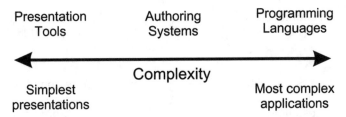

Figure 6.1 Development tool continuum.

developed. The subject of which development tool should be used for which application is a large one and is addressed to a greater extent in Appendix B. However, it is worthwhile discussing briefly, if only as an introduction to the subject.

Multimedia software development tools generally fall into three categories: presentation tools, authoring systems, and programming languages, which can be arranged along a continuum, depending on the complexity of the final product.

In general, the parameters that indicate which development tool to use include the complexity of application, time frame, cost, experience of the "programmer," and distribution intentions (see figure 6.2). The less complex the application and the faster it must be finished, the smaller the budget, the less experienced the programmer, and the smaller the intended distribution, generally the better suited is a development tool toward the left end of the spectrum. For example, an electronic slide show that must be completed in a week for a few hundred dollars by a non-programmer, for use once on a single machine, should probably be done with a presentation tool (such as PowerPoint). On the other hand, a unique, feature-laden consumer application to be released in two years, with a million-dollar budget, C++ programmers available, and an intended distribution of hundreds of thousands of units, should probably be custom-coded in a native programming language like C++. Applications that fall between these two extremes, such as marketing kiosks and training applications, often end up being developed in authoring systems such as Macromedia Director or IconAuthor.

Video Production Technology

When initially planning to create video for use in a multimedia application, it is common to underestimate the cost and magnitude of the job, especially by those without experience in video production. While various "desktop video" production tools are available, they do not eliminate the costs of creating high-quality video. To produce high-quality video, you still need talented, experienced, technically proficient video production personnel using suitable equipment. While some of the graphics, special effects, and editing can now be done on personal computers, most of the usual video production costs for scripting, shooting, audio, and music will still be incurred.

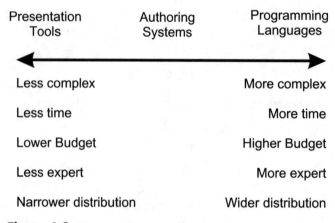

Figure 6.2 Factors relevant to choosing a development tool.

The Development Process

7

The Development Process: Overview

Multimedia applications are software, so when you are developing one, it is important to use a software development process, not a modified print or video production process. Remember, regardless of the kind of content or data to be prepared, whether it's video to be produced, text to be written, and/or audio to be recorded, at the heart of the project is a software program, so you must use a software development process.

Misadapted Processes

When producers of other media, like video and print, try to develop multimedia applications, they often rely on imagined similarities and analogies between their normal, established workflow and those needed to develop a multimedia project. Video producers and print editors often fail to appreciate the central role of a software development process in creating multimedia. This is why many large publishers of print and video materials have had such difficulty developing successful multimedia businesses and why, despite being generally smaller companies, experienced software developers dominate the field.

For example, a company that tries to adapt a successful video production process to develop a multimedia application will often use incorrect analogies to structure the workflow. While the three stages of video (preproduction, production, and postproduction) can be imagined to be similar to software design, development, and testing, in reality, they are very different kinds of tasks and require different skills, emphasis, and procedures. The scripting, shooting, and editing stages of a video production are but a subtask of multimedia development. A producer who views multimedia development as analogous to video production will miss the essential points and nuances that allow for the correct software development process. One of the most significant differences is that software development usually has more than three phases, and the software development phases are

overlapping and iterative. Oversimplifying the software development process will lead to a gross underestimation of the task.

Likewise, print publishers who try to fit the square peg of a multimedia project into the round hole of print publishing may also find the task overwhelming. Software design is not editorial work, software testing is not proofreading, and programming has no analog whatsoever in the print process.

This is not to say that video producers, print editors, and others are not important to a multimedia production team. Their work of writing or video editing is essential, since it comprises the production of much of the program's actual content; however, from a software development point of view, the content is "simply data." While the content to be delivered is a primary consideration and influences design goals, it is the actual software design, programming, and testing that are at the center of the process. To effectively manage a multimedia project, video producers and print editors must learn the skills of a software project manager, and the company must support and use a software development process.

One fundamental difference between multimedia development and other kinds of media development is that designing software is like designing a machine. (That's why it's called "software engineering.") Software *does* something; it reacts to the user in myriad ways, like a complex machine, as opposed to other media, which simply present content in linear form. For this reason, software has an infinite number of states, and things can go wrong or malfunction at almost any point, unlike video or print, which have virtually no potential for mechanical or "runtime" error.

Another difference in developing multimedia as opposed to other media is the advantage of using a project team approach rather than an assembly line. Most successful multimedia applications are developed by small teams of individuals working nearly full time on a single project.

THE SOFTWARE DEVELOPMENT PROCESS

The software development process varies widely from company to company, and within a company from project to project. However, most multimedia projects go through the following nonlinear phases, in one form or another (although they are usually overlapping and sometimes revisited or nonsequential):

Analysis and Planning

In the analysis and planning phase, you set the goals and specify the requirements of the final application, then develop a workplan to carry out the development effort. This phase is the starting point, where the initial research occurs to identify what the application must be able to do and how it will be built. In setting the requirements, you are in a sense finding and setting up the target to be aimed at during the remaining design and development phases. You can develop

a successful application only with a clear conception of what the application is supposed to accomplish. This product concept is arrived at by discussing the needs with marketing personnel, clients, potential customers, subject matter experts, and other stakeholders, in order to determine the overall requirements of the program. The analysis starts with a basic concept for the application and the business case for doing it, including marketing needs and assumptions and the cost of investment.

As the requirements become apparent and further refined, you start to get an idea of the project scope and features. This lets you create a workplan describing how the application will be built, with detailed descriptions of the project factors—time, task, and resources. The workplan will contain a detailed description of the kinds of resources required (personnel, materials, equipment, outside services, and so on) and when those resources are expected to be needed. The task to be done is contained in the requirements specification, which essentially describes the application envisioned: its features, look and feel, and other characteristics required. The time factor is laid out, with milestones to be achieved and definitions and expected delivery dates for each milestone. The workplan should paint a complete picture of how the application will be built, suitable for review by senior management and others on the project team. The final deliverable for the analysis and planning phase is this workplan document.

Design

In the design phase, you design what the application will do and how it will look, given the technical requirements and limitations. Based on the requirements specification, the design lays out exactly what the application will be able to do, feature by feature, and what it will look like, screen by screen. The resulting description is a nontechnical document. Those involved in the project should be able to read and understand it, comment on it intelligently, and ultimately approve this initial design (and know what they are approving). It is a waste of time to ask people to review and approve a technical document they don't understand; even if they do approve it, that approval is a worthless signature on a piece of paper. They can demand design changes at a later date, regardless of whether they signed the approval or not. The design specification is in essence a negotiating tool that changes until everyone agrees on what the application will look like, how it will function, and its range of features, given the budget and time constraints.

As the user interface and features are designed, the technical personnel should begin laying out the technical design, so they have a workable software architecture proposed before implementation begins. Considerations include breaking up the program into modular components, planning the flow of data between modules, version control issues, development tools and libraries, file formats, and so on. The resulting document is the blueprint for implementing what is described in the functional design. Software engineers must work out the underlying software architecture, the nuts and bolts of how to design the code.

During the design phase, one way to polish the ideas and achieve a mutually agreed-upon user interface design is to develop one or more prototypes. The prototype is the first incarnation of the program (or an individual program module or feature) and permits the user interface and major features to be reviewed. With a prototype, everyone can get a better grasp of what the application will look like and how it will function. It facilitates trying out the design and making any final modifications before the design is implemented. It is also helpful to prototype individual elements and features of the design that are in question or require special attention.

The prototype(s) can be done using various tools, from programming languages to quick authoring systems to paper representations. The goal is to be able to actually see and test the design before coding begins, so you can flush out the inevitable design flaws that were not envisioned during the abstract thinking that generated the written design specification. The prototype also serves a valuable purpose in allowing the application to be demonstrated long before it is finished. This prototyping process should not take an inordinate amount of time, since 1) much is learned quickly, and the law of diminishing returns quickly sets in, and 2) the goal is not to create the perfect prototype or develop a pseudo-application but to gain enough knowledge to start safely programming the interface from a solid, tested design foundation.

Implementation

In the implementation phase, the application is actually built. This is when it is programmed, where video is digitized, photos are scanned, text is written and formatted, and other data prepared. The implementation phase is iterative and additive, in the sense that it consists of the "release" of various versions of the program, each building functionality onto the previous version and adding content, until the application is complete (and ready for final testing).

The implementation phase usually seems to fall into three basic stages of development: 1) first implementation of the original functional design; 2) modifications and fine-tuning of the user interface and features and then freezing the design; and 3) final programming and data preparation. These three stages are usually referred to as alpha, beta, and gamma. They may be carefully delineated or they may blend into each other, but most applications seem to pass through them in one form or another.

In the alpha stage, the program is usually developed incrementally, with each new version containing additional functionality, until all the features have been implemented for the first time. The alpha version usually consists of the full and complete user interface, with all features working in a demonstrable form. The content (such as text, data, graphics, video, audio, photos), however, is usually not complete, so the alpha version is often restricted to a small set of sample content (or data). While the final application may be designed to incorporate twenty video clips and three hundred text articles, the alpha version may have only one active video clip and a couple of text articles running, for demonstration purposes only.

The beta stage is usually when the first full design (embodied in the alpha) is reviewed and user-tested and when final design revisions are prioritized, and approved. The functional design is then (hopefully) frozen, so that no more changes are accepted, and the way is cleared to finish the programming and data preparation without the threat of redesign or "feature creep." While the programming staff may oppose any design changes at this stage, changes almost inevitably occur. Therefore, it is prudent to plan for these changes, try to limit them to minor cosmetic alterations, and identify this early beta stage as the last chance for people to suggest changes if the application is to be completed on time. The end result of the beta stage is the approved beta version, which should have few serious software defects and be relatively finished in terms of the user interface design.

The gamma stage begins with this fully functional beta version, the design of which has been frozen. During gamma, data preparation is completed and final quality assurance testing begins, feature by feature. A version considered the "final gamma" should have no fatal software errors and few, if any, casually observable feature or content errors. It is usually then the publisher's (or client's) responsibility to find any and all bugs through complete and strenuous software testing and make those errors known to the developer or data preparation staff so they can be fixed.

Quality Assurance Testing

During the quality assurance phase, the application is rigorously tested to ensure its quality and reliability prior to release. This phase usually overlaps with the gamma phase and ends with the acceptance of the final version for release. Depending on the application, "release" may mean different things. In a consumer CD-ROM, it may mean turning over the application to the manufacturing department for duplication. For an internal training application, it may mean running off the first few copies to send out to the field. For an electronic presentation, it may mean actually allowing the display machine to be shipped out to the presentation site.

The quality assurance testing should be done by an unbiased party, someone other than those on the project development staff. A significant portion of quality assurance work consists of keeping track of the errors found, their relative severity and priorities, and whether they have been fixed or not. In larger applications, this is often accomplished by using a bug-tracking database.

Support and Maintenance

Generally, software applications must be maintained and supported if they are to be successful. Software is unlike most other media in this respect.

Support

Aside from knowing how to read, no one needs support in how to use a book. If a videotape won't play, it's either because the VCR is broken, the tape is defective,

or there is some other mechanical problem unrelated to the actual video production process. These problems do not require the assistance of the original book or video publisher. However, software is different. If software malfunctions, the users of that software will need a support mechanism to assist them. Who hasn't experienced a piece of software that is difficult to operate, won't install on his or her machine, or has bugs? The user needs and expects to obtain assistance from the company that published the software application.

Maintenance

Software also must be maintained—continually improved and fixed—if it is to remain viable. This happens for a number of reasons. First, both the hardware and operating systems are continually changing. If a piece of software is left on the shelf, sooner or later it will be woefully outdated and may not even function on the then current platforms. Second, if a piece of commercial software is successful, it is often imitated by competitors, and this starts a feature race, with each company trying to add more features to its program than the other company, in order to win uncommitted customers. (This is why the popular word processors are so heavily crammed with obscure features that are of little value to most users.) Software publishers must continually update their products in order to stay competitive.

These maintenance and support issues must be planned for from the beginning; otherwise, the sudden need to take customer calls, fix outstanding bugs, and port the program to a different platform will be a rude surprise to a company's senior management.

THE REALITY OF THE PROCESS

The process described above is a nonlinear process and must be adapted to your own needs. As a nonlinear process, it has no clean breaks between the phases. Each phase does not necessarily begin when the previous phase ends or end when the next phase begins. There is significant overlapping and revisiting of the various phases, and project personnel need to understand this if they are to have the proper expectations.

Three Perspectives

Programmer's Perspective

The last thing most programmers want to see is design changes after the functional design has been completed and approved. Most programmers seem to want and expect to be handed a "permanent" functional design and then left alone to implement it. They generally loathe any changes to the design, especially if they have already implemented features now being redesigned. To many software engineers, redesigning and asking them to reimplement features that have already been implemented is like asking them to tear apart their very own painting and patch it

Analysis and Planning	Design	Implementation	Testing	Maintenance and Support

Time

Figure 7.1 The ideal software development process, from the perspective of many systems and software engineers.

back together in a different form. The ideal development process, according to many systems and software engineers, can be diagrammed as in figure 7.1.

This process is a simple, linear sequence from one stage to the next, without overlap or the chance of changing the design after it has been approved. It is analogous to handing off a baton in a relay race. Once the baton has been transferred, it cannot go back.

Marketing Perspective

On the other hand, marketing and sales personnel always want the option of adding or modifying the design up until the last minute before an application is released. While you are busily developing your own product, a competitive product may appear with additional or superior features. Marketing people want the flexibility to add features midstream to reposition their own product against such competition. The process preferred by most marketing personnel can be diagrammed as in figure 7.2.

Notice that this diagram is virtually the opposite of the programming diagram. The phases allow the design to be modified up to the last minute. Testing is a necessary evil to be done at the end of the process, and maintenance and support are basically an afterthought.

Needless to say, the two previous paradigms represent extremes and are mutually exclusive. If only the programming perspective were respected, the resulting product would most likely be ill-designed and probably unsalable. However, it would probably be delivered on time and be very reliable. On the other hand, using the marketing approach, the product would probably never get finished, because new features would constantly be added and testing would never end. If it did somehow manage to get finished, it would be a late, unmaintainable conglomeration of coding quick fixes ("kludges"), which are unmaintainable and expensive in the long run. However, it would probably look great and have a lot of nifty (though unreliable) features.

Project Management Perspective

In practice, the actual software development process usually ends up looking something like figure 7.3. This shows the actual overlapping nature of the phases.

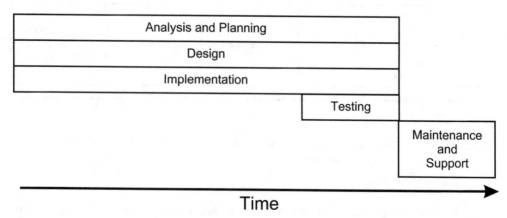

Figure 7.2 The development process preferred by most marketing personnel.

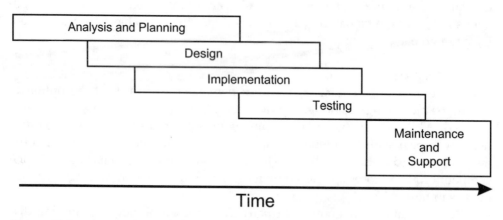

Figure 7.3 The actual software development process.

While this may not be the most blazingly efficient way to develop code, or may not provide unlimited design flexibility for marketing needs, it represents a workable scheme for developing multimedia applications and, more important, shows how most projects actually do end up getting developed.

> Every multimedia project is different in some way. The amount of overlap, the length of each phase, the emphasis on various phases, will vary depending on the needs and peculiarities of a given project. The extension of the design and implementation phases toward the latter part of the project reflects the ongoing fine-tuning of the user interface that usually occurs. The overlapping phases in this diagram may differ greatly from the phases planned in your own projects. When planning and executing a project, you must remain flexible and let the project influence (if not determine) the process. Otherwise a slavish, by-the-book adherence to a particular development process can actually prevent successful completion. For example, a consumer CD-ROM may require flashy

graphics and stringent quality assurance testing. In this case, the design and testing phases will take relatively more time compared to an electronic presentation, where the emphasis may be on the requirements specification phase, in which the outline and script are written.

The Funnel

Another way to conceptualize the development process is like a funnel, with the greatest number of and most important decisions made early in the process, diminishing in number and importance toward the end, until virtually no decisions are left to make, aside from simply finding and fixing the remaining bugs.

As parameters are defined, subsequent decisions are made, which further define the requirements and limit the options. In the beginning of the project, when doing the requirements analysis, the general domain and use of the application is being investigated and defined. Many crucial decisions are made and alternatives compared and prioritized. If this is done poorly, all subsequent work will be of dubious value. In a sense, the target will have been misplaced, so there will be little hope of developing a successful application. Setting the requirements defines the project parameters and the factors of time, task, and resources and allows you to develop a workplan based on these factors. The decisions made in developing the workplan are many and detailed, since it is essentially a matter of thinking through and planning the entire project in the abstract, including target delivery and development platforms, risk assessment, and contingency plans. The requirements specification contained in the workplan sets the stage for the design phase, where decision-making is of a different and somewhat more restricted nature.

When doing the design, an important, second tier of decisions are made. Specific features and interface elements are established, defined, and designed in detail, and the user interface is conceptualized. The functional design defines and describes the basic look and operation of the final product and so will have a significant impact on the success or failure of the application. The functional design,

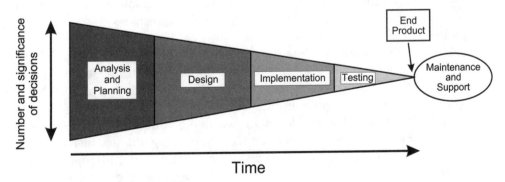

Figure 7.4 The decision-making funnel.

in turn, limits and influences the technical design, which is basically a technical plan for fulfilling the functional design. The technical design is a blueprint for implementing the application. After the design has solidified (hopefully through the use of a prototype), the implementation phase is when that application is built. By this time, the decision-making is down to a limited context, focusing on how to implement the specific features and functions called for in the design. Once the application is implemented, testing verifies that the implementation was done faithfully to the design. Decision-making has by this time been reduced to what is basically checking and double-checking the quality of the implementation. Test plans are written based on the functional design, and defects are found and categorized. Support and maintenance are the direct result of releasing the application, and the magnitude of the support and maintenance phase will depend, in large part, on the quality of the testing and bug fixing.

> Multimedia applications must be viewed as software first and foremost. Only in this way can the development process, which is a software development process, be conceptualized. Those who consider multimedia something other than software just because it comes on a CD-ROM or over the Internet or because it contains digitized video, may be in for a rude awakening if they try to manage a multimedia project.

EXAMPLES

Electronic Slide Show

In developing an electronic slide show, the phases outlined above are generally compressed into a small amount of time, often only a week or two. Many of the early decisions in the analysis and planning phase are obvious, assumed, or easily made. The design is simple, in the sense that it is usually a linear presentation, although the graphical design may require some experimentation, as will the exact elements (text, video, audio) to be included on each screen. The technical design is usually of minimal significance, simply because most presentations are created with presentation software like PowerPoint. Implementation is the lengthiest phase, since creating the graphics and linking the screens is the most time-consuming part of creating the presentation. However, testing must be undertaken diligently and with significant time allowed.

Frequently, you experience unexpected difficulties during testing, especially if the program is created on one computer (the development machine) and then transferred to a different computer (the display machine) to actually give the presentation. Often, the development machine is different from the display machine. It may be a different brand or have different capabilities, such as memory size, processor speed, or graphical display characteristics. Although the program runs fine on the development machine, for one reason or another it may not function correctly on the display machine. In addition, quite often various

files must be copied into various directories, memory issues occur, and so forth. For some reason, unforeseen problems always seem to arise at the last minute, including incompatible projector display connections, missing extension cords, or even equipment that arrives damaged from shipping. Since most presentations have a fixed date and time, the application must be functioning perfectly by that date (with no room for schedule slippage), so adequate time must be reserved in the testing phase to fix any problems that may arise.

If the presentation is being given off-site, such as in a distant city, time must be allowed for shipping the display machine to that location, verifying that it arrived, and setting it up and testing it prior to the presentation.

Consumer Multimedia CD-ROM

A successful retail multimedia title can be a complex, time-consuming, resource-intensive project throughout the development process. With the heavy competition in the retail market, only the highest-quality titles with the best marketing and distribution have much chance of success. All the phases must be well executed. Adding to the complexity is that phases tend to overlap to a great degree. For example, it is not uncommon to find significant user interface design changes proposed late in the process, even during final testing. (This is not to be encouraged.)

The early analysis and planning phase is crucial to developing a product with winning sales potential. This includes researching competitive titles and their design and features, establishing a marketing and distribution plan, holding focus groups, and so on. Unless a title has some compelling design or content feature, it has little chance of success, especially if it is competing with other CD-ROMs in an already crowded field, like electronic encyclopedias. The workplan should be complete and carefully constructed in order to forecast needed resources, set milestones, and facilitate a high-quality design.

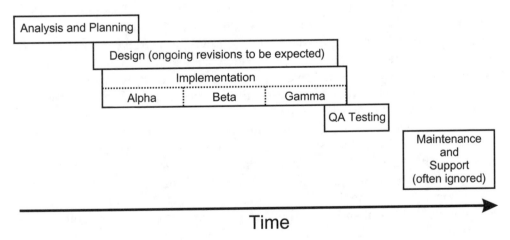

Figure 7.5 Phase diagram for electronic slide show.

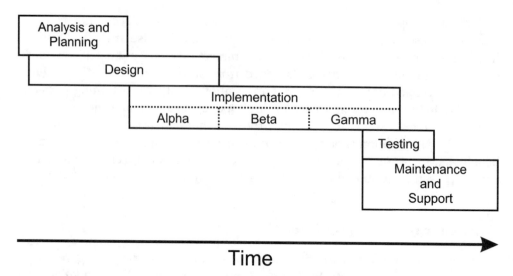

Figure 7.6 Phase diagram for consumer multimedia CD-ROM.

The design must present a visually appealing and compelling interface that can be implemented efficiently in the chosen development environment. The target machine, including the computer platform(s), and the minimum system configuration will greatly affect the technical design. Prototyping the intended application is also an important consideration, because of the sizable financial investment usually required. You must also feel certain that the design can be implemented in the scheduled time frame, or there could be serious financial consequences.

For example, imagine developing a CD-ROM about the Olympic Games, for which the optimal time to be selling it is the months leading up to, and during those games. Unless the program has been reviewed in magazines and is available on store shelves a few months prior to the Olympics, it will be a difficult sell, both to consumers and to distributors and store buyers. If production runs late, it will have a direct negative effect on the sales potential of the title. Therefore, development time must be carefully controlled. Adding to the pressure, if you are in the later stages of implementation—late beta, for example—and a competitive product is released, the temptation is strong to analyze that product and make design changes to yours. Making design changes at such a late stage, however, will inevitably destroy the original development schedule and budget and raise the chances of financial failure for the product.

Testing must start during the implementation phase, and the earlier the better (even with alpha, if possible), to allow sufficient time to fix defects. Consumer applications are often fairly complex engineering tasks, so they require much functional testing and should also be tested on a wide variety of hardware and software platforms.

Consumer multimedia applications are difficult, costly, technically demanding projects that are often underestimated by companies new to the software industry (such as print publishers).

Trade Show Kiosk

When creating a trade show kiosk, the emphasis is often on the early phases of development, with the later stages a (relatively) simple matter of execution. The intended objectives and goals of a kiosk application must be well defined and planned, since the criteria for success are often difficult to quantify. Usually, such an application is displayed in very controlled conditions, so testing is relatively less critical than, for example, a retail title that will receive use by potentially tens of thousands of users with a wide assortment of machines and computer skills. By comparison, a trade show kiosk uses dedicated hardware and is positioned in a monitored location (the trade show booth), where an attendant, demonstrator, or sales representative can offer support to the casual user.

The analysis and planning phase is essential, because the often ambiguous goals of the application require some quantifiable means of determining success. Often the goals and objectives need to be clarified, and any possible by-product uses of the program (such as for distribution to the sales force) considered, since they may affect the decision on the target platform. The workplan is important, if only to document certain assumptions regarding the responsibilities of the various individuals, sources of content and funding, and a description of the milestones, so the project's progress can be tracked and monitored.

Since the application is fundamentally a marketing effort, the design often needs to be approved by various people within the company, including not only the marketing and promotions departments but often senior management as well. Realistic expectations need to be set early, to prevent misconceptions from undermining the project's chance of success.

Once the design has been approved, implementation and programming are usually fairly straightforward, assuming feature creep can be avoided. Trade show kiosks often depend on visual appearance and artwork rather than the complexity of the underlying code and are usually not exceptionally complicated applications to engineer and program. Implementation, while perhaps not complicated to program, can be quite time-consuming in the data preparation area if emphasis is placed on large quantities of content, such as photos, artwork, video, and text. If testing is done concurrent with programming, it is generally not a major bottleneck. Since trade show kiosks generally emphasize data and content, testing can begin in the early stages of development, using sample data and content. In addition, the controlled environment in which the application is used tends to limit the testing requirements. If a touchscreen is used, the keyboard and mouse may not even be accessible to users, which can greatly decrease the range of possible inputs and, therefore, testing parameters. If the program uses a touchscreen exclusively, you don't have to test for random or unexpected keystrokes and key combinations. Occasionally, even late beta and gamma versions of the application can be used in a kiosk temporarily, with a final version installed upon completion.

Web Site

The development process for a Web site is similar to other multimedia development during the initial launch phase. However, it differs from other multimedia development in the significance of the maintenance task and the ongoing opportunity for incremental modifications and enhancements. Getting your company to agree on a design and having the design pass the approval of senior management can prove a significant undertaking. Various company departments, such as marketing, human resources, catalog divisions, training and development, may want or need to be represented on such a Web site. Obtaining consensus on exactly what is to go up on the site often requires long meetings with individuals from the various departments. For this reason, the analysis and design phases often take on a much greater relative significance than on other projects, along with the previously mentioned maintenance and support phases.

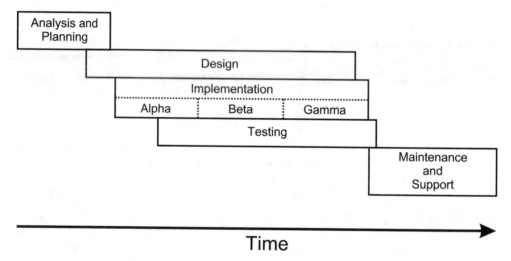

Figure 7.7 Phase diagram for trade show kiosk.

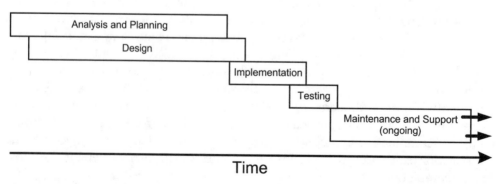

Figure 7.8 Phase diagram for Web site.

8

Analysis and Planning

The goals of the analysis and planning phase are to analyze whether the project is a worthwhile endeavor, determine program requirements needed for success, and create a workplan to accomplish the project. This analysis is a crucial step, and many of the reasons for the success or failure of a multimedia project can be traced to this stage in development. While exploring and analyzing the proposed application in this phase, many hidden issues are often uncovered that can pave the way for success.

Analyzing for Success

The analysis phase can determine the success or failure of a project. A good analysis will support and polish a good product idea and will spotlight the flaws in a bad idea. In fact, the analysis must be judged successful if it prevents a company from developing a poor product concept, because it protects the company from wasting precious resources and lets it get on to more promising projects more quickly.

At one company, we were all set to develop a large-scale educational astronomy CD-ROM until the analysis showed it would have little chance of market success. At first glance, the product seemed worthwhile, with high sales potential, and several of us wanted to develop it in part because of the interesting subject matter. However, during the analysis phase, it was found that the reading level of the existing text materials, on which the product was to be based, were too high for the intended audience of fifth-grade students. In addition, the competitive analysis showed that the market was already crowded with high-quality consumer astronomy CD-ROMs selling at extremely low prices, with which we would be competing. It was then decided to curtail development rather than invest hundreds of thousands of dollars with little chance of recouping the investment.

On the other hand, sometimes ideas that at first glance show little promise turn out to be ideal candidates for development after further investigation. A marketing kiosk that generates sales leads running unattended in a public place may

initially seem frivolous, until it can be shown that the value of the number and quality of sales leads generated is far in excess of its development and maintenance costs. In addition it may accomplish de facto advertising. Together, these reasons make it a worthwhile project to develop.

Companies that are in other businesses and seek to use multimedia for marketing or training generally view these applications as filling the same need as other non-multimedia projects, such as product brochures, magazine advertisements, telemarketing efforts, or the use of stand-up training instructors or video-based training. These other methods usually form the basis of comparison and evaluation. This is important for the multimedia developer to understand, since the budgets for multimedia applications will be compared to the budgets for these other activities and generally need to fall within the same ballpark. For example, if the company is accustomed to paying $20,000 to have a brochure designed, printed, and mailed, a proposal for a $250,000 CD-ROM could run into some stiff opposition, even if it is expected to be twenty times as effective. The company may simply be unaccustomed to paying such high sums for this kind of work. These budgetary parameters (resource factors) can have a significant effect on the kinds of applications that are developed and the designs on which they are based.

Criteria for Success

In addition to determining whether the project is worthwhile or not, one of the main goals of the analysis phase is to determine the criteria for success. These criteria can be quantitative and/or qualitative. It is important to know how the success of the application will be measured, in order to apply development efforts in that direction. If the criteria for success of a consumer CD-ROM is that it break even within a year, then development expense and delivery dates are crucial, and all efforts should be focused in that direction. On the other hand, if the criteria for success are more qualitative, such as to please the vice president of sales, then even if the application is delivered early, under budget, and performs flawlessly, it may be judged a failure if the VP is not pleased. Training applications frequently use behavioral objectives to measure success, such as efficiency of job performance by employees before and after training.

ANALYSIS

Evaluating Project Ideas

Ideas for multimedia applications can originate from almost anywhere—customers, potential users, management, product development personnel, even family members of company staff—and should be evaluated objectively, regardless of the source. These product ideas tend to take on a life of their own, especially in the minds of their creators. Just because an idea originated with senior management doesn't mean it is a good idea (or a bad idea). The important thing is to evaluate

the idea as impartially as possible by finding an agreed-upon measure of its value. If it seems to have merit, start refining it into a usable concept for more thorough analysis and market testing.

The first step is to verify the potential market and/or internal need for the application. To be successful, a great concept must fulfill a need. Without a receptive market, there is little point in developing the project. Doing a CD-ROM catalog of a company's product line is pointless if most of your customers do not have CD-ROM drives on their computers. On the other hand, if your company's customers are currently using the Web to access your competitors' catalogs on-line and place orders, a Web site for your company is probably worth considering when trying to verify the market need for a particular application. An important voice to listen to is that of a subject matter expert (often called an "SME" in the world of instructional design and training). An SME is an expert in the particular field that forms the topic for the application and often has the most realistic perspective on the potential success of an application. An SME might also suggest beneficial modifications to the product concept as well.

If you are one of the project advocates, try not to not let your own enthusiasm for the project blind you to its real chances of success or failure. If the project is worth doing, it will become apparent. If not, it is usually better not to do it at all, than to proceed with a project that has little chance of ultimate success. In fact, once it becomes apparent that a project stands little chance of success, it should be abandoned as soon as possible, to avoid sapping company resources and to let you get started on a new project with a better outlook.

If the initial analysis shows that the project is based on a good idea but is not quite viable as envisioned, it may be worth modifying the concept into one with a better chance of success—perhaps something that requires less investment to break even or implementing the project in phases, so it will start paying back on the investment earlier. These situations usually involve changing the requirements and/or the design. Stay flexible. You may originally have estimated that the project will take six months to complete, but management wants it in four (which is only 66 percent as much time as you need). Or the project is cost-estimated at $100,000, but management can only afford $50,000. Remember the three project factors of time, task, and resources. In both cases, the only room to maneuver is to change the design, so that the project can be finished faster, for less money, or both.

Gathering User Requirements

In the analysis phase, you need to find out if, or how, the project can be a success. This is done by communicating with the various people who have an interest in or may be affected by the project—including, but not limited to, potential users, decision-makers, those responsible for marketing and selling the product, and other stakeholders. This effort is real work and requires time and personnel—and, hence, funding. If funds are not available to do the analysis, any funds approved for actual development are likely to be wasted.

One of the most important tasks is to gather information about required product features—both high-quality information and a significant quantity of such information. Talking with one person in the marketing department for half an hour about what features he or she would like in a proposed CD-ROM catalog is not sufficient, even if that individual is the vice president of marketing. On the other hand, holding a day-long brainstorming session with half a dozen people in the marketing, sales, and telemarketing departments can give you a pretty good start in formulating design requirements. Not only do you hear various viewpoints, but the participants themselves often generate new ideas and may even arrive at a consensus regarding the priorities of various proposed features.

The most obvious place to start the analysis is with potential users. All manner of discussions and communications with them are valuable. Some of the most common methods are surveys (both mail and phone), focus groups, and individual interviews.

Surveys

Surveys, both by phone and by mail, are valuable for obtaining large, statistically significant amounts of data. With a survey, you can contact enough potential users to check the marketability of the proposed product and establish the relative priorities of proposed product features. You can expect relatively low response rates from mailed surveys, sometimes only in the 2–5 percent range. The length of the survey form or phone interview itself must be limited to what can be completed by the subject in fifteen to twenty minutes, and certainly no longer than half an hour. Beyond that, the response rate will drop off, because completing a longer survey is too time-consuming. In addition, the information received from a longer survey may be less reliable, as the subject's concentration wanes. The ideal survey is two to three pages of easily answered questions. It is also beneficial to provide some small compensation or incentive for the subject's efforts. The goal is to get valuable information quickly and let subjects go on their way.

Focus Groups

Focus groups are another effective way of obtaining feedback on a multimedia product idea. The traditional focus group is a highly structured affair run by a professional moderator, videotaped, and observed through one-way glass. However, you may not need to go to such lengths for your application, and if you can't afford it, less controlled focus groups are still valuable. Even informal gatherings of potential users can elicit valuable information. For example, if you were to analyze a potential educational application, it would probably be worthwhile to hold a discussion group (with coffee and doughnuts, of course) for teachers at a conference they happen to be attending. For a corporate application, you might invite a group of key customers at a trade show to your company hotel suite and get their thoughts on a new trade show kiosk concept. These informal "focus groups" may not have the same statistically significant value as a traditional, professionally moderated group, but they can provide an additional, convenient, low-cost alternative

with much value nevertheless. If you exercise a little foresight, focus groups can be a great source of information, and they are also helpful in finding individuals who might be worth calling back later for in-depth interviews.

Focus groups should be composed of potential users, as well as those with the authority to purchase the product (if it will be for sale). These may not be the same individuals. For example, in an elementary school, potential users may be the teachers and students, but purchasing approval may rest with others in the school administration, such as the principal. In this case, it would be ideal to hold three different focus groups: teachers, students, and school administrators. In this example, perhaps the input of additional individuals, such as parents, should be solicited. The types of individuals to include in the focus groups will depend on the application and its intended use, but try to get as varied a range as possible, in order to become aware of the various viewpoints and perspectives.

When holding a focus group, the key is to keep an open mind and try to maintain objectivity. This is easier said than done, because you usually have a stake in the outcome. Try to be aware of your own expectations and assumptions, which can easily distort the discussion and the subsequent interpretation of the results. It is helpful to have several observers present, so that observations and impressions can be cross-checked later to minimize the potential for biased interpretation. In addition, it is usually important to prepare a short questionnaire to gather baseline data on the participants prior to the discussion. This questionnaire should solicit not only their vital information (name, organization, address) but their personal histories and prerequisites. For example, if you were running a focus group of science teachers to discuss an educational application, you might want to know each participant's subject area specialty, number of years of teaching experience, grade levels taught, kind and quantity of computer equipment available in class and in the school at large, and other pertinent information. This is essential in interpreting the results of the discussion. Finally, it is often helpful to have some audiovisual aids available, such as an overhead projector for transparencies or an electronic slide show to help display materials to the group, especially any screen sketches or electronic prototypes.

Individual Interviews

Interviewing individuals in-depth is an invaluable means of gaining a more complete understanding of users' needs and wants. Often, issues are raised or identified through a survey or focus group but cannot be explored in that context for lack of time. An individual interview lets you gain a fuller understanding of a particular issue. For example, a feature thought to be a big selling point may receive a lukewarm response on the survey. In this case, you might find it worthwhile to interview one or two of the individuals in depth to learn why the feature is not more appealing. The feature may simply not fit their needs, or they may already use another piece of software to accomplish this task. The feature may be on the right track but does not go far enough, or possibly the description of the feature on the survey itself was misleading. Only by talking with a potential user in-depth can you learn the real reason.

Otherwise, you could easily make incorrect assumptions and include something extraneous in the requirements specification or omit something essential.

Individual interviews offer other benefits as well. By interviewing people in depth, you can learn many details about the intended users and their environments that help you see things from their perspective and enable better decision-making during the development process. Individual interviews can also be a good way to identify potential content and subject matter experts for participation in the project. A member of the target audience who really seems to know the subject and is easy to communicate with can be invaluable during development when content needs to be produced or prototypes and interim versions user-tested, or to help make other contacts. Often these people appreciate the opportunity to become more involved in developing a multimedia application.

Analyzing the Competition

In addition to getting feedback from interested parties, it is essential to analyze the competition. No product or service is sold or produced in a vacuum. There may be

Try to remain objective during the process of gathering user requirements. Regardless of how well things may seem to be going, you should take everything you hear with a grain of salt. Potential users are rarely experienced software designers and often cannot accurately envision the application being described; therefore, their responses may be clouded by wishful thinking or simple misunderstanding. It is difficult enough for an experienced designer to accurately envision an application from a printed description, much less for inexperienced potential users to do so. In addition, other factors may color subjects' responses, such as if they perceive some benefits from participation that influence them to be overly positive toward the subject or if they have some other hidden agenda.

During the analysis, try to get input from as many interested parties as possible. When discussing the idea of doing a multimedia product that will be sold, it is essential to get input and support from the marketing department. It is also important to get input from the manufacturing department (if your company has one), since it will be responsible for reproducing the product and may have suggestions or even requirements that could affect the design or packaging. Likewise, the product must be supported by a customer service group. If such a group does not exist, the issue of how customers obtain technical support will have to be decided early and weighed into the break-even equation.

For a trade show kiosk, it is important to talk with those who transport and install the trade show exhibits, to make sure it can be integrated into the booth and shipped safely.

For a training application, the initial input of SMEs is important, since they are knowledgeable about the content that must be taught and the environment in which the skills will be used. When developing a training application, SMEs should be involved throughout the development process to help make the application as successful as possible. The specific groups and individuals you need to talk with will depend on the kind of application and corporate situation.

direct competition for a product, such as another consumer title on the same subject by a competitive software publisher; or indirect competition, such as a print catalog that addresses the same need as a CD-ROM catalog under consideration.

If your competition is direct, in the form of another multimedia application that performs essentially the same function, make sure you plan a product that is superior in some important way. It is also worthwhile studying the competitive company itself, to determine if, given the right product, your company has the marketing resources and expertise to compete with the other company in the market. For example, other software publishers have the ability to create interactive encyclopedias of the same quality as Microsoft's *Encarta*, but how many of those companies have the resources to compete with Microsoft itself?

If the competition is indirect, in the form of non-multimedia products that address the same need, your product, to be successful, must provide the user with some compelling advantage. For example, simply converting a print catalog to CD-ROM may not be worth doing if the CD-ROM only provides the same information. In fact, such an application has an inherent disadvantage, in that to use it requires a computer, while the print catalog can be used anyplace, at any time. The application will probably cost more to produce than a print catalog and have lower-quality photos, because of the better resolution possible in print compared to computer displays. Doing such an application would be a poor choice.

However, if your CD-ROM catalog makes good use of the computer capabilities to do things that can't be done in print, such as running promotional video clips and letting customers sort through massive amounts of product data, perhaps even an interactive graphing utility to help make product decisions, it really might be worth doing in CD-ROM format, because it would pay off in increased sales.

In summary, there must be a *compelling* reason to do the project as a multimedia application, as opposed to in another medium, such as video or print. It is this compelling reason that we must provide through creative design.

Requirements Specification

A primary goal of the analysis phase is to identify and describe the application's crucial functions and features: what the application needs to be able to do. This is embodied in a document often known as the requirements specification. This document attempts to specify the requirements for a successful application and essentially sets the task factor of the project. For example, a particular presentation, to be successful, may need to be of a particular length, present certain subject matter, display photos of products described, and contain any other known or identifiable characteristics. A children's "edutainment" CD-ROM may need features and elements competitive with or superior to other products on the market (both software and other media). The requirements specification is crucial to the success of the application, because it is the starting point for the workplan and cost estimate, and later for the design itself.

Modifying the Requirements Specification

Once you set the requirements, it becomes much easier to predict whether the project has much chance of ultimate success and to reexamine and perhaps modify the project to increase those chances of success. Imagine that a project is cost-estimated at $500,000 based on an initial requirements specification. Imagine (for the sake of argument) that the other costs for marketing and sales and so on are equal to the development costs, making the total investment in the product $1 million. The analysis also shows that competitive products are being sold at retail at a $50 price point and that the publisher generally gets 50 percent of the retail sales price, giving you an expected return of $25 per copy, from which you must subtract $5 for cost of goods, which totals to $20 per copy sold. If the project cost $1 million and each copy makes you $20, you would need to sell 50,000 copies to break even. Is the market for the product big enough to support such sales? If not, one way to change the break-even point is to lower development costs by lowering the requirements, allowing the project to be done in less time or with fewer people. Given the previous situation, if development costs were decreased to $300,000, the project would cost $600,000 (theoretically) and would need to sell only 30,000 units in order to break even. In this way, the feature requirements can have a major impact on the success of the application.

Usually this reexamination and modification of desired features forces a fresh prioritizing of the features and helps identify what's needed (and only what's needed) to achieve the project requirements. Marginally useful functions and "nice to have" features accumulate quite rapidly on a "requirements" specification. These (often superfluous) features must be eliminated to avoid weighing the project down and decreasing the chances of successful development. Every additional feature increases real costs exponentially, since each additional feature must be designed, integrated, and tested in combination with the other features. The requirements specification should identify and include only those features and functions necessary to the ultimate success of the product, not those with the most vocal or high-ranking internal advocates.

WORKPLAN

Once the analysis has been performed, a requirements specification has been produced, and the project idea has been deemed worthwhile, the next step is to develop a workplan. A workplan is a document that essentially details the three factors of time, task, and resources for the particular project. The time factor is embodied in the project PERT and Gantt charts, milestones and development schedule. The task (what needs to be done) is derived from the requirements specification. The resources are the people, equipment, materials, and outside services necessary to develop the product.

Only by planning these three factors in detail can the full scope of the project come into focus. Envisioning the individual dimensions forces you to think

Cost

Number of (relatively equal) features

Figure 8.1 The cost to implement each successive feature increases exponentially, (not linearly).

Number of
features

Time

Figure 8.2 As the number of features increases, the time required to implement each successive feature becomes proportionately longer. The first few features can be implemented relatively quickly, but eventually, the time required to implement even one more significant feature takes inordinately longer because of the ripple effects.

through most of the issues and anticipate the details and concerns it will be necessary to deal with.

The format and content of the workplan will differ greatly from one project to another, depending on the specifics and complexity. The workplan may range from a single-page document (for a simple application like an electronic slide show) to a multivolume marketing, development, and implementation plan (for a

large-scale consumer CD-ROM). The plan should be as complete as necessary without being too detailed. Remember, the goal is not to create the perfect workplan, but to plan out the project in enough detail to foresee significant issues and deal with them. At some point the analysis must end and the development begin. In fact, sometimes, perfecting the workplan can become a way to actually procrastinate making a go or no-go decision on the project itself.

While writing and editing the workplan is primarily the responsibility of the project manager, the document should be viewed as a jointly produced document that represents the consensus of the various decision-makers on the project. The project manager will be in a much stronger position if all interested parties have had input into the workplan and agree with it than if it is presented for approval without their input.

In fact, the process of developing the workplan helps achieve this consensus. Putting it down on paper makes the assumptions and expectations more tangible and viewable, and subject to much less interpretation and misunderstanding, than concepts and descriptions that are simply discussed and agreed upon verbally. In this way, the workplan is actually a tool to help those involved develop a common understanding and agreement on how the project will be accomplished.

Time

The workplan should detail the time factor—in particular, the development schedule embodied in the PERT and Gantt charts and descriptions and dates of the milestones.

The PERT and Gantt charts are crucial in putting together a development plan, because not only do they force you to think about the different tasks and the workflow necessary, but they allow this information to be shared and discussed, and they graphically depict how you expect the project to unfold. They also provide a way to document the project's complexity to those who question the time and cost estimates.

The schedule is monitored according to milestone delivery dates, such as "alpha version delivered." These dates provide a way to track progress objectively and also provide achievable intermediate goals for the development staff to work toward, rather than simply some distant final delivery date.

To make effective use of these milestone dates, they must be well defined. This helps management understand in what stages the project will be developed and lets development staff focus on what needs to be accomplished to achieve those milestones. Including milestone dates and definitions in the workplan permits them to be examined, discussed, and modified if necessary and provides proof of the clear thinking that has gone into the workplan.

Task

When creating the workplan, the first step is to try to define the task in as much detail as possible. This means reviewing and expanding the details in the requirements

specification. Identifying the task at this level of detail provides the basis for laying out the other factors. For example, the initial requirements specification may contain a target hardware description and a list of perhaps two dozen features, with a sentence or two describing each. These descriptions need to be expanded and detailed so programmers, content producers, and data preparation staff can begin estimating the time and equipment needs to accomplish the task. For example, a requirements specification feature might be described as follows:

> *Video Access:* Access video from anyplace in program. The user needs to be able to view video appropriate to the topic and have access to all the video clips from any point.

While this is a perfectly valid feature requirement, it is not sufficiently detailed for a programmer to provide a valid time estimate. It doesn't inform at all regarding factors like manner of access, number of videos, or indexing scheme. After reviewing this feature with those who wrote it and possibly with potential users, the description might be expanded as follows:

> *Video Access:* On the toolbar, which is always present at the bottom of the application window, one of the buttons will be labeled "Video." By clicking on that button, the user will receive a new video window containing

1. a video controller,
2. the title of a video clip,
3. a scrollable list of video clip titles, and
4. a button labeled "return." The video controller will automatically display the first frame of a video clip appropriate to the topic being viewed on the previous screen. From the video window, the user can immediately and directly operate the video controller and view the video clip. The scrollable list will contain an alphabetized list of all twenty-five video clips available in the application. By clicking on one of the titles in the list, the user can bring this clip into the controller frame and play it as well. The return button will close the video window and display the previously viewed topic.

This description helps clarify the "Video Access" feature and ensures that everyone agrees this is a suitable implementation that fulfills the requirements for the feature. It also provides enough detail for a programmer to start estimating the time required to implement such a window and integrate it into the main application. The description also provides information to those involved in content development and data preparation that there will be twenty-five video clips and that they have to be linked in some way to the "topics."

Clarifying the requirements in this way permits the task to be defined at a more detailed level.

The target platform must be specified, as well as any restrictions regarding the software development tools, graphical design, audience demographics, and other information pertinent to the overall task. The resulting document is generally known as the Design Specification.

Resources

The resources required to develop a project include the people themselves (personnel), equipment they will need, outside services, and materials that will be consumed in the process.

Determining the resources needed and planning for them requires careful examination of the tasks involved, what it will take to accomplish them, what resources will be available when, and how to obtain resources that would not otherwise be available.

The starting point is the previously mentioned design specification, built up from the requirements specification. This design specification can be used to estimate the personnel time required to implement each feature. Try to consider all aspects for implementing each feature, including programming, data preparation, testing, and other pertinent tasks. The time estimates are best done by several individuals, independently estimating the same task for comparison. Then the estimates can be discussed in a group, if necessary, and a consensus arrived at. You should be especially careful with time estimates cited by programmers themselves. Programmers can be notoriously optimistic in their estimates, and sometimes project managers simply double a programmer's estimates as a matter of course. While this may seem extreme, more than one project has failed because the programming effort turned out to be an order of magnitude greater than originally estimated.

Personnel

Once the total time investment required for each job function for each feature has been determined, the estimates can be totaled for an initial view of the personnel requirements. This initial view is usually a rough approximation and does not include contingencies for unknowns and getting project personnel up to speed. However, it does help you start blocking out how many and what kinds of individuals will be required to develop the application, and for how long.

It is also helpful to consider whether these people will be existing internal staff assigned to the project, whether you will need to hire permanent staff, or whether you can use freelancers or contract personnel. Different kinds of personnel may require different approval processes. For example, reassigning permanent staff may require a commitment from management to make these people available. Hiring new permanent staff may require a lengthier approval process. Hiring consultants and freelancers may be more expedient, but the expertise they gain while doing the project will most likely disappear with them when they leave after the project ends.

Equipment

Different types of employees may require equipment from different sources. If permanent company staff are assigned, they will presumably have their own existing equipment to use. If they are new staff hires, equipment for them to work on will most likely need to be purchased. If they are temporary personnel, it might make more sense to rent equipment.

You must also consider what kinds of supplementary equipment it will be necessary to use or acquire, including computers capable of digitizing video, additional peripherals such as hard drives and printers, and various other hardware you may not currently possess.

Materials

Materials required will include everything from office and computer supplies, to software for people to use, to content that must be purchased. If you intend to use photographs your company does not own, there will be licensing fees. If you need to obtain data, it will usually be at a cost. Even if content or data is publicly available, there may be a hefty service fee required to obtain it.

Outside Services

Like all other resources, the outside services needed will depend on the specifics of the project. These kinds of services typically include CD-ROM mastering; video, photo, and audio digitizing, video production, music composition, outside testing, and other items you may not have the capabilities or resources to do in-house, or that may simply be more cost-effective or expedient to contract out.

Assumptions

It is also helpful in some part of the workplan document to state any assumptions you are making in creating the workplan. These assumptions may vary greatly depending on the nature of the project, including unresolved technical issues, staffing issues, and other items that may not be firmly rooted in certainty. The primary reasons to state these assumptions are to make sure everyone is aware of them and to protect yourself later in case the assumptions change or prove incorrect.

For example, you might state your assumption that certain critical staff members will be available to work on the project by certain dates, and if they are not available, then the schedule may slip. If this actually happens during the project, you will be able to go back to the workplan and point out this assumption, to which everyone agreed, and that was approved.

It is worthwhile to try to identify as many important assumptions as you can, in order to gain agreement that they are valid. Then the risk is shared by all, rather than just you.

Executive Summary

Finally, it is often worthwhile to include an executive summary of the project analysis in the first few pages of the document. The full analysis usually contains several levels of detail more than an executive may want for an overview of the project. The executive summary should be concise and no longer than a few pages. In such a form it is likely to be read, and the workplan considered and acted upon.

APPROVAL

Once the workplan is complete, the next step is to obtain official budgetary approval from the company's senior management. This is sometimes easier said than done.

The method of getting official approval to start (or continue) a project varies widely, depending on the organization and the application. A software development or publishing company in the business of developing and selling multimedia applications may have a well-defined procedure for taking a project from idea to completion. On the other hand, a company with an unrelated core business may have no formal (or even informal) mechanism to approve such a project and may even allow it to move forward simply by not stopping it.

Other companies may have ambiguous approval processes, such as a training company that provides instructor-led training but wants to start selling training CD-ROMs. If the company does not have an established method of considering and approving a multimedia application, such approval could be delayed beyond reason, if not indefinitely, despite huge potential benefits to the company.

Rogue Projects

If your project is not approved, it is tempting to try to "go it alone," without approval, using hours and resources allocated to officially approved projects. This is an extremely risky proposition for the people involved, and the risks can outweigh the potential rewards. First, it is difficult to keep such a development effort quiet. Not only do coworkers notice what's going on, but it's difficult for most people to refrain from discussing interesting new projects they are working on. In addition (in keeping with Murphy's Law), such covert operations are usually discovered by senior management at the most inopportune moments, such as when an important due date is missed on another project and senior management starts investigating the cause. If the rogue project actually makes it to a showable stage, then no matter how ingenious the application, management will certainly want to know why it was done without approval. Your own boss may even suspect you of attempting a power grab. So if you start significant development work without approval, you not only risk never getting the project approved, you may also risk your own job.

While there are rare cases in which a project is developed "off the charts" (and usually after hours) and results in a great success, these projects usually have a champion within senior management to shield the project from scrutiny and provide a suitable context in which to unveil it. Usually, the best strategy is to be patient and get official approval before you start applying significant resources to a project.

By the Way...It's Already Started

During the analysis phase, we are often focused on trying to get approval to start the project. However, what may be less apparent is that regardless of forthcoming

approval, the project has already begun. The time needed to do a proper analysis and requirements specification, including holding focus groups, working out budget estimates and break-even points, and prioritizing features, is significant. This start-up phase actually costs time and money, and while a project may not yet be officially approved, time and money are already being consumed during the analysis phase to prove or disprove the concept.

EXAMPLES

Electronic Slide Show

When doing the analysis for an electronic presentation, the issues of break-even price points, getting approval, and sometimes even cost estimates may not apply. Usually the presenter simply needs the presentation, and development costs are charged off to the departmental budget. In this case, the analysis leans heavily toward understanding the desires of the presenter in terms of length, style, and intended message. This will help greatly in designing the appropriate application, (including artwork and screen layout) and logistical concerns, such as presentation machine requirements, shipping arrangements, and arranging to have projection equipment available on-site.

Consumer Multimedia CD-ROM

The analysis phase for commercial multimedia titles usually focuses on the product's break-even point and, beyond it, profit potential. Focus groups and other means of gathering information will help identify features and functions that contribute to a salable application. Once the requirements specification has been determined and a cost estimate created, the cost of goods, marketing expectations, and sales projections will help management decide whether the project is worth building. Often, however, other reasons are considered when analyzing a consumer title, such as strategic positioning of the company within a market. It is extremely important to analyze competitive products and speak with their users. This detailed level of research also extends to the marketing, sales, and technical support issues, to create a full product development and marketing plan and thereby increase your chance of success.

Trade Show Kiosk

When performing the analysis for a trade show kiosk, a wide variety of factors must be taken into account, including business reasons for doing the kiosk, measurement criteria for success, and the environment in which it is to be used. Perhaps the most critical of these is the measurement criteria for success. Kiosks are most often used to attract attention to a product or service or convey customized information on demand. Often, therefore, few quantifiable benefits are available

to measure the success of the application. It is sometimes difficult to know for sure whether applications of this sort are worth the development time and expense, even after they are completed and in operation. It is important to establish the objectives of the project early, to know whether or not they have been met through the final application. The measurement criteria might be linked to items like product awareness. To determine whether a trade show kiosk has been successful in exposing people to a particular product, you might survey people exiting a particular trade show before the kiosk is used, then again after installation. The measurement criteria will depend on the goals and objectives of the kiosk in the first place, which should be derived in large part from focus groups, surveys, and interviews.

Web Site

The analysis phase for a Web site is crucial, because such a project can be not only expensive to develop but also to maintain. In addition, there must be some compelling business case for creating such a site. If the goals of the site are not clearly established, it can easily become a significant waste of time and money. Such goals can also be somewhat difficult to establish, given the number of individuals from various departments who tend to get involved in the decision-making process, each of whom brings his or her own set of expectations.

The two fundamental questions to answer are, "What are we trying to accomplish with the site?" and "How much is it worth to accomplish such objectives, on a yearly basis?" Only by answering such questions in a quantitative manner can you expect to develop a successful corporate Web site. The answers to these questions will determine the design of the site, the time frame in which it can be completed, and the cost.

9

Designing and Prototyping

Designing a multimedia application is an iterative process and consists of two basic portions: designing the user interface and features and designing the underlying software architecture to achieve that level of functionality. The design of the user interface and features can be referred to as the Functional Design. The design of the underlying software architecture can be called the Technical Design. Together, these documents comprise the design specification.

Design Process

The design process is the act of conceptualizing what is to be developed and then creating a description of it in appropriate form and sufficient detail to allow others to understand and build the product. In the process of documenting the proposed product, new ideas are generated, inadequacies are uncovered in the existing design, and the description is altered to accommodate these changes. In this way, the very act of describing the design concept influences and changes that concept, which is then described anew. For this reason, the design process is iterative, with continual changes to be expected (and encouraged, up to a point), based on increased understanding and conceptual refinement. When designing an interactive training application, for example, it may become apparent that a glossary button is needed on a particular screen. After incorporating it, it then occurs to the designer that if such a button is necessary on this screen, it may be useful on others as well. In trying to decide on which screens it would be useful, the designer may come to the conclusion that there is no reason to make this decision for the user—that in fact, a glossary button should appear on every screen. This could affect the user interface design, and hence the software architecture itself, by requiring a global toolbar. It is in this way that the act of describing the concept can influence that concept.

The iterative nature of the software design process means that the design must remain open to change until the end of the design phase (at least), the length of which is notoriously difficult to predict. While it is important not to rush the design process because of the many disadvantages of implementing an application

based on an incomplete or ill-conceived design, it is also important to not let it stagnate and lose momentum. If too much time is allotted early for user interface design, this can waste significant time and money, because it will invariably get modified again later. In addition, the nature of the medium usually requires design changes to be made (albeit in decreasing frequency and significance) throughout the development process, simply because it is virtually impossible to visualize from a print-based design exactly how the final application will operate. When you actually see the application running, you often find many things you want to streamline or modify, not to mention the avalanche of new design ideas that arrive unsolicited from everyone imaginable. The need for substantial design changes can be minimized, however, by doing as complete and well-conceived a design as possible from the very beginning.

The design process can be imagined as being located close to the wide end of a funnel that represents the whole development process. In terms of flexibility for decision-making and changes, the design phase is second only to the analysis phase and in large part sets the direction for most of what happens later in the project. This is where the final feature list is decided upon, visual treatment is planned, and screens, dialogue boxes, and button functions are specified, which all set parameters for the rest of the project—from staffing needs to development tools. Once the main design has been established and implementation begins, the funnel narrows further, leaving less room for modification and fewer design options.

Functional Design

The design process starts with the detailed requirements specification produced in the analysis phase and ends with the design specification. One major piece of the design specification is the functional design, which basically describes the user interface and function. The form and detail of the functional design will vary, depending on the application and development environment, but it is usually a detailed rendering of the intended product for the benefit of programmers, artists, software testers, documentation writers, and other team members, and forms the cornerstone document to hold the whole project together as the project moves through the remainder of the development process.

The functional design describes, in great detail, exactly what the application will look like and how it will function. It is not a description of how those functions will be implemented on a technical level (which is the purpose of the technical design). The functional design is usually handed off to the software engineer or programmer, who uses it to create a technical design. Since it is assumed that most readers are not software engineers or programmers themselves, the focus of this chapter is on the functional design rather than the technical design.

The functional design is usually a printed or electronic document that contains as much detail as appropriate for the project. A functional design for a feature-rich consumer application can run more than a hundred pages and contain

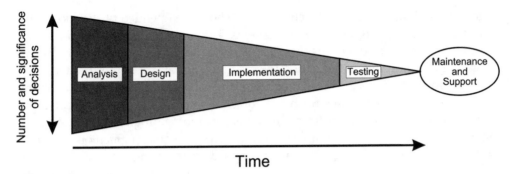

Figure 9.1 The decision-making funnel.

text, pictures, and flowcharts in a well-organized outline form. On the other hand, when designing a short electronic slide show, a couple of quick sketches of the screen layout and a listing of the text bullet points may be entirely sufficient. The details and length of the document really depend on the multimedia application itself, as well as the use to which the functional design will be put. If the functional design is to be used by a C++ programmer as a reference from which to develop a detailed technical design, it would be expected to be much longer and more detailed than a functional design being used to plan an electronic slide show.

Prototype

One important step in the design process is to create a prototype. By including the prototype in the design process, the designer gets a chance to virtually see the application before it is built and to try various design options before committing to a particular path. In this way, the prototype is part of the design process, not a way of simply validating the design after it has been completed. The prototype is usually done while the functional design is being developed and is a tool to help arrive at a sound functional design.

FUNCTIONAL DESIGN

The composition of the functional design will depend on the particulars of the project, but it usually contains text descriptions, flowcharts and diagrams, and screen drawings, all of which serve to define and describe how the user interface will function. In addition, the functional design should contain any helpful notes for the programmer that will make it more understandable or give clues as to how the design can be implemented. A complete functional design usually begins with a structural diagram, showing a "road map" of the program and how the screens are related. Each screen is given a unique identification number. All significant screens, windows, and dialog boxes are numbered and then sketched out on separate

pages. The individual screen sketches should show the intended button positions, drop-down menus, and other screen elements. The screen elements are then keyed to text descriptions or diagrams that describe the function of each element in sufficient detail. (Sample functional designs are given at the end of the chapter.)

The functional design should represent the collective vision of the key members of the development team. Such a vision is established through frequent, high-quality communication between team members, including programmers, designers, marketing individuals, editorial staff, and the project manager. Such open discussions and inclusive meetings, if established early in the design process, will bear fruit in the form of a stable and well-crafted functional design that can be implemented with maximum efficiency and a minimum of difficulty and revision.

As mentioned, the project and application will determine the details of the functional design. For example, a simple electronic slide show will usually not need an intricate design document. These applications are usually straightforward linear presentations containing mostly still-frame graphics. It may be sufficient to merely sketch out each screen on paper. On the other hand, a complex and feature-rich training application that keeps track of user scores, does interactive modeling and animation, runs motion video, and has other significant features should be documented in as much detail as possible to help the programmer accurately implement the desired design.

The description of features, and exactly how they are to work contained in the functional design is of paramount importance to the software testing staff. The software testers must create a testing specification or checklist, sometimes referred to as a test plan, to make sure they test every feature and function, every nook and cranny of the application. This test checklist is created mainly from the functional design. Therefore, every little twist and turn of the design should be described in the functional design document.

Functional Design versus Technical Design

The functional design is mainly a detailed description of the user interface—that is, how it looks and works. The technical design, which details the architecture of the underlying software program itself, is a different document, usually prepared by the lead programmer after the functional design has been approved. Sometimes, enough of the program functionality and user-interface design is known ahead of time to allow the lead programmer to start this technical design early, even before the functional design is finished. In general, however, the technical design is derived from the functional design. The technical design consists of specifications regarding how the software modules will interrelate and function at a programmatic level. This technical design is mainly the province of the programmers and software engineers and forms the underlying software architecture blueprint for how the user interface design will be implemented.

Other Elements of the Functional Design

In addition to a description of the program itself, the functional design may also include various other elements, such as the target hardware and platform, look and feel considerations, and content issues.

Target Platform and Hardware

The functional design includes a description of the selected target hardware and platform. It confirms in writing the specifications of that machine (hard drive space, RAM required, CD-ROM drive speed, peripherals required), as well as whether the intended hardware is a Macintosh, a PC, both, or some other platform. This is extremely important information for programmers to have documented. Only by documenting minimum system requirements can you make sure programmers are making the correct assumptions about the user's machine. If this is not documented, the programming staff may assume it is permissible for the application to run on one kind of computer, while the marketing department assumes it will run on quite another. For example, in the functional design of a consumer title being built to run on Windows, it must be specified what version of Windows, how much memory, what kind of processor, running at what speed, and so forth. Otherwise, the marketing department may assume the lowest possible machine to maximize market size, and the programmers a much higher-caliber machine (coincidentally identical to their own development machines).

This decision regarding target platform can have a major effect on the difficulty and cost of development as well as the salability and usefulness of the final application, ruling out or including whole groups of potential users. For example, in 1992, multimedia developers of educational applications had a tough choice to make regarding target application platforms. The market was divided fairly evenly between DOS machines, Windows 3.0 machines, and Macintosh. The DOS market had a huge installed base but was not a platform for the future. Although the Windows installed base was growing, machine turnover in kindergarten through high school is relatively slow, so DOS machines were not being replaced quickly at that time. Windows alone did not really have enough penetration into the school market to justify developing a large scale application exclusively for Windows. The Mac market was dedicated, but isolated and not growing. If you were developing a new application, it was a tough choice. To play it safe, you would have had to develop for all of them, which would have been quite expensive. Ultimately, as DOS faded away and Windows 3.1 became popular, applications available for Windows and the Mac succeeded, and DOS applications were ported or did not survive.

These decisions about target platform are important and problematic, and many applications have not succeeded in their first versions simply because they were developed for what turned out to be the wrong platform. In general, it is wise to lead the market slightly when selecting a platform, but stay with a proven platform.

The target hardware is the kind of computer system the application will be designed to run on. It is usually expressed as "minimum system requirements." This describes the minimum system on which the application will run without intolerably slow performance. As a rule, the lower the computing power and the fewer the resources of the minimum target system, the more difficult (hence time-consuming) it will be to develop. The fewer resources the program has to run with (smaller hard drive, less RAM, slower CD-ROM) the more difficult the programming task becomes. With smaller target systems, you often cannot use authoring systems, because the authoring system run-time program itself will take up RAM needed for data elements like video clips and graphics. Sometimes, applications can be written to be self-adjusting, so that they maximize their performance depending on the machine on which they are running. This can be done by techniques like copying fewer files to the hard drive and minimizing animation and video, to avoid data transfer, processing, and display bottlenecks.

Look and Feel

The functional design usually includes a description of the intended look and feel of the application. This helps the graphic artist designing the screens or anyone reviewing the design to visualize the application. In general, it is sufficient to describe the feeling or motif you are striving for, not necessarily the exact color scheme or background patterns.

Content Issues

The functional design should also address any outstanding issues of editorial content, including a listing of all the kinds of content, such as text files, photos, illustrations, maps, movies, and audio files intended for inclusion. Describing, itemizing, and totaling up this list constitutes a reality check on how feasible it is to do the application as intended. As previously mentioned, multimedia is really just software with an emphasis on the audiovisual content. Therefore, the graphics, video clips, and other audiovisual elements generally make up a large portion of the application. If they are specified early in the design document, no surprises should await the programmers or audiovisual production staff.

How to Do the Functional Design
Defining Features

The basic strategy for doing a new design from the beginning is to start with the functionality of the application, as defined in the analysis phase, and then look for ways to deliver those functions. Often, however, the designer would like to incorporate special features that may not have been identified in the analysis phase. When analyzing a trade show kiosk, for example, you may find that your survey respondents have not specifically identified the need for a database to look up product specifications. However, they may well have said they want specific information about products on demand, in an easily readable format. The use of a

database with various display forms may provide a much greater level of functionality than requested by potential users. However, the added time and expense to include data in a database format with the necessary search engine and display forms must be carefully weighed against the immediate needs of the audience. It's possible the database solution is actually the only viable way to deliver the required level of functionality. Or it may be that simpler text files would suffice, or perhaps a combination would be most cost-effective.

Based on the feedback from focus groups, interviews, and surveys, you can start working up a feature list with the features requested by various individuals. This list should include all features proposed, without prejudging their relative priorities, as in the following sample:

Sample feature list: trade show kiosk (unprioritized)

- Catalog of available products
- Ordering on-line
- List of sales offices by state
- List of sales offices by region
- List of sales personnel by product specialty
- List of offices by personnel
- List of personnel by offices
- Option to display or not display prices
- Attract mode ("splash screen")
- Seasonal reminder screens
- Keyboard input
- Photos of each product
- Text descriptions of each product
- Videos of products in action
- Touchscreen input
- Print out coupons
- Take names and addresses of potential customers
- Solicit names and addresses of potential customers
- Print out a graph based on information input by user

Using this list, the features can be prioritized, either by recontacting the same individuals or contacting new potential users. Prioritizing them helps you identify which ones are most important and can be realistically accomplished within the project budget and schedule, and those that should be left off or placed on a wish list for a future version of the product. This prioritizing of features is a delicate and important task, since the right feature mix is crucial to a product's success, and simply adding more features does not necessarily create a better or more marketable product. However, as the developer, you are not in a good position to prioritize the list, since your perspective is biased by many factors, such as the difficulty and cost of implementing particular features and perhaps who is advocating them. You

must strive for the most objective prioritization of the feature list possible, by interviewing marketing personnel, target users, editorial personnel, and other project stakeholders, and trying to establish a consensus for the relative priority of the various items. While it is rare to achieve perfect agreement among the various personnel about priorities, agreement can often be reached regarding what constitutes the top 25 percent of the features, which are crucial to the product's success.

The amount and kind of functionality the final multimedia application allows is a crucial factor (perhaps *the* crucial factor) in an application's success or failure. However, more is not always better, and an application can suffer from having too many features (sometimes called "feature bloat") as easily as having too few.

Overfunctionality in a design (too many features) can cripple a project by requiring too much work to be completed in a given time and by confusing users and obscuring the main purpose of the application. Every added function and feature increases the need for resources exponentially, because each additional feature must be integrated into the existing structure, both programmatically and within the user interface, and must be tested both independently and as part of the integrated application. One common cause of failure for multimedia applications is an overly ambitious design, coupled with feature creep during development. Adding significant functions and features late in the process has a harmful ripple effect.

In addition, too much functionality can also confuse and frustrate users by obscuring the core intended usage of the application. If users have to thread their way through an overbuilt and hence confusing application, it will be less enjoyable and more difficult to learn. This design defect can often be identified during demonstrations of the prototype to a focus group of potential users. Strict feature prioritizing and continued testing of the prototype can be useful in such situations, to prune an overgrown design.

A design that contains inadequate functionality will also be subject to problems, mainly related to its lack of usefulness to the user. While from a project management (budgeting and scheduling) perspective it is much safer to err on the side of simplicity than complexity, from a marketing perspective, inadequate functionality can be fatal. This inherent conflict can require trade-offs, compromises, and creative solutions that often ultimately benefit the product.

From Paper to the Screen

Usually, the designer starts working on paper, sketching screens, drawing flowcharts, and writing descriptions of the various functions and features. Once the first usable design has been generated, the ideal course of action is to create a prototype and start getting reactions from potential users. While the prototype is usually done electronically, sometimes paper-based prototypes are useful and effective in the design process. Whichever method is used, it is important to get feedback early from potential users, and a working prototype is much more meaningful and easily understood than a printed description. It is hard enough for designers and developers themselves to accurately imagine a product based

on the printed description, much less the typical potential user with no technical background. Starting with the first session in which the prototype is demonstrated, many beneficial changes will become apparent. Those changes are then made to the prototype, and it is retested. After enough iterations, the feature set and basic design are established, and the functional design can be completed. The prototype itself can also be a reference to help describe the design in the eventual functional design.

Advantage of an Ambitious Schedule

When designing an application, the designer must always work within restrictions and parameters—most commonly, time and money limitations. While there usually isn't enough time and/or money to do projects as we would like, these limits can actually benefit a project indirectly, by keeping it moving along. By its nature, the design process has no inherent end, and unless it is limited by external parameters like the schedule or budget, it can go far beyond the point of diminishing returns. For this reason, an aggressive schedule is not always a hindrance (assuming it is within reality to achieve) and can sometimes be beneficial, by forcing decisions and helping drive development forward. While you must be certain you have a workable design, remember, the design itself is merely a means to an end, not the end in itself. No one gets the design exactly right the very first time in the design phase. You need to recognize that the design will inevitably change as the project moves forward, and the most important thing is to start prototyping, make revisions until it mostly satisfies most of the users, and document it in the functional design, rather than debating the finer points and polishing the user interface design for months on end, past the point of diminishing returns.

Approval of the Functional Design

Finally, the functional design must be approved by an individual with sufficient corporate rank to allow production to proceed without being second-guessed later. One of the most frustrating situations in development occurs when the functional design has been approved by one individual in management and is then changed during final testing by that person's boss. You must make sure the person approving the design has the necessary authority to do so without being second-guessed or overruled later.

PROTOTYPE

A prototype is an early, test model of the intended application. It is not the first version of the program itself, but rather a *representation* of the intended program (or some aspect of the program), much like a scale model is not the first real version of the building it is intended to represent.

The need for a prototype is a significant difference between multimedia applications and video and print products. While a prototype has superficial similarities to a first, rough edit of a video, it also has crucial differences. The video rough edit is intended to be modified eventually into the real thing, while the software prototype is simply a design tool that may go through vital structural changes many times and is then eventually discarded before the real application is built. A prototype can be modified with impunity and is a tool used to arrive at and help describe the final intended design. If it can actually be turned into the final application through careful selection of a development tool, so much the better. However, that is not the primary intent. The main use is as a sketch pad to make sure the design is on the right track and enable you to make corrections and adjustments without incurring long-term cost.

The ideal situation (and one that rarely occurs) is when the application can be built directly from the prototype. If a designer has built a prototype in Visual Basic or Macromedia Director, a programmer might possibly be able to take it over and build up the actual application, starting where the designer left off. This is ideal, because theoretically no effort is wasted between prototyping the design and actually implementing the application, as usually happens. However, this situation rarely occurs, because the underlying software architecture for a final application is usually much different than for a mere prototype. In addition, few tools are both easy enough for a designer to use for prototyping and powerful enough for a programmer to build up a significant application.

Discussing a prototype with employees in other departments (specifically the manufacturing department) may give rise to a misunderstanding as to what the term "prototype" means. In the traditional manufacturing process, the prototype is a sample product for proving out and refining the manufacturing process. It is a model used to figure out how to manufacture the real item. This is different from what the term refers to in software development, where the prototype is used for design purposes and is continually changing and being retested.

Kinds of Prototyping

The kind of prototyping done depends on many factors: the application, the skills of the designer, and the availability of programmers, to name a few. For an electronic slide show, the prototype can be considered either the paper-based rendering of the screens prior to production or a first version of the presentation with rough graphics in place. In a trade show kiosk, a designer with some technical aptitude may develop a demonstration version in an authoring system like Macromedia Director before the programmer implements the final design in C++. In a complex consumer application, in which the programmer is working on the project from the beginning, the prototype may be a pseudoprogram (or "shell") developed by the programmer in C++ prior to coding the real application once design has been finalized.

Paper Prototypes

Not all prototypes must be built in software. One time-tested method is to create a paper prototype. This consists of paper-based samples of the screens and data in the program. Each sheet of paper represents an individual screen, with smaller cut-out pieces representing windows, dialog boxes, and so on. This kind of a prototype can be valuable for several reasons. First, it doesn't require a programmer to build the prototype. Just about anyone (a nontechnical designer, for example) can do it with standard office supplies. Second, the prototype doesn't get mistaken for the application itself, which is a common problem encountered with prototypes: designers and developers get carried away, and without realizing it they start investing time creating the actual screens, writing routines to process data, and other real programming tasks, and are then loath to change it as the design is modified. Third, potential users easily understand that what they are seeing is a representation rather than the real thing and are quick to make valuable suggestions. Finally, simply sketching your ideas on paper is so quick and easy that it lends itself to the iterative and experimental process and allows you to try out many more ideas than might otherwise be possible. If you don't like a screen, throw it in the wastebasket; if you want to try something new, sketch it on a piece of paper. You can even cut and paste on top of the original and then photocopy the combined screen. With such easy revision, the design can be greatly refined and polished. Finally, if the designer has little programming aptitude, it is generally less expensive to do a paper prototype than an electronic one, because you don't need a programmer to implement the prototype itself.

Paper prototypes are handy when the application is relatively simple, starting with an electronic slide show. Such a presentation can be "prototyped" using individual sheets of paper corresponding to the frames of the slide show. These can be redrawn and reordered with virtually no ill effects. Likewise, a simple trade show display with a few simple modules from a main menu is easily prototyped on paper. However, where paper prototypes start to become cumbersome is in large, complex applications, where it becomes difficult to manage and cross reference all the proposed screens, data, content, and dialog boxes, and where a highly dynamic level of interactivity is intended (computer games, etc.)

Prototyping Tools

Various pieces of software are sometimes referred to as "prototyping tools," including visual programming languages like Visual Basic (Microsoft) and authoring systems like Authorware (Macromedia). The fact that these systems are sometimes referred to as "prototyping tools" reflects both the fact that they can be used to create effective prototypes easily, and that some "real" programmers (usually C and C++ programmers) do not consider them strong enough tools with which to develop full-fledged applications. This may or may not be the case, depending on the application. These tools are plenty strong enough for many significant applications; in fact, many successful multimedia applications have been written with these

programs. In addition, they let you begin piecing the program together extremely fast, and the results are immediately showable for user feedback.

Defending Prototypes

When a project manager begins developing a prototype, there are sometimes voices of dissent. Management may consider it a frivolous waste of time and money. Programmers may not want to "waste" their time building an electronic prototype when they think they could be building the actual product instead. Designers may believe they already know exactly what the user interface should look like and what features are needed. Yet in hindsight, when prototyping is a part of the development process, we often remember thinking, "We could never have done this without a prototype." And after finishing a program in which a prototype was not done, developers often concede that perhaps if they had done one, it would actually have saved them much time and aggravation, due to re-work caused by the need for design changes that became obvious once the application was up and running. These same design flaws would easily have been caught by a prototype early in the design process.

There are many reasons for doing a prototype, including visualizing what has been designed on paper, permitting accurate design approval, showing it to potential users for feedback, demonstrating progress to management, providing a form of cheap insurance, and, in some cases, testing out the proposed development tool itself.

Visualizing

The greatest individual value of doing a prototype is as a method of visualizing on-screen what has been designed on paper. It's hard enough for experienced people, including the application designer, to accurately visualize an application in detail, much less others with less experience designing multimedia applications. Only by creating a mock-up, a scale model of the application, can others who need to become acquainted with the program get a mental image of how it will look and function. Those who need this mental image may include management, sales, and especially potential customers.

Design Approval

A helpful and significant byproduct of creating a prototype is avoiding the "Well, you approved the design" syndrome, in which management expresses dissatisfaction with an application when it is virtually finished. A prototype is an effective way to get early input (and buy-in) from management regarding the proposed design. Good design ideas can come from anyplace, and a prototype can be a great way for management to participate in the design process.

A common and frustrating situation occurs when a voluminous, print-based design is submitted for approval to upper management and they give it a cursory

approval with hardly a glance between the covers. They may be simply too busy to try to read and understand the whole thing. However, a busy manager who hasn't got the time to read and review a full, detailed design proposal will often find time to view a working prototype. Not only is it quicker to do so, it is much more fun than wading through a fifty-page functional design document. Using a prototype in this way is a good method of getting meaningful input from management on the proposed design. If you're going to get that feedback eventually anyway (and you surely will), it is much better to get it earlier in the design process rather than later during the final stages of the implementation phase.

User Feedback

Another major benefit of doing a prototype is that it is a great way to get input from potential users. Prototypes are invaluable tools to put in front of potential users at focus groups and individual interviews. If it is difficult for management to understand and imagine an application from a paper-based design, it is almost impossible for potential users. Yet these potential users are the very people who may have some of the best input and design suggestions. They will often give frank feedback about the features and user interface. A prototype is therefore an excellent tool for flushing out hidden user interface issues and problems before they get built into the first version of the actual software.

Sometimes, based on feedback generated by the prototype, it becomes apparent that the application simply is not as useful or salable as expected and that perhaps the project should be canceled. You would have expected to find this out earlier, in the analysis stage, but for various reasons it may not become apparent until later. Imagine that a book is being used as the base content for an educational program for third graders. When a prototype containing sample text is shown to real teachers, they mention that the text content is fine for sixth graders but too difficult for their third-grade class. A "minor" detail like this can easily be overlooked in the analysis phase. If the prototype had not been shown to an audience of potential users, the whole application could easily have been built with this inherent flaw and be ultimately unmarketable. At the very least, identifying such issues generates discussion and forces a decision. Whether that decision is to change the target market, to use a different text base, or to scuttle the project altogether, the prototype has saved the day by raising such a significant issue. It's much better to deal with these issues immediately rather than after a year of development and an investment of perhaps hundreds of thousands of dollars.

Demonstrating Progress

Another valuable use for a prototype is in demonstrating progress to management. While this may seem unnecessary, it can actually be a helpful rear-guard action to maintain upper-level support for a project. If a project is approved, design work begins, and after two months all there is to show for the work being done is a stack of paper called a "functional design," upper management may

start questioning whether anything is really getting done. If, however, an actual onscreen prototype is made during this time, it can be shown, and demonstrates real progress. Such prototypes have an almost magical ability to impress (especially if the artwork is pleasing), sometimes even to the point of turning doubters into supporters. In fact, management may even start requesting that the prototype be demonstrated in their meetings. While this may seem like an inconvenience, it is actually a high compliment and an ideal opportunity for the project manager to raise the visibility of the project. It also means management is buying into the project.

However, without a prototype there is no chance for this political windfall. Remember, it is always better to have something to show, even if just a few screens linked together, than nothing. For this purpose, it matters little if the prototype is up-to-date compared to the latest design modifications. What matters is having something tangible to show for all the work that has gone into the design phase.

Cheap Insurance

Occasionally, there is resistance to doing a prototype because it is "too expensive" or "a waste of resources" or some other reason indicating that a more effective use of resources would be to just get on with programming the application. However, prototypes are actually cheap insurance, and usually insurance that is ultimately collected upon. The most expensive risk to software development comes from significant design changes that occur late in the implementation phase. The prototype safeguards against this by letting you make fundamental design changes early and test these solutions ahead of time.

The later a design modification is introduced, the more expensive it is to implement. It follows that the goal of the design phase is to create the most complete and well-tested design possible, to minimize changes later. While the ideal state of "no changes" is rarely accomplished, it is really a matter of degree. The fewer changes that are introduced and the earlier they are introduced, the less expensive they will be and the sooner the application will be finished. The use of a prototype generally reduces the number of late changes.

Testing Development Tools

Another potential benefit to doing a prototype is in testing a proposed development tool. Occasionally, you may be unsure what development tool to use. Often the question is between using an authoring system and a programming language. In general, the simpler the application, the more appropriate it is to use an authoring system, like PowerPoint for an electronic slide show or Macromedia Director for nonlinear applications. However, for more complex and technically innovative multimedia applications, programming languages are more appropriate. If there is a question about whether a particular tool is up to the task, it is

sometimes useful to try building the prototype with that tool. This lets the programmers learn by direct experience, before committing to that tool to develop the actual application. The limitations of such a tool usually become apparent soon enough, and if it is inadequate to develop a simple prototype, it will most likely not serve as a real development tool.

How to Do a Prototype

The goal of doing a prototype is to create a "scale model" that can be demonstrated, easily modified, and then demonstrated again. The main thing to remember is that *it is only a prototype*, so keep it simple. The goal is not to build the application itself! This may seem obvious, but as a prototype takes shape, you may find yourself actually building real functionality, which is a great waste of time if the prototype is to be discarded sooner or later.

Represent Features

The prototype is only a representation of the intended application. It will have a diminished level of functionality compared to the real application. The intended features need to be represented but not actually functioning. In general, a prototype should contain dummy screens and sample features. You need to be able to make fast changes to the prototype, and the simpler it is, the faster you can make such changes. In addition, a programmer or designer who spends time implementing functions in a prototype may subtly, even subconsciously, resist making changes to it (which defeats the purpose of doing a prototype in the first place). With the prototype, you must be at complete liberty to modify or delete any or all of the existing design in the experimentation needed to reach a final design.

Try to avoid implementing any programming-intensive features, like live list boxes, real data modeling, and so on. The goal is not to make a perfect prototype but to arrive at a viable functional design. Remember, the prototype is simply a disposable tool to help you get to that point. However, there is one notable exception:

Real Artwork

One element of the prototype in which it may be well worth investing significant time and effort is the screen design and artwork. While simple line drawings may suffice in the beginning, it is helpful to let a graphic artist invest time and energy in the screen artwork, even for the prototype, for several reasons. First, effort invested in artwork is generally not wasted. The prototype screens can often be used as-is in the final application. Second, "seeing is believing," and high-quality artwork is key to an impressive presentation. If the prototype is going to be used for that purpose (to show to target users, and management), appealing artwork will pay dividends. Third, artwork is exceptionally hard to visualize, and it can take much experimentation to hit upon the right look and feel. This

aspect cannot be well prototyped. The better-looking the graphics, the better the prototype will be received. High-quality artwork will not only show the prototype in the best light, it will give you a head start in developing the look of the final application.

Open to Testing

When doing the prototype, it is important to remember that the whole design is open to question. At this point, any design modification or proposed modification should be considered, and that consideration should not be based on the difficulty required to modify the prototype itself. The most important thing at this stage is to get ideas into prototype form and test them on potential users. Everyone has strong opinions on user interface design. The only way to find out which ideas work best is to try them out on potential users.

Keep It Simple

It is ideal to allow the prototype to go through several iterations and therefore make several versions of the prototype, but with a complex prototype this can get expensive. Therefore, it is important to keep the prototype simple. The more elaborate it becomes, the less likely you will be able to easily change it, because of all the time and energy invested in it.

It is also important to limit the prototype to what can actually be implemented in the final version. (As they say in video production, "No pink elephants.") Since the prototype is simply an imaginary representation of the application, a prototype could easily depict features that are difficult or even impossible to actually program. For example, you could easily create a dummy screen showing some sort of elaborately rendered three-dimensional object floating in a virtual-reality universe, but the chances of actually having this programmed and running on the target machine may be practically zero. Many prototypes have caused trouble later for developers by raising expectations beyond what is realistic to accomplish. For this reason, it is helpful to have the programmer involved in the prototyping process, to inject a measure of reality into the representation of features depicted.

Prototyping Tool Affects the Design

If you are using a prototyping tool that is different from the eventual programming language (which is normally the case), another problem may arise. The prototyping tool will give you the capability to do certain things or may prevent you from doing things, either of which then becomes part of the design, regardless of what can be achieved with the final development tool. In this way, the design itself may be altered to accommodate the prototyping tool. For example, if the prototype is done in Macromedia Director and the real application is done in C++, there may be things Director cannot do, so those things will not be included in the prototype or the eventual design, despite the fact that C++ could handle them easily. In this

way, the prototyping tool can have a major influence on the final design. This is another reason to have your programmer or software engineer participate in the prototyping process.

The design phase in general, and the prototype in particular, is when you get to modify and try new features, so take full advantage of the time and explore as many ideas and solutions as possible. This is the least expensive time to make changes. The cost in time and money to make changes grows exponentially from this point on, so try to make sure the design is as final as possible, and avoid late design changes.

TECHNICAL DESIGN

The technical design varies widely, depending on the application, from nearly nonexistent in a linear electronic slide show to a set of documents that can fill several notebooks for a feature-rich consumer application. The extensiveness of the technical design depends on the complexity and originality of the application as well as the development tools. Applications created with authoring systems tend to need less detailed and exhaustive technical designs, because most of the real programming has already been done in the authoring system. Those done in programming languages such as C++ are more detailed, because of the amount of new code that must be engineered and implemented.

The technical design is a document showing how the application is to be (or is being) constructed. It helps divide the application into modules and thereby allows the programmers to "divide and conquer" the workload. Not only is it important for the original programmers to document for their own reference how the application is being built, but it provides a way for future programmers to pick up on the work later for maintenance purposes.

The technical design should incorporate whatever elements are needed to specify how the application is to be built. It should describe the development environment, including the hardware, platform, and any development tools or equipment used. It must describe all the software libraries, utilities, and tools used and the software architecture, division of modules, how data is exchanged between the modules, and the format of that data.

As things evolve, the technical design should be updated to keep it current. As the product is implemented, the technical design can be augmented with commented source code, so that by the time the application is completed, the technical design comprises a collection of detailed technical documents describing the completed application. In fact, it is often a good idea to take some time after product release to clean up and complete the technical documentation and design, so that future programmers who may be maintaining the product can find the information they need, and that the information is accurate.

The Programmer in the Design Process

If the programmer can be assigned to the project full time during the design phase, many benefits will be obtained, including shorter development time, better decision-making, and faster prototyping. However, programmers tend to be in high demand, and it is seldom the case that they can be assigned to a new project full time during the design phase. Management may think a programmer can easily be phased into the project once the design is done. In practice, however, you should try to include the programmer in the design process as much as possible.

A programmer able to participate in the functional design of the application can bring expertise to bear during this most important decision-making phase and help the project avoid significant technical pitfalls. The programmer can warn about features that may appear in the design but be technically difficult or impossible to implement, and propose viable alternatives. In addition, the discussion and design work is helpful to the programmers themselves, because they become privy to the reasoning behind design decisions and will be better able to make appropriate software architecture decisions. This has great long-term benefits in the form of development time.

Programmer as Part of the Team

Finally, by being included early in the development process, the programmer is seen by others as an integral part of the development team and will start identifying with the successful completion of the project. This is an important psychological consideration in establishing a well-functioning development team. A programmer who does not feel like an integral part of the development team has little psychological stake in the outcome of the project. Since the programming is the key to the development process, an uncommitted programmer can easily derail a project.

EXAMPLES

The following are sample diagrams and explanations from the four case study examples. These are meant to show what the design documentation might look like for such applications. Design documentation varies greatly, depending on the needs of the application, personal preferences of the individuals involved, and many other factors. The materials shown here are conceptual design sketches, done in Microsoft Word. They represent initial design concepts, prior to review and input from an artist. They are not meant to be finished design documents but are rather the kind of initial functional design used to generate discussion and provide a printed reference from which to discuss design elements.

Electronic Slide Show

The following is an example of the initial screen designs for an electronic slide show for a psychological counseling service. Each sketch represents an individual slide.

Midwest Guidance Center

Helping Our Patients Help Themselves

Our Mission:

"To Listen, Discuss, and Explore with our patients so they can take control of their own lives and achieve true independence and happiness."

Figure 9.2 Slide #1.

Midwest Guidance Center

Range of Services

1. **Family Counseling**
2. **Drug Abuse Therapy**
3. **Career Guidance**
4. **Marital Counseling**

Figure 9.3 Slide #2.

Midwest Guidance Center

Range of Services

 1. *Family Counseling*
 2. **Drug Abuse Therapy**
 3. **Career Guidance**
 4. **Marital Counseling**

Figure 9.4 Slide #3.

Midwest Guidance Center

1) Family Counseling

- *Historical analysis*
- *Single fee system*
- *Art therapy*
- *Extended Family issues*

Figure 9.5 Slide #4.

Consumer Multimedia CD-ROM

Target machine (minimum system requirements)

CPU: Pentium 100, 65 mHz
Operating system: Windows '95 and Windows NT

Memory:	16 megabytes
Free hard drive space:	5 megabytes
Video display:	16-bit color (thousands of colors)
Audio capabilities:	Windows-compatible 16-bit audio
Peripherals:	CD-ROM drive, audio speakers

Global parameters

- This is a non-windowing application. The application will take over the display and fill up the window. However, the user can toggle between the application and other applications using the Alt/Tab key combination.
- All buttons and hotspots will highlight or depress when selected.
- Rollover labels will be used to identify the function of all buttons and hotspots.
- Aesthetic: The overall appearance is intended to convey a clean, modern appearance (e.g., shiny metal over rich, curving lines).
- Audio: Audio reinforcement will be used throughout, and sound effects upon button selections will contribute to and enliven users' experience.

Screen #2 is the Search for Information screen. This module allows users to search through the content in the application in four ways (Word Search, Topic Search, Alpha Search, Media Search). After a search has been made, titles of media elements that relate to that search are listed in the Search Results window. The user then clicks on the item of his or her choice, and it is displayed in the Media Display window. It can be manipulated using controls and scroll bars and can be printed out.

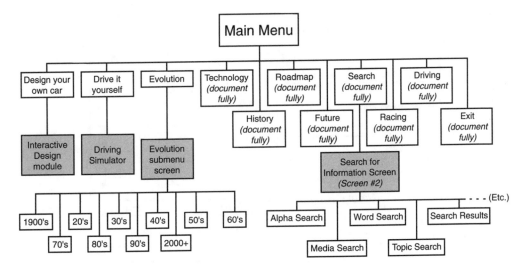

Figure 9.6 Module diagram (*not fully documented*).

Screen #1: Main Menu

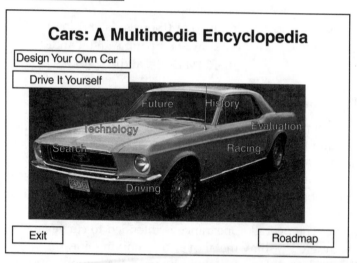

Figure 9.7 Headlight hotspot (Search): Clicking on the headlight invokes the Content Search dialog box (see Screen #2), which provides random access to article and multimedia content. Engine hotspot (Technology): Clicking on the engine takes the user to the Technology module (Screen #3) [not shown in this example], which provides information on automobile technologies, including design and engineering processes. Front window hotspot (Future): Clicking on the front window takes the user to the Future Developments module (Screen #4) [not shown in this example], which provides information and multimedia elements regarding expected developments in automotive use, design, technology, and manufacturing methods in years to come.

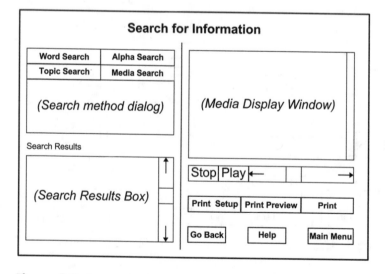

Figure 9.8 Screen #2: The Search for Information screen.

Inputs consist of the following:

Figure 9.9 Word Search (screen 2a): Brings up this special dialog window in the Search Method dialog box.

Figure 9.10 Alpha Search (screen 2b): Brings up this special dialog window in the Search Method dialog box.

Figure 9.11 Topic Search (screen 2c): Brings up this special dialog window in the Search Method dialog box.

Media Search: Choose a media type below
Text Articles
Video
Illustration
Photographs

Figure 9.12 Media Search (screen 2d): Bring up this special dialog window in the Search Method dialog box.

Trade Show Kiosk

System requirements

CPU:	Pentium 130, 100 mHz
Operating system:	Windows '95
Memory:	32 megabytes
Free hard drive space:	1 gigabyte
Video display:	16-bit color (thousands of colors)
Audio capabilities:	Windows-compatible 16-bit audio
Input device:	Touchscreen (only)
Peripherals:	Audio speakers

Global parameters

- This system is intended to be housed in a kiosk enclosure build into the exhibit booth structure.
- The system will be dedicated to running this application, and the application will occupy the entire display, with no pull-down menus.
- When powered on, the system must automatically boot up and run this application.
- Aesthetics: The program should convey an image of stylish reliability. Suggested motifs include decorative brick and carved stone or polished brass and greenery.
- The system must be instantly understandable and usable by even the least experienced user.
- The system should proactively occupy the user for a period of 5–10 minutes to allow a salesperson to get free and begin soliciting the customer directly.

Note: Screen #2 is a template screen, which displays photos, text, and other data related to a specific home. The screen layout for each home is identical.

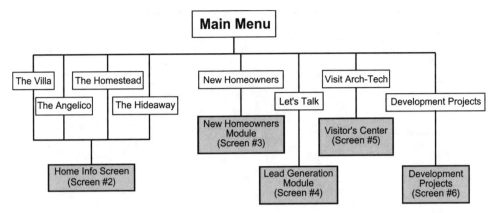

Figure 9.13 Basic flow diagram.

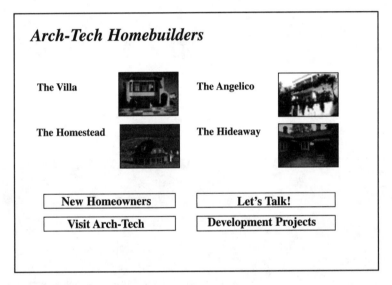

Figure 9.14 Screen sketches and descriptions.

- The Villa: Displays informational screen (screen #2) containing Villa data
- The Homestead: Displays informational screen (screen #2) containing Homestead data
- The Angelico: Displays informational screen (screen #2) containing Angelico data
- The Hideaway: Displays informational screen (screen #2) containing Hideaway data
- New Homeowners: New homeowners module (screen #3)
- Let's Talk: Lead generation screen (screen #4)
- Visit Arch-Tech: Visitor's screen (screen #5)
- Development Projects: Video gallery of construction (screen #6)

Figure 9.15 Initial Web site home page design. Please note sparse design, lack of decorative effects in initial functional screens.

Figure 9.16 Initial Web site functional screen design for "General information" link on previous screen.

10

Implementation, Stage 1: Alpha

Once the design specification has been created and approved, the implementation phase can begin. The implementation phase usually falls into three basic stages: 1) the first full implementation of the original functional design; 2) modifications and changes based on usability testing feedback, whereupon the functional design is frozen; and 3) final programming and data preparation. These three stages can be referred to as *a*lpha, *b*eta, and *g*amma. They may be carefully delineated with milestones and deliverables or they may blend into each other, but most applications seem to pass through the three stages in one form or another. In this chapter, we will look at alpha.

What Is Alpha?

"Alpha" software is a term that can mean different things to different people. Here, we will use it to refer to the phase during which the first complete implementation of the code takes place, which results in the "alpha version" of the application.

The accepted alpha version contains full (or nearly full) functionality and is the end result of the alpha development phase. This version of the program should be functionally complete. Although it may not contain all the final content and is often not rigorously tested for software defects, the alpha version represents the first overall completion of the program functionality.

THE ALPHA PHASE: WHAT TO DO

Version Implementation

Usually, the alpha phase is divided into several mini-milestones called versions. Each version contains additional modules from the program's functional design. For example, if a marketing kiosk is designed to contain a main menu from which five modules are accessible, the first version (V.01) may consist of the main menu and the first module, with the other four modules "stubbed out" (shown on the main menu but not functional). The second version (V.02) may consist of V.01 and

	Main Menu	Feature Set 1	Feature Set 2	Feature Set 3	Feature Set 4	Feature Set 5	Misc Features
Version 1	X	X					
Version 2	X	X	X	X			
Version 3	X	X	X	X	X	X	
Version 4	X	X	X	X	X	X	X

Figure 10.1 Alpha versions for a marketing kiosk.

modules 2 and 3; the third version (V.03) could consist of V.02 and modules 4 and 5. Version .04 may contain V.03 and any extraneous functions, like the help utility or installation program. In this example, delivery of V.04 would correspond to delivery of the "alpha" version and completion of the alpha phase.

Modular implementation has several advantages, including independent implementation, error containment, and unit testing.

Independent Implementation

A big advantage of breaking up the program into discrete modules is that several programmers can work on the program simultaneously and thereby help minimize overall development time. A programmer who can focus on a particular module or group of related modules will not only feel ownership toward it but can be held accountable for his progress in implementing it. It also gives each programmer discrete, reachable goals, which provides significant motivation. A programmer who can focus on attaining distinct, reachable goals in reasonable time frames will feel a sense of accomplishment and success at regular intervals throughout the project. This is of great psychological benefit to the programmers and hence to the project in general.

Error Containment

By breaking up the programming task into manageable modules and having individual programmers work on individual modules, errors can be contained to those particular modules. If a programmer is responsible for finishing and testing one module before going on to the next, software errors will tend to be localized to that one module. However, if the programmer is working on the whole program at one time, similar kinds of software defects may be strewn throughout the program, making bugs much more difficult to locate, isolate, and fix. This situation is compounded if several programmers are on the team, all working on various modules. For this reason, it is advantageous to divide the modules up among the programmers and test each module separately before integrating it into the overall program.

Unit Testing

Breaking up the program into individual modules and completing each module independently permits testing to be done much earlier in the process. This is called

"unit" or "module" testing (as opposed to full "system" testing, which is done once the whole application is running). With unit testing, each module is tested (usually by the programmer) as it is completed. For this reason, testing can start much sooner than if the whole program has to be finished before testing begins. In addition, if the modules are tested one at a time, testing can be more useful, because testers will be able to more easily isolate errors to a particular module (rather than trying to figure out which module or combination of modules produced a particular error). When this kind of testing is done on an ongoing basis throughout the development cycle, it is sometimes referred to as "concurrent testing," because the testing is being done concurrently with the programming. Concurrent testing helps find defects early, so they can be fixed before they cause ill effects.

Keeping Bug Lists

By testing the individual modules early in the process, you start getting immediate feedback on the quality of the code. This feedback can be of great use in keeping track of errors as they are found and fixed. The best way to keep track of software defects (bugs) is with a database in which each defect is entered, along with information that pertains to it, such as a unique identification number, a description of the defect, where it occurred, which version of the program it was found in, relative severity, instructions on how to replicate it, the date it was reported, current status (open or closed/fixed), who reported it, and so on. Various programs are available to help track software errors, ranging from the simple and inexpensive to the sophisticated and costly. You can also use a generic database program to keep track of these defects.

When categorizing them, it is helpful to make a distinction between software errors, content errors, and design issues. If the problem is a software error, it can be routed to the programmers to be fixed; if it is a content error, it must be fixed by whoever is handling editorial issues or data preparation; if it is a design issue, someone with proper authority will have to decide whether it is worth modifying the design at this point in the implementation. By keeping track of the defects in a database, you can sort and search them in many helpful ways. For example, sorting defects by module gives you all the problems in a particular module. Sorting defects by type gives you all the software errors versus content errors versus design problems. Sorting the defects by module *and* type results in a listing of all the software errors in each module, which is a very convenient and helpful list for the programmers of those individual modules. In fact, in many development houses, programmers and other personnel have access to a copy of the database itself, so they can sort and filter it as they desire.

Starting Documentation

The alpha phase is also the right time to start designing and writing the user manual or other print documentation. The manual can certainly be outlined and designed. It

can even be written, to some extent, while allowing for the fact that it will have to be revised if there are design changes (which there always seem to be). It is a good idea to start on the manual early, because if you wait until the beta phase, time will be short, and the software may be completed first. It is unfortunate for a completed application to be delayed in release because the print manual is not ready.

Some traditional print production people have a tendency to wait until the software is finished before starting on the manual. They reason that, given the high chance of last-minute design changes and that it is more efficient not to have to rewrite the manual, they would rather await the final software version. However, this method misses an essential element of the process: the software is *never* done. The programmers will continue to work until they *have* to turn it over. There is no point in turning over the software until the manual is done, so it can become a vicious circle. In addition, even if the manual has to be revised, it can be done as the software is being debugged at the final stage, rather than waiting until the whole program is finished to start on the manual. The proper time to start working on the manual is as early as possible—at the beginning of the alpha phase.

Packaging Considerations

The beginning of the alpha stage is also an excellent time to start discussing the issues of packaging and distribution. What the user will receive needs to be decided early. Will it be a floppy diskette or a CD-ROM? Will it be more than one floppy? How many? How thick will the user manual be, and of what dimensions? If it is for sale, what kind of box will it ship in? Will other materials be included, and if so, what are they and what are their dimensions? These and many other questions need to be asked and answered early; otherwise, there is a good chance of an unpleasant surprise at a very late stage. You may have been planning to include an extensive user manual in the box, but it turns out this will make the package too heavy to send economically through first class mail, the designated means of distribution. Something has to change; perhaps you'll decide to go through retail distribution instead, or create an abbreviated version of the user manual for printing and include the full manual on the CD-ROM in a text file. The important thing is to consider these packaging issues early to avoid unpleasant surprises at late, inopportune moments. Sometimes it is even helpful to create mockup versions of the packaging, with blank boxes, a dummy CD, and empty user manuals, to help visualize all the components and see if anything is missing, such as a warranty card, quick reference card, small product catalog, and so on.

Testing

The alpha version represents the earliest opportunity to show potential users the actual application up and running. The sooner you can find any problems in the design, the sooner and easier they can be fixed, so this is the right time to note any flaws

in the functional design that might be corrected in time for the product's release. Software defects are to be expected in the alpha version. The purpose of such alpha user testing is primarily to make sure the application will meet its objectives, not to test the reliability of the software. These end-user tests are sometimes performed in a test lab facility, where subjects can be videotaped for later review.

Because of the prevalence of software defects in the alpha version, it is usually most appropriate to conduct user testing in a somewhat structured way—that is, to have a demonstrator or facilitator operate the software and give the user a tour of the application, rather than placing the user in front of a piece of fresh, defect-ridden software to see what happens. If users are asked to simply sit down and start operating it, feedback will be of dubious value because of all the software bugs they will encounter. It will also be a waste of the users' time to start clicking their way into software defects, content errors, and stubbed-out code. However, with some preparation, demonstrators can pick their way through the application with a minimum of failures. Once users have received a decent tour of the application and heard the necessary disclaimers about software defects, they will be prepared to operate it themselves. Hopefully, these problems will not color their impressions of the user interface design.

Test subjects are sometimes nervous or inhibited at the beginning of these tests, simply because many people do not like to take tests. To help them relax and put the test in perspective, an important point to make is that *it is the software that is being tested, not them.* They are helping you test the software.

It is also helpful to encourage users to think aloud as they operate the application. This can really help highlight design flaws. If they are talking aloud, it will become immediately apparent that they cannot figure out what to do on a particular screen or if the interface is misleading or confusing in some other way. While the user does this, the observer should take copious notes to spark later conversations and discussions. Additional methods of documenting the test include audio- and videotaping the subject and outputting the monitor's display signal directly to a video recorder.

Despite your requests, however, users will probably not verbalize everything they are thinking. They may not want to be impolite by criticizing the application, they may not want to offend you or others on the project team, they may want to give only positive feedback in order to gain some perceived reward, or they simply may not want to look dumb. For this reason, only the careful observer will be able to pick up some of the hidden cues that may indicate design flaws by careful observation of the user's facial expressions, tone of voice, and body language. These are all meaningful cues to the user's subjective impressions of the application. Another telltale sign is random, extraneous movement of the cursor on screen as the user tries to figure out what to do.

The alpha phase is a good time to start working up quality assurance testing specifications from the functional design. The goal is to create a detailed checklist of all functions and features contained in the program, to use for full quality assurance

testing (which may begin as early as the beta phase). Alpha is a good time to start working on this test plan, since it takes some time to create. However, it should be recognized that if the design is modified during the alpha phase based on user testing (or for some other reason), the testing plan will have to be similarly modified.

If a prototype was done during the design phase and is reflected in the functional design, the alpha version should correspond closely to the prototype. If it does not, then it is apparent that someone made design change decisions during alpha implementation, and hopefully there are not only good reasons for making these design changes but that the changes were approved and documented as well.

SIGNIFICANCE OF THE ALPHA VERSION

Psychological

The alpha version is of significant psychological benefit, because this is the first time team members actually see the multimedia application up and running. Suddenly the program is "real." Until this point, the program was an abstract concept or a collection of features, screens, and data. However, when alpha is completed, it generally constitutes a whole greater than the sum of its parts. The development team feels a sense of satisfaction for having achieved a significant milestone, and management can see some tangible results for all the time and investment. The program can be demonstrated for various purposes, from internal company gatherings to sales meetings to press conferences. In addition, a subtle shift often occurs in the motivation of the project team, from the "Let's get this started" feeling of the early project to the invigorating feeling of now being fully involved in a real project.

See if It Works

Another significant benefit of the alpha phase is that you learn quickly if the chosen development environment can support the user interface and features as designed. When designing innovative product features, sometimes the technical staff starts relying on development tools that may be new or untested. While they may have done exhaustive research to select the most appropriate tools, including class libraries, conversion utilities, and so on, an element of risk is always associated with untried development tools. The alpha version can quickly highlight those issues and let people determine whether the tools work as advertised, whether the program can be implemented as designed, and whether the project schedule is in danger.

Data Preparation Issues

During alpha, those people assigned to data preparation tasks will be creating sample data for use by the programmers in the alpha version. This is when the data preparation staff will (hopefully) uncover the significant issues and concerns in creating and formatting the necessary data elements. For example, it may become apparent that the company's stock photos are unsuitable for the application for one reason or another, that stock video footage will be more expensive than previously thought, or that text material must be reformatted and cleaned up to a degree beyond what had been expected. Often, new data elements must be located, rights negotiated, photos digitized, and files reformatted. These are significant issues in the development process, and this experience in the alpha phase is a good indication of the future issues, and expense and workflow projections. By focusing on these issues early, necessary adjustments can be made in personnel and their methods, so that the project will have the best chance of hitting the scheduled milestone dates.

Production Issues

The alpha stage is the time to be working out glitches in various aspects of the production process as well, the details of which depend on the given project. On a particular project, these issues may include developing expertise using the write-once CD-R equipment, ordering a supply of blank CDs, or obtaining a fast Internet connection to allow large-volume data transfer. Addressing these issues in the design phase may be a little premature, because production usually hasn't started. By the beta phase, you should be in full production mode. Therefore, the learning and production flow setup needs to take place during alpha. This applies to various production issues, depending on the application; for example, with a trade show kiosk, there will be concerns about the kiosk housing, placement in the booth, and shipping considerations. With an electronic presentation, you might want to try running a sample application on the display machine to make sure the final application will function correctly, rather than waiting until the last minute before discovering any technical obstacles. In general, it is helpful to take advantage of the time available during alpha to accomplish any learning or remaining research, before the schedule pressures start building up during the beta and gamma phases.

EVALUATING THE ALPHA DELIVERABLE

The alpha phase ends when the first complete alpha version is submitted and accepted. While what constitutes alpha can be clearly defined in the development contract, of all the phases and milestones, perhaps none is more subjective than when an application has achieved the alpha milestone. Two reasons for this are 1) the many changes in the functional design that usually occur during the alpha

phase, and 2) the difficulty of actually implementing 100 percent of the functionality called for in the functional design. As an application is implemented and pieces of it start running for the first time, it is natural to start making suggestions for improvements, some of which may be glaringly obvious and even necessary. If this is the case and it is apparent that the functional design will change significantly, it may not make sense to fully implement the entire original design in those areas that will change, since this work may have to be discarded.

If approval of alpha is interpreted literally as having every feature in the user interface operational, then in a project undergoing significant midstream design changes, alpha acceptance may become postponed indefinitely. In such a situation, the programmer can find him- or herself in a frustrating, endless cycle of implementing design changes with no end in sight, including the alpha milestone. While this is frustrating for an on-staff programmer, for an out-of-house developer who is being paid based on milestone completion, it can be financial disaster.

This is frequently a source of friction when using external developers. The problem occurs when alpha is defined in the contract based on a design or functional specification of features. However, by the time the "alpha" version is running, so many design changes have been requested that the original definition of alpha is now somewhat obsolete and inapplicable. (Perhaps several minor features have been dropped and a new key feature added.) In the absence of a current and mutually agreed-upon definition of what constitutes alpha, the decision of whether the version qualifies is subjective and up to the client, since the client is the one withholding approval (and payment). This situation can easily escalate and instigate a dysfunctional relationship between client and developer.

One way to help make the decision about when an application has reached alpha is to reconsider the true goals and purpose of the alpha version—namely, to assess the functional design, try out the data preparation process, and actually get far enough along in development to make mid-course design corrections. The goal is not necessarily to implement every design change, but to at least identify them. If the application fulfills these criteria and you are working with a developer you trust, then it is probably okay to approve the alpha version submitted.

Internal versus External Development

This subjective issue of whether the multimedia application has attained alpha has a very different character depending on whether the work is being done internally or externally.

If an application is being developed internally, the development team looks forward to completing this milestone, and it is a significant psychological achievement. (In addition, bestowing the label "alpha" on the application allows you to report attainment of this important milestone to senior management.) The project manager, or whoever is empowered to approve acceptance of the alpha version,

can often simply make an arbitrary decision either to call or not call a particular version "alpha." The consequences are usually psychological rather than financial.

However, for external developers, alpha approval is usually a financial event as well as a psychological one, because it involves receiving a milestone payment. Approval withheld (which equates to payment delayed) can not only place a great burden on a small company, it can potentially push such a company into financial trouble. This is not only disastrous for the developer but can spell the end of the project as well. In this case, it is important to establish an objective measure of alpha completeness as much as possible and to work with trustworthy developers who deserve the benefit of the doubt, and trust that any remaining work will be accomplished to your satisfaction.

If you choose to withhold approval of the alpha milestone, it must be done in reference to the definition of alpha in the software contract. Without some objective, quantifiable reference point, mistrust can easily develop between the internal project manager and an external software developer. In addition, it is important to describe exactly what deficiencies in the current version prevent it from being approved and the minimum work necessary to achieve the milestone.

EXAMPLES
Electronic Slide Show

For an electronic slide show, an alpha version usually corresponds to the first complete presentation, containing all the slides with their corresponding text and data elements, as originally specified. The application may not have final background graphics, fonts, or illustrations, but the substance and text of the presentation should be viewable. Such a presentation is usually completed all at once, rather than module by module, because it is usually created in an authoring language conducive to this approach and it is usually only a single, simple module anyway.

This is generally the first opportunity for the presenter (usually your internal client) to get a good look at the full presentation, and takes the form of some sort of review, possibly during a first rehearsal of the presentation. During the review, the client will find imperfections that need to be fixed. Such changes are usually mechanical and easily implemented. If, however, the client starts requesting significant design changes, it is important to inform the client of the possible effects in terms of time, cost, and readiness for the presentation. Upon learning these costs, a client will sometimes reduce significant design change requests, occasionally retracting some of them entirely. In addition, it is important to be both honest and cautious (but optimistic) about implementing such significant changes. If you imply that everything being requested is easily done, the client may feel emboldened to ask for even more, possibly frivolous changes. On the other hand, if you

react as if everything requested is nearly impossible, the client will begin to doubt your competence—or, worse, your honesty.

Consumer Multimedia CD-ROM

Consumer CD-ROM applications usually benefit from a modular approach in which program features are implemented individually and tested concurrently. Consumer applications are frequently executed in programming languages (such as C and C++) that lend themselves to highly integrated software architecture. Commonly used routines that are defective will exhibit themselves in many portions of the code. A single database query module may be called from several different modules in the application. Rather than trying to discover, identify, report, fix, and retest the same database bug in many locations after it has been implemented, it is much more efficient to implement the function in isolation, and test it thoroughly in one location in the program before adding it to the other locations.

Deciding when a consumer CD-ROM has reached alpha is a somewhat arbitrary decision but an extremely important milestone. It is usually only with the release of the alpha version that you get to see how well all the features work together and to try it out on real users. This inevitably leads to significant design changes and modifications. It is crucial, however, not to mix these design changes into the requirements for completing the final alpha version, even if they affect the screens still to be implemented. During the alpha phase, the application should be continuously demonstrated to potential users in order to assess the interest level (and, hence, the sales potential) and the user interface. Take copious notes during these user demonstrations and keep them in a database of possible design changes. Potential changes should be reviewed by the project manager and the designer and ranked in priority for programmers to start working on after the final alpha version has been delivered. Again, it is important to let programmers finish the final alpha version unimpeded, regardless of the number of changes that may be requested in the future. In addition, as mentioned earlier, the test plan, user manual, and packaging should be started during the alpha phase in order to raise any important issues early, so they don't become obstacles to timely project completion later.

Trade Show Kiosk

Approving the alpha version for a trade show kiosk is an important step, and obtaining appropriate feedback is crucial. Generally speaking, a trade show kiosk will contain large amounts of content in the form of text databases, photos, and video clips. Data preparation of this content is rarely complete at the alpha stage, and the most that can be expected is sample data (representative graphics, digital video, audio files) for the programmer to access. Therefore, the alpha version will often simply use this sample data to allow functionality to be demonstrated.

What is intended as a series of photographs in the final version may simply alternate between two images in the alpha. Or a completely unrelated video clip might be substituted for the intended one, because the real video has yet to be produced or digitized.

Trade show kiosks are often created in authoring systems. Since, in an authoring system, the programmers (or "authors") are usually not working at a lower coding level, the whole program can often be created in one effort, rather than module by module. Individual specialized functions (for example, on-line access, or OCR scanning of business cards) may have to be developed in a specialized programming language (like C) and may be separated for later (or parallel) implementation. In general, however, the bulk of the application can often be implemented at the same time without serious risk.

Once the alpha version is complete, as much feedback as possible must be garnered from everyone concerned, including marketing personnel and potential users, in order to set some final limits on changes and redesign work. The alpha version should also be presented in a simulated or real trade show environment, so as to encourage the most complete and relevant feedback. For example, the application should be displayed in a kiosk housing, with operating touchscreen, if specified. It is also helpful to observe the kiosk operating in the actual exhibit booth at a trade show at least once, since this may stimulate final thoughts about design changes or spotlight correctable flaws. It may become apparent only from observing the alpha version actually set up and running, that the noise level at a trade show competes with the kiosk for attention. The kiosk may need louder speakers, different audio, and/or an animated attraction screen. On the other hand, a continually looping audio track may alienate booth personnel or others who must work nearby, such as security personnel or information desk staff. Ideally, these people could be enlisted to support the application. However, if they become alienated from the application by a loud, repetitious audio segment, they may actually be relieved if the program dies and therefore refrain from reporting any malfunctions of the system (assuming they do not pull the power cord themselves).

Web Site

The alpha version for a Web site often corresponds to the first full implementation of the functional design, with screens linked together and interface elements in place and working. The interface elements (list boxes, forms, etc.) are usually implemented at a basic level in HTML, with an additional scripting language like JavaScript (Netscape) or VbScript (Microsoft). Often these screens contain interface elements like drop-down lists or forms that simply accept data and then demonstrate the ability to retransmit or redirect that data accurately. It is helpful to have in-line "applets" (in Java or ActiveX) or back-end server programs somewhat demonstrable, although this will depend on the level of functionality implemented on the pages themselves.

The malleability of a Web site lends itself to a more "organic" design process than other interactive media. This is beneficial in allowing maximum flexibility during the design process. On the other hand, this flexibility can easily encourage feature creep in the alpha stage. Such a project can get off track, into functional areas not originally envisioned. Therefore, it is important to closely monitor the level of functionality being planned for a Web site in development, to prevent it from exceeding the resource and time constraints. In addition, a cost-multiplying factor is at work when developing a Web site, in the form of the ongoing maintenance and support costs associated with running it. The more functionality and media available on the site, the greater the ongoing maintenance and support costs will be.

The alpha version should attempt to prove out the intended user interface and its usefulness to the goals and objectives of the site. This should be done with extensive internal and focus group testing long before a site goes on-line. In this way, the functional and visual design can be fairly well established by late alpha.

11

Implementation, Stage 2: Beta

Once the alpha version has been completed and the program is up and running, it can be evaluated, which usually leads to a period of redesign and modification. This period of modification and final design decision-making can be referred to as the beta stage of the implementation phase. These changes can be as significant as adding features never contemplated in the original version or as trivial as positioning buttons or selecting fonts for the background graphics. The beta phase ends with the acceptance of the final beta version, in which design changes and modifications have been implemented, and the design is "frozen," with little opportunity for anyone to modify the design. The beta version should also contain most, if not all, of the actual data, including text, graphics, photos, audio, and video elements.

FREEZE THE FEATURES

During the beta phase, any remaining design modifications should be resolved as soon as possible. Ideally, all modifications will be proposed and decided upon early in the beta phase, given the disproportionately high cost and time required to make design changes during the latter part of beta. During beta, hard choices must often be made between accepting changes that pose a risk to the project schedule and budget or denying such modifications and possibly compromising on marketing features. A balance must be struck between adding new features (often advocated by those outside the product development team) and the needs of the development team for the design stability needed to finish the project in a timely fashion. At some point in the beta phase the design must be frozen, to allow those final features to be implemented and the product to move into gamma and final quality assurance testing. This compromise between features and time is a delicate issue that can hopefully be handled through negotiation between reasonable people, personal diplomacy, and the judicious use of a "wish list" for the next version (assuming the first version is successful enough to warrant a subsequent version).

Entering the beta phase, the most important issue is to identify and finalize any design changes, so as to freeze the design and implement those changes. These changes must be clearly defined and designed, to give programmers a reachable goal. Design changes should be kept to an absolute minimum, and the window for their acceptance closed as soon as possible. However, it is important to remember that design changes and feature additions may significantly affect the success and user acceptance of the final product. While it might be preferable if newly desired features had been included earlier, the fact that they weren't makes them no less desirable and no less important to the overall success of the project. Sometimes, significant new features and extensive redesign is desired by all concerned. However, the time and resources to implement such changes are usually limited. This situation usually results in a compromise, which generally falls to the project manager to negotiate and manage.

The beta phase is one of the riskiest parts of a project, because by this time the company is usually too far into the project to cancel the project, but the end is not yet in sight. There is often a spot during the beta phase when it seems as though little, if any, progress is being made, especially if changes are continually being accepted and implemented with no attempt to freeze the design.

In the end, however, a time comes during the development of any application when the design must be frozen; otherwise, it will never be finished. If design changes are allowed to continue unabated during the beta phase—or worse, new features are added at the end of the beta phase—the inevitable result will be massive schedule slippage. Such slippage will have many harmful effects, including increased development cost, lost opportunities in the market, damaged reputations, and unmet expectations. Unfortunately, there is always a conflict between adding more features and finishing up the first version. As mentioned earlier in the book, this accumulation of new features is a well-known phenomenon in the software industry and goes by the name of "feature creep."

Final User Interface

Beta is the last (and worst) chance to make modifications to the user interface. As previously mentioned, any changes made after the final beta version is complete will usually have serious schedule and cost repercussions, because late changes are disproportionately expensive and time-consuming. This has two corollaries: 1) support only the most important and easiest-to-implement changes; and 2) if they are really important changes, make sure they get added, because you probably won't have a chance again until after the product is released and a second version is underway (if that happens). Once the product is in the beta phase, even simple items like changing the label on a button can cause undue expense and frustration.

The later in the process that changes are made, the more time-consuming and costly they are. If a minor modification, like placing an "Exit" button on a particular screen, is made during the prototype or alpha stage, the cost in time and

expense will be minimal, because that item can easily be incorporated into the technical design and can be included in the artwork from the beginning. However, if the change is added after the beta version has been accepted, it could have significant cost and time ramifications: artwork will have to be changed (sometimes significantly), and that one button may affect the placement of other buttons. Programming will have to be redone, the software architecture and modularity may be compromised, the functional and technical designs must be updated, and adding that button will require additional testing to a module that may already have undergone testing. In addition, the user manual may need to be changed. While you may not have the authority to forbid design changes during beta, it is important to try to minimize their number and scope.

Minimizing Feature Creep

While feature creep cannot be completely avoided, it can be minimized in at least three ways: 1) express the cost to implement the desired feature in the quantifiable, objective terms of time and money; 2) give an individual advocating a new feature the option of putting it on a wish list for the next version of the program; and 3) "just say no," if appropriate and possible. Cost and time estimates for adding new features should be very conservative and include the additional time and expense for redesign, programming, testing, the ripple effect on other features, and on the user manual as well. It is sometimes useful to give the person asking for the new feature the option of putting it on a "wish list" for the next version of the program. This is sometimes acceptable to the individual, since that person may have thought it was "now or never" for the new feature. If the person can feel confident the new feature will be considered for future versions, his or her estimation of its immediate priority may be lessened. Finally, ill-conceived features or design modifications are always proposed, and it may simply be a matter of saying "no" (diplomatically) if you have the required authority to do so, because there simply is not enough time to develop them.

SCHEDULE

The project schedule attains a primary role during the beta phase, because this is when it usually becomes apparent whether the project has much chance of being delivered on time. This is an important time to check progress against the project PERT chart and closely monitor the progress of data preparation through quantitative means. The user manual should be well under way, and once the design is frozen, work should continue on it full speed. Likewise, if the product is to be packaged, package design work should be in full-scale development. During the beta phase there are many competing priorities, and it is important for the project manager to continually assess, balance, and prioritize them to keep the project on track.

Speeding Implementation

If redesign is needed, it may become apparent that the schedule is endangered. Design changes translate into increased programming and testing time. You may want to put a stop to any further design changes, but this may be impractical or even impossible, given the corporate rank of those advocating such changes. In such a case, if the budget is sufficient, it is tempting to add programmers to the project in an effort to add features. However, this is a dangerous strategy. Adding programmers late in the process is almost guaranteed to actually slow the project down as the new programmers get trained by existing programmers, work gets restructured and redistributed, the new programmers get adjusted to the work environment, and those in the existing work environment get adjusted to the new programmers. If programmers are to be added, they should be added as early as possible, to allow them to get up to speed and become useful before the end of the project. In addition, the software architecture must lend itself to a modular approach, to give these new programmers discrete and relatively independent modules to work on to minimize their involvement in other programmers' code.

USER MANUAL AND PACKAGING

By the beginning of the beta phase, the user manual design and writing and the packaging artwork should be well underway, and by the end of beta, they should be going full steam. While an early start on the user manual can be achieved based on the functional design, if design changes occur during beta, the user manual will have to be altered to reflect those changes. This means that from a print perspective, there is a potential for rework. From a print production perspective, the most efficient way to write the manual is after the software is completed. Yet, while that method may result in the least print production work, it will cause massive delays in shipping the final multimedia product while awaiting production of the print manual. For this reason, reworking of print pieces due to software design changes is to be expected in a significant project, should be planned for from the beginning, and should be included in cost and time estimates.

UPDATING DOCUMENTATION

Any design flaws uncovered or changes made should be well documented, and the functional design and the technical design documents updated to include those changes. Simply implementing these changes in code without adding them to the design documents may create significant problems in the current project and will certainly cause problems when it comes to maintaining and updating the product in the future. The functional and technical designs should remain complete and current blueprints for the application. The functional design can be used

as the basis of a testing framework. The technical design is the way to document the code, data flow, file formats, and so on, and becomes an essential reference document for programmers to refer to when debugging their code, or for the reference of a new programmer who gets added to the team later than you might hope.

TEAM DYNAMICS

During beta, the group dynamics of the development team will start coming into play in force, if they haven't already. As pressure mounts to finalize the design and plow through the remaining production and data preparation, team members will need to remain flexible. The roles and responsibilities of some team members will change significantly during this stage, as the emphasis on the project shifts from design and redesign to implementation, data preparation, and testing. In addition, the development schedule moves more to the fore as a team concern. This changing complexion of the project puts increased emphasis on regular team meetings. With design, programming, data preparation, testing, and user-manual creation all happening simultaneously, regular team meetings become important to keep everyone apprised of the progress being made in each other's area. Time spent in these meetings may seem to some like a waste of valuable production time, but it can be instrumental in saving great amounts of time and wasted energy for the team as a whole. For example, a programmer may believe that a better use of his or her time is to continue programming. However, by being present at a one-hour meeting, he or she might alert the user-manual writer about changes in the installation process and thereby prevent that individual from wasting several hours writing the installation procedure based on an obsolete design.

EXAMPLES

Electronic Slide Show

The beta phase in presentations is usually when the presentation gets polished. This generally involves touching up background graphics and illustrations, proofreading text, and splitting, merging, or adding screens. The presentation must be frozen at some point, however, and those changes made, so that testing and installation on the target presentation machine can begin.

Consumer Multimedia CD-ROM

The beta phase in a consumer title is one of the riskiest times during the development process. With the wealth of features and functions that may be needed to create a truly competitive application, the user interface may become complex and feature rich, requiring considerable testing and modification. In addition, since the development team is under tremendous pressure to create an application that

measures up to the competition, a competitive new product released by another company during your own development process can cause a flurry of redesign efforts. Also, an application which is less than visually appealing will not survive long on the store shelves. These factors tend to keep the product in a continual redesign mode, which can become a slow disaster as development costs increase and marketing opportunities slip away if product release is delayed. Yet beta is a delicate stage. The design must be frozen early enough to get the product finished and into QA testing. However, it cannot be frozen before the necessary features have been incorporated to comprise a competitive, if not market-leading product.

Trade Show Kiosk

For a trade show kiosk, the beta phase usually concentrates on graphical and visual changes rather than significant programming changes. Since a kiosk generally assumes a novice, short-duration user, these applications generally cannot become too complex or feature rich anyway. They usually rely on simple user interfaces that allow access to large amounts of data and content. To this end, the user interface is best kept as simple as possible, so user interface changes should be relatively fewer, simply because there is less user interface to critique and change. However these applications are much concerned with visual appeal, so design changes are often significant in the area of graphics and screen layout.

Web Sites

The beta stage in Web site development usually corresponds to final approval for the functional and visual design of the site and the delivery of working versions of any back-end server programs or in-line "applets." While time still permits small visual adjustments to the HTML pages themselves, adding functionality to the site that will require additional programming is not recommended. Such additions during beta will risk introducing coding errors to the existing programs, and will increase the testing workload before the site is launched, as well as increased maintenance costs once it goes on-line.

Content development (text and media) is usually in full gear, as well as data preparation tasks. Often this consists of obtaining content and data from other company departments and manipulating and reformatting them as necessary. Depending on the application, it can be as simple as reformatting a few text documents into HTML or as complicated as extracting data from a proprietary in-house database, then reformatting and importing it into a new database structure and rechecking that data. The primary goal of the beta version of a Web site is to demonstrate the intended functionality and to flush out any remaining technical issues so the project can move swiftly to completion and go on-line.

12

Implementation, Stage 3: Gamma

Once beta has been achieved, data preparation must be finished and the application subjected to functionality testing. This portion of the implementation phase is often called the gamma stage. In addition to data preparation, several other tasks are finished up as well, including the user manual and the packaging. The end of the gamma phase typically overlaps with and blends into the final Quality Assurance testing phase.

During the gamma phase, the complexion of the project changes. The schedule takes on increased importance (if that is possible), and all design work should have long since ceased, to be replaced by the hard, nitty-gritty work of any final data preparation and the sometimes frustrating work of testing and debugging. This phase is marked by extensive attention to detail and keeping track of software defects and content errors. This is where attention paid to creating a well-integrated and smoothly functioning development team pays dividends. The spirit of teamwork goes a long way during gamma, and its absence can actually put a project at risk.

COMPLETING DATA PREPARATION

Finishing data preparation requires checking all the various data elements, including the content and accuracy of any text, video, audio, graphics, illustrations, and numerical data. Depending on the application, this can range from a trivial to a monumental task. For an electronic presentation, it may simply mean proofreading all the screens and fixing any typos. For a multimedia encyclopedia, it could take weeks (or even months) to double-check articles, format text files, link photos into articles, attach captions, and so on. Depending on the number and variety of the various data elements, it may be appropriate to keep track of them individually in a database, so as to maintain current and accessible information regarding their various states of completion and review status.

Underestimating Data Preparation

Data preparation is often, if not usually, underestimated. This is because the true time needed to create, check, and test the data is often not accounted for when the sample data is created. However, data preparation is an area where additional people added at this late stage might actually speed up the process (in contrast to programming, where adding more programmers late will usually slow things down). The reason for this is that data preparation is usually a repetitive task that can often be done in a relatively mechanical fashion. In addition, the length of time it takes to prepare data can usually be reliably quantified, and therefore relatively accurate time estimates can be derived. It will then be apparent whether more staff is needed to complete the task.

Beware, however, of adding too many people to the process at this late date: adding individuals to a development team will disrupt the interpersonal dynamics of the team, creating inefficiencies that must be balanced against the desire to speed up the process. During the gamma phase, when time is of the essence, it is tempting to try to "crash" the schedule by adding new people, but unless the work they will be doing is relatively simple and mechanical, it may actually slow things down.

Imagine that production is falling behind schedule in preparing digitized photographs, and that several hundred need to be cropped, reformatted, and saved with specific naming conventions. It may be worthwhile to have a temporary employee added to the team to do this rather menial task. However, if you are falling behind in preparing these photos because the licenses or rights to use the images need to be negotiated, a temporary employee may well slow down the process while being trained to negotiate photo rights.

USER MANUAL AND PACKAGING

By the time gamma starts, the user manual should be well underway; by the end of the gamma phase, it should be virtually done. If an application has truly reached gamma, the screen design will have stabilized and screen shots can be gathered and incorporated into the user manual. There is no time to lose in finishing the writing and desktop publishing of this manual. In fact, it is most efficient, from a scheduling point of view, if the user manual can actually be finished before the application itself, simply because the lead time to print a user manual is usually longer than to replicate a CD-ROM. If the user manual is not completed first, the project could easily end up waiting for the manual to be finished and printed before the product can be released and shipped.

Like the user manual, by the time gamma rolls around, packaging design issues should have been long settled, with final artwork being prepared. Turnover of packaging artwork must be done early enough to allow time to reproduce packaging materials, in quantities that depend on the application. In consumer

applications, bar codes must be assigned and printed, along with all other necessary elements, such as system specifications, screen shots, text descriptions, and developer credits (if necessary).

THE LONG HAUL

The gamma phase is often a long process for the development team, especially programming and data preparation personnel. It is one thing to get all the features up and running with sample data for the alpha version. To get all the features fully debugged, and to completely finish creating and preparing all the data (including text, video, animation, audio, graphics, and photos) can be a very long process, depending on the application.

At this point, testers are finding more and more bugs, there may be a technical hurdle or two to solve, and little external progress can be demonstrated. A dull fatigue can settle into the project, sometimes reminiscent of "Mirkwood," the dark forest in *The Hobbit*, a long period of darkness, with little to go by but candlelight and an old map. This is often the acid test of the development team and its *esprit de corps*. Even though the end of the project is not far off, if this pessimistic mood is not overcome, the project can still fail in a number of ways. Management can get cold feet and pull the plug, the programming staff can slow down when it sees a large number of defects being reported and the magnitude of the remaining task, and potential users can become fickle in their support of the project. During the gamma phase, projects may appear, from the outside, to be bogged down because of the lack of external progress. The best ways to deal with this kind of slowdown are by objectively measuring and documenting progress as much as possible and by speeding the debugging process in several ways.

Measuring Progress

Two ways to measure progress are by tracking progress being made in data preparation and by early functionality testing.

Data elements should already be quantified in the functional design. That is, you should already know how many photos, video clips, text articles, and so on are to be included and prepared. By keeping close track of the quantity of each kind of data element being delivered you can make a relatively accurate forecast of when data preparation will be finished. This helps you predict the completion date and also alerts you to the opportunity or necessity of adding data preparation staff, either by hiring new people or reassigning existing project staff.

It also important to measure the progress of the programming staff relative to the reliability of the code. You can do this not only by monitoring how fast programming modules are being completed but also by keeping track of how fast new defects are being discovered by the testers and how fast known defects are being fixed by the programmers. Imagine, for example, that five hundred bugs are

known and that they are being fixed at an average rate of one hundred per week. One could predict that they will all be fixed after five weeks. However, if new bugs are being discovered at a rate of two hundred per day, then clearly, five weeks is an unrealistic estimate. Keeping track of these ratios can greatly help you figure out where the project actually stands in the bug-fixing process. For example, consider the data shown in figure 12.1.

A graph of the data would look something like figure 12.2

Week	New defects found	Defects fixed	Total defects outstanding
1	150	100	50
2	200	120	130
3	300	110	320
4	150	100	370
5	100	80	390
6	50	150	290
7	30	100	220
8	20	80	160
9	20	100	80
10	10	90	0

Figure 12.1 Sample bug-tracking data.

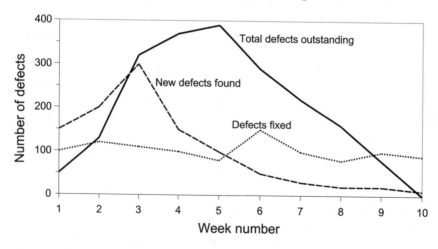

Figure 12.2 Software debugging progress graph.

For the purposes of illustration, this example assumes that the defects are of approximately equal difficulty to fix. (While this may not be the case, the more defects there are, the more they will conform overall statistically to a consistent average difficulty.) While these numbers may differ greatly from your own data, this graph helps illustrate a few points. First, it is apparent that bug fixing on this application will probably be finished by the end of the tenth week. It also helps illustrate how important it is to keep track of this information with some automated means, like a database, or bug-tracking system. Without this information, there is no way to tell when the application may realistically be expected to finish. Conversely, if this data is collected, you can make increasingly accurate estimates of the completion date and thereby keep unpleasant surprises about schedule slippage to a minimum.

Somewhere around week 4 or 5 in the example the team may start to experience morale problems, simply because the sheer number of bugs outstanding seems overwhelming and is also rising. However, by the end of week 6, the downward trend of the curve can be clearly seen. Just knowing they are gaining ground and the end is in sight can be a great psychological boost to the development staff. Otherwise, all they know is that an awful lot of defects are sitting out there to be fixed, which can be somewhat demoralizing. If you can show them that significant progress is actually being achieved, with an end in sight, chances are good of raising the spirits of those who are essential to completing the project, to keep them motivated and maintain productivity.

With this information, the schedule can be analyzed and actually influenced, to a certain degree, by somehow increasing the rate at which bugs are fixed. While it may be tempting to add programmers, doing so at such a late stage usually backfires and actually slows the project, as previously discussed. However, the speed at which debugging occurs can often be increased in other ways:

Increasing Debugging Speed

Help Programmers with Menial Tasks
To increase the speed at which programmers fix bugs, try to increase the amount of time they actually spend programming (as opposed to other activities) and help them maintain their concentration without interruption. One way to do this is to temporarily relieve them of non-programming tasks they may normally be expected to perform, such as attending nonessential meetings. Some other tasks may be temporarily reassigned to other project members, thereby increasing the total time that programmers spend actually fixing bugs. Additionally, you can provide them with a knowledgeable assistant to help them comment the code and write up documentation, so they don't have to spend their own time doing so.

Raise Quality of Test Reports
Another way to help the programmers fix defects is to decrease the amount of time it takes for them to locate and duplicate these bugs, by raising the quality of the

bug reporting itself. Test reports can often be improved by making them more specific. In this way, programmers can spend more time fixing bugs rather than trying to find them from casual and offhand reports. A description like "The main menu buttons don't always work right" will consume much more of a programmer's time (in trying to understand what is meant and duplicating the problem) than a description like "Catalog List button does not highlight: On the main menu, click on Catalog List, then click on Main Menu, then click on Catalog List again. The second time Catalog List is clicked, it does not highlight." Another way to speed the process is to batch the defects into modular groups, such as all main menu items together, or all printing issues together. In this way, the programmers can focus on fixing several problems in a single module at once rather than jumping around between modules to fix unrelated defects. These kinds of tactics, and others you may find, can greatly increase both the amount of time programmers spend actually fixing bugs and their efficiency at this task.

Avoid Unreasonably Pressuring Programmers

While it may be necessary to repeatedly impress upon programmers the importance of the work they are doing, it can be self-destructive to use coercive means to apply unreasonable pressure. Keep in mind that the work they are doing is hardcore problem solving, which is best performed in a relaxed but aware frame of mind. If programmers are already sufficiently motivated to fix the errors, undue pressure may distract them from the actual task. If they are browbeaten into burning the midnight oil for weeks at a time, they may start making more errors through mental exhaustion than they fix. The ideal situation is to find ways to let them debug as many hours a day as possible in a relaxed and rested mental state. Such programmers will be much more productive than exhausted and dispirited ones with little commitment to the project. The best motivator is the internal obligation they feel to the project and to the other individuals on the development team.

PROGRAMMER TESTING

One tends to assume that programmers thoroughly test their code themselves before releasing it, but this is often not the case. Only the fastest programmers typically have the time to thoroughly test their code, and only the most conscientious will consider it their responsibility. Many programmers simply make changes, run it once or twice to see if it works, and then let someone else catch the bugs. However, when programmers take the time to assiduously test their own code, they will find and fix things it takes testers at least twice as long to find. This kind of testing has an extremely beneficial effect on the quality of the code and, hence, on the product development process, so programmers should be strongly encouraged to take the time to thoroughly test their own code. Sometimes they can be motivated to do this by having testers track the number of errors found in each programming module, thereby highlighting which programmer's code is of higher or lower quality.

EXAMPLES

Electronic Slide Show

The first dress rehearsal of an electronic presentation by the presenter on the actual display machine could be considered gamma. This is when technical issues arise, such as problems displaying the computer signal with a particular LCD device or slow performance on the display machine. This is also a time when the speaker notices subtle issues of timing and word selection elicited by the live presentation, which may require fine-tuning the application or screen design. A dress rehearsal is strongly recommended for such presentations, with time scheduled for any such last-minute changes to the program to help polish the presentation.

Consumer Multimedia CD-ROM

The gamma phase for a consumer multimedia CD-ROM usually comes once the feature set has been frozen and some structured testing has occurred. Sometimes it corresponds to the first version of the software that the developer or programmers consider final, subject to quality assurance testing. Sometimes this version will be submitted as the first "final candidate," meaning that the developer claims not to have found any defects and it is now up to the publisher to find any remaining errors before they accept it. Typically, the first final candidate version is fairly stable but requires a significant amount of debugging, and subsequent final candidate versions will be submitted as a result.

During gamma, it is essential to have and maintain a reliable and useful bug-tracking system. The sheer number and complexity of features in most consumer CD-ROM products requires such a mechanism to keep track of all the problems. This is the only reliable way to categorize, prioritize, and allow regression testing to be performed on these items.

When an external developer is creating the application, the acceptance or rejection of gamma for milestone payments can become quite a significant issue if payment is tied to approval. In the sometimes arbitrary world of milestone approvals, gamma is a significant hurdle to pass, especially if the developer is behind schedule. This is a crucial milestone, and it is important to be firm in your standards regarding what constitutes an acceptable gamma version. The gamma payment is one of the last payments. If a buggy product is allowed to pass, you risk software instability in the final version as well.

One difficult situation that may arise is when an external developer is responsible for programming and has implemented all the functionality, but your company is responsible for providing the data (such as photos or text), and you have not yet finished this work. In such a situation, you may be reticent to approve the gamma milestone for the developer because the application is not yet finished enough to go into final testing (due to your own missing content). Yet the developer may justifiably claim that this is not their fault, since programming has been

completed and you are the one who is late and that they should not be penalized by having payment withheld. Such a situation must be carefully considered to make a fair and equitable compromise, and to avoid alienating a developer who is necessary for the successful completion of (and perhaps long-term maintenance of) your project. In such cases, partial payments are sometimes made, and milestone dates may be adjusted as necessary.

Trade Show Kiosk

The gamma phase for a trade show kiosk is usually a time of simple cleanup work to the application, especially to the graphics and data elements. More time is usually spent reviewing and modifying the data itself than the application. As stated previously, such applications tend to be of simpler design than consumer applications, simply because the users rarely have time to learn how to use a more highly functional and complex multimedia application.

It is worthwhile to try out the gamma version in a real trade show booth at a small trade show, to make sure everything is working correctly. Once you see it running in such a situation, however, you tend to get many ideas and to receive suggestions for improving or adding various features. This is a good time to start a "wish list" of features for the next version.

One important aspect of gamma testing for trade show applications is the mechanical system itself, including the kiosk housing, touchscreen connections, cabling issues, and shipping container. Ideally, these should all be stress-tested in real-life situations to minimize chances of mechanical failure. This can be done by such means as shipping the equipment out by truck to a remote location and then back again, to see if it survives the trip, or letting it run in the kiosk housing for days on end to make sure it won't overheat or shut down for some other reason, or by putting the system in a public place, such as your office lobby, to test it under real-life user conditions.

Web Site

The gamma phase for a Web site refers to the latter stages of the completion of a site (or a large new feature of an existing site) prior to launching it for general Internet or limited "Intranet" access. During this phase, final content is being completed, including any multimedia, text, or tagging of pages. Final server or applet code is also being tested and debugged.

The testing process should be in full swing, with pages being viewed and operated in different browsers. Currently, Netscape Navigator and Microsoft Internet Explorer are the most popular browsers, and your Web site should be tested using various versions of both of them. It should also be tested with a few of the less popular browsers to ensure compatibility and appearance. Web site testing can be extremely time-consuming, especially if many external and internal links need to be

verified, changes tracked, and retesting done. Sometimes automated testing of Web links can save a great deal of time.

Before being declared gamma, the site should have any customized programming virtually finished, whether it runs on the user's machine or on the server itself. In addition, it should be running on the actual host server, linked to the intended target audience (the general World Wide Web or the internal corporate network) but accessible only by password. This lets testers actually run and try the program in exactly the same environment as the intended user.

Web sites often come together quickly before being set on-line, and it is sometimes difficult to pinpoint a particular day on which the Web site can be declared "gamma." However, once the content is in place, programming code is complete, and testing can move into full gear, the nearly finished site can usually be considered to have reached the gamma milestone.

13

Quality Assurance Testing

Quality Assurance (QA) testing is the process of locating, isolating, and describing errors in the final multimedia application, so they can be fixed by programmers or the data preparation staff. QA testing usually starts sometime during the late gamma phase, between the beta and gamma versions. By the time the gamma version is submitted, QA testing can be going at full speed. QA testing generally ends when the final version has been accepted and released. In fact, QA testing determines when the application is released, since it is the final quality-control gate through which the application must pass before being declared finished. The more widely the application is to be distributed, the more important the QA testing process. This phase is a crucial part of the software development process for sales, training, and especially consumer multimedia titles, which are intended for distribution to large numbers of users with little to no control over the hardware systems they will be using.

QA testing is focused mainly on finding software defects and to some extent on content errors. Design flaws, suggestions for redesign, and proposed design changes are duly noted, but hopefully any outstanding user interface design decisions have already been made. QA testing is primarily responsible for finding program malfunctions (software defects), so they can be fixed before release.

In general, QA testing becomes increasingly important as the application nears completion, until, by the end of the project, it is *the* main activity (along with fixing defects found). Unfortunately, this phase is often overlooked and underbudgeted by those new to the process. Typically, as discussed earlier in the book, testing and debugging consumes about a third of the development effort in one form or another, which can cause great consternation among those funding the project if it is not planned for. Testing is sometimes given short shrift by those new to developing software, who may view it as unnecessary effort being expended to repair work on something that "should have been built correctly in the first place." (This misses the essential point, since in most cases, the application *is* being built for the first time.) Those with some experience developing multimedia software have usually learned the hard way that attaining even a tolerable level of software

reliability and stability can only be achieved through QA testing. Taking the time to find the defects and fix them at this point is usually better than rushing a product to release, only to receive an unfavorable response later, when users have problems installing and/or running the program on their computers.

QA testing determines the end of the product development cycle, because an application must pass final QA testing in order to be of high enough quality to be released. QA testing usually starts up in force sometime during the gamma phase and extends until the final version is released. Sometimes QA testing continues as part of the maintenance and support phase even after the product has been released (for example, on a Web site). Once the whole application is up and running, with virtually complete data, QA testing can start. Before this, it is usually premature to start QA testing in force, since during the beta phase the product is often being redesigned, and many of the defects that exist may well be known anyway. Testing almost always takes longer than anticipated (and scheduled), and getting started early is one of the secrets of successful multimedia development.

Difference from Other Mediums

QA testing is one of the major differences between software development and the development of other media, like print and video. Little in the way of print or video production compares with software QA testing. A video program may be reviewed several, if not many, times, but it is a linear medium, so it has only a single path to inspect. Software, however, is nonlinear, with an unlimited number of potential "paths," most of which have to be tested. Every functional choice and button must be tried alone and in combination with other features. If it is a consumer title, it must be tested on a variety of hardware and software platforms in a process called "compatibility testing." Software testing is not analogous to proofreading a print product either. Software QA testing requires considerable technical skill and ingenuity, along with meticulous record-keeping of the results of actions performed in the various combinations and permutations allowed by the user interface.

This QA effort is a significant responsibility and usually requires significant resources. If the product is to be commercially released, the software publisher usually ends up with the responsibility to test it, whether the project is planned that way or not. The development shop can rarely test its own work adequately. Testing must be done objectively, and the skills necessary to test software are different from those needed to develop it. Since the publisher will be the one releasing the product and therefore the one who is ultimately at risk, it is the publisher's responsibility to see that the application is thoroughly tested and defects are fixed before it is released. This often means finding an outside company to assist in testing and/or setting up an independent, in-house testing group.

High Quality Standards

While you can be realistic and accept the fact that most likely the application will be released with some outstanding defect(s), this in no way condones lax quality control standards. It is important to maintain a commitment to fixing as many defects as possible before releasing an application, even to the point of refusing (if necessary) to release an application that is untested or is known to contain many significant errors. If time pressure is extreme and one or two defects are obscure (hard to find by the casual user) and harmless (do not affect functionality), it may be acceptable to release the product. If a multimedia application contains a misspelling in the main body of the title screen, it may be harmless but it is certainly not obscure, so it must be fixed. If the same misspelling is buried at the bottom of the page in a caption in the third credit screen in the help system, it might not be severe enough by itself to hold back a product from release. Likewise, if a defect freezes or crashes the system, it must be fixed; however, if through a strange combination of dialog boxes and keyboard input a defect prevents a button from highlighting every tenth time it is used, it will be relatively obscure and might in some situations be considered harmless enough to allow the product to be released.

KINDS OF TESTING

Unit Testing by Programmers

When programmers test their own code, module by module, it is referred to as "unit" testing. Each programmer tests his or her own modules thoroughly and doesn't start a new module before testing and fixing the previous one. This testing is done *not* by simply running the code a few times to see if it works, but rather by feeding the code common, uncommon, and even unexpected inputs to make sure it handles them correctly and doesn't malfunction. This is the cost-effective and efficient testing technique, and is a way of promoting "quality at the source." Programmers willing and able to thoroughly test their own code module by module after each is written will generally find defects faster than other testers and be able to fix them in the shortest time. This stops problems before they can crop up in other modules, and it prevents other testers from having to spend time finding, isolating, and documenting these defects and then retesting for them later (regression testing) to make sure they were fixed.

However, having programmers thoroughly test their own code can be difficult to enforce, for several reasons. First, most programmers like to write code, not test it. Testing is sometimes seen as monotonous work and sometimes as not even part of a programmer's job. Second, programmers are often under extreme pressure to produce usable code as fast as possible; therefore, the emphasis is often on quantity rather than quality. If programmers are on a tight schedule, there is little chance

they will want to spend "extra" time thoroughly testing their own code instead of logging the completion of that module and starting work on a new module.

It is important to encourage programmers to take the time to test their own code thoroughly and fix defects they find before turning it over. One way to motivate them is to let them know that the quality of the modules they finish will be monitored during testing.

Integration Testing

When the various modules are combined and the application is all running together, the program is said to be integrated, and testing of the full program is called "integration testing." While all the modules may seem to work perfectly in isolation, they frequently exhibit defects when combined to perform as a system. Reasons include unexpected inputs and outputs between modules, memory leaks and conflicts, incompatible variables, and just about anything else that can (or shouldn't be able to) go wrong. Professional software testers are experienced in finding such flaws, and integration testing is usually performed in force by non-programmers, because by not knowing how the application is constructed, they are more likely to operate the software in a way programmers had not anticipated and so uncover errors programmers wouldn't uncover.

Concurrent Testing

Concurrent testing refers to the ongoing testing of software while it is still in development. Testing the application this way allows the project manager to realistically monitor the application's progress, by building testing time right into implementation. For example, if QA testing doesn't start until after the whole application is supposedly "finished," you would have no idea how many defects are actually lurking out there in the code and how long it will take to fix them. In addition, there is a good chance the defects will be repeated in various forms throughout the program. However, if the software is tested as it is being built, defects can be caught earlier (especially defects in the software architecture) and will be easier to fix, cause fewer follow-on defects, and give a better indication of actual progress to date.

Regression Testing

The most thorough method of testing is not only to test for defects fixed from the previous version of the application, but to retest for defects fixed in earlier versions. This process of repeatedly retesting for defects to see if any old ones have reappeared is called regression testing. For example, if a particular defect was found in beta version 0.5 and fixed in version 0.6 it is wise to continue testing for it in versions 0.7 and 0.8. At first glance this may seem excessive; however, it can uncover serious problems and safeguard against them. There are various reasons

why defects that were apparently fixed in one version may reappear in subsequent versions. An old copy of a particular file may have been used by mistake to build a later version of the application, or a new or different programmer may attempt to optimize code and reintroduce an old error.

Another reason to do regression testing is that in the process of fixing old defects, new defects may be introduced. It is entirely possible for a programmer to inadvertently introduce one new defect for every twenty fixed. In fact, that single new defect may be much more serious than any of the twenty that get fixed. If a few hundred defects are outstanding, this can cause a "nontrivial" amount of risk. Regression testing allows a much better chance of discovering these potentially serious defects.

Compatibility Testing

Finally, software to be used by a large number of users on their own machines should go through compatibility testing. This refers to testing an application on various kinds of hardware and software platforms that conform to the minimum system requirements, to make sure it is compatible. This includes not only systems from different manufacturers, but those with different video cards, operating system releases, printers, memory configurations, CPUs, and clock speeds. Problems reveal themselves in such situations that might never be discovered otherwise (except by end users, of course).

WHO CAN TEST

QA testing is a specialized and unique skill, which must be learned. Adequate testing cannot be accomplished by giving the application to a couple of teenagers to pound away on for a week after school. Software QA is a highly skilled profession, and the task includes designing a comprehensive test plan to ensure that the application has been thoroughly tested. The test plan is then followed by conscientious and detail-oriented personnel. Good software testers are hard to find, and external professional testing services can cost nearly as much as external programming services. It is therefore important to include such testing services in the original project cost estimates, so that the project budget will allow for such expenses.

Testing Companies

Several companies in the United States specialize in software testing, some of whom are experienced in multimedia applications. These companies can develop test plans, help identify platforms for compatibility testing, and test on machines with various kinds of peripherals. In addition, they are knowledgeable in providing detailed test reports that isolate and identify defects, so programmers can reproduce them. (If a defect cannot be reproduced, it can hardly be fixed.)

Variety of Testers

When testing an application, it is important to have several individuals perform the testing, since each will follow a slightly different pattern when using the program and will therefore find defects the others may not discover. It is also worthwhile to make sure there is a new person always testing the program each week or so. The new user is in a unique position and will tend to do unexpected things with the software, which is exactly the type of situation required for real testing. Once users have learned the application, they tend to settle down into an efficient and predictable usage pattern. They are less apt to break the rules and therefore less apt to encounter problems caused by unexpected usage patterns and combinations of functions.

Non-controlled Testing

Testing by casual users external to the company (often called "beta testing") can be of some limited value. The real world is always more diverse and surprising than even the most thorough test environment. When real potential users get their hands on software, things happen that the development team would never have expected. It is helpful to uncover and fix such problems before the product is released, rather than afterward.

For example, after developing an educational application optimized for a screen resolution of 640 x 400, one of your beta testing teachers calls to say it doesn't work. After a little discussion, you learn she was running it with 800 x 600 screen resolution and projecting it onto a wall through an LCD panel, which is not designed to accept an 800 x 600 resolution display. In this case, your application has nothing to do with the problem the user is experiencing. "Fixing" the problem may simply involve having the user reset the screen resolution to the normal 640 x 480 that the video projector will accept. You may also want to let the technical support staff know about such a situation. Field testing results can help identify such oddball situations that occur in real-life user environments.

Letting Customers Test

A publisher who releases a product without thorough testing is guilty of gross negligence and will suffer the consequences as the first wave of new users make their feelings known about getting stuck with an unstable, poorly functioning program. While *potential* customers can be allowed to "beta test" the product prior to release, real users cannot be subjected to this without negative repercussions. Real users must have product that functions as reliably and with as much stability as possible. Sometimes a prerelease version of the application is distributed to potential users and reviewers in a so-called beta test. However, this is often done as much for marketing reasons as for product development benefit. The feedback from such

casual "beta testers" is usually anecdotal at best and is rarely of high enough quality to provide solid test results. Potential customers given a prerelease version of the product in exchange for test reports usually serve to validate what professional testers have already found and can at best point professional testers in the direction of possible new defects.

Out-of-House Testing

Software testing is a good task to have performed at least partially out-of-house, through an external organization. Doing some testing out-of-house will result in its being done more independently and, hence, more objectively. If testing is done in-house, the software testers are often under subtle pressure to curtail their efforts or lower their standards so a product can be released on time. (This in no way absolves in-house development staff of responsibility for managing that testing process and keeping records and a database of identified defects.) In addition, companies that specialize in such testing provide an essential cross-check of the quality of program code. The more complex and feature-laden an application, the more reason to have it tested by these experienced, out-of-house personnel.

TEST PLATFORMS

One of the keys to performing reliable testing is to have the proper test environments available. You must test the application on the variety of hardware and software platforms on which it may be used, starting with the minimum system requirements and progressing to higher-end machines. The application might need to be tested on older versions of the operating system. In addition, you must test on a variety of system and peripheral equipment from various manufacturers, depending on the application. For a consumer application, it is important to test printing capabilities on a wide variety of printers, from dot matrix to bubble-jet to laser printers, and from different manufacturers. It may be that a file that printed out nicely from a laser printer takes an unacceptably long time on a dot-matrix printer. In this case, you might want to provide the user with a choice of quality versus speed, to allow acceptable printing on high-end and low-end printers.

For a nonconsumer application, the variety of hardware and software platforms may not be as large, because the conditions under which it is used tend to be more controlled. A kiosk application may be running only on a single machine in a single kiosk, so testing it on various platforms may be of little value. For presentations, it is extremely important to test the application thoroughly on the actual playback machine and the display equipment (including the LCD panel or video projector) and not assume it will run well simply because it runs on the development machine. Computer equipment from various manufacturers, and even various models made by the same manufacturer, can have both major and minor

variations that can easily derail a presentation at the last minute, leaving no time to recover. Therefore, testing must be done on the actual display equipment and for a suitable length of time to flush out any significant defects.

EXECUTION

Types of Errors

When recording software problems found through testing, it is helpful to categorize them according to one of three types of problems: 1) design flaws and suggestions, 2) content errors, and 3) software defects. Design flaws refer to user interface problems or suggestions, such as proposed new features, relabeling buttons, and screen layouts. Content errors are errors in the data, including inaccuracies, data with formatting problems, or data of poor quality in some other respect (photo image quality, text misspellings). Software defects, commonly called "bugs," are technical problems encountered when trying to run and operate the application. "Mechanical" problems, like system freezes and crashing, display and input problems, incorrectly calculated results, and conflicts with other programs, are examples of software defects. During final QA testing, the biggest concern is with finding software defects, since by the gamma version, all the data should have been created and checked, and final design decisions should have been made much earlier.

Prioritizing Fixes

A commercial software or multimedia application has probably never been released that did not have a known defect. Even applications with few defects when first developed will exhibit problems when run on marginal target-computer platforms (those with minimal system resources) or on updated versions of operating systems. While zero defects is an admirable goal, it is virtually unachievable on most software projects, so someone has to decide where (and how) to draw the line on defects before releasing a multimedia application.

The issue is one of priority. Defects can be prioritized by severity, obscurity, and difficulty to fix. If a defect is hard to find and reproduce (obscure), relatively harmless (low severity), and hard to fix, it is probably low priority. On the other hand, if it crashes the system (high severity) in a frequently used part of the user interface (obvious) and is easy to fix, it should have high priority. By fixing defects in order of priority until a crucial project parameter (time or money) is reached, you can maximize the application's quality.

If you know the product must be released by a particular date, with no chance of altering that date, you obviously need to fix the highest-priority defects first. One way to establish priority is to assign a severity level, difficulty level, and obscurity level to each defect and then multiply those numbers. For example, defects can be

ranked on the basis of severity from 1 to 10 (1 = most serious, 10 = least serious). Then they can be ranked by expected difficulty (1 = easiest to fix, 10 = hardest to fix). Then assign each an obscurity ranking (1 = most obvious, 10 = least obvious). When these numbers are multiplied together, the items with the lowest total will be the most serious, most obvious, and easiest to fix, and should be started on immediately. The items with the highest numbers will be the least serious, least obvious, and hardest to fix, and therefore should be worked on only as time and money permit. While not an exact measurement tool, this method is a good way to establish a rough order in which the defects should be worked on. However, this rough order shouldn't be followed in lockstep, and sometimes arbitrary decisions will have to be made, given the unique qualities of a particular project.

Keeping Good Records

The goal of testing is not only to find problems but, having found them, to document them and the conditions under which they were found, so they can be fixed. Keep good records of this information, to make sure these defects can be referred to again by number, that they can be reproduced, and that it is known who reported them, when they were reported, in what version of the application, and on what kind of machine. This information can be valuable in eventually getting to the source of a defect, especially when the defect is difficult to isolate and/or reproduce.

This record-keeping is most effectively done with a database, rather than with a spreadsheet or a word processing program. With a database, you can keep track of the defects found and their current status—whether they have been fixed (closed) or remain unfixed (open). You can also sort through the data by various attributes, which is extremely helpful. If the defects have been prioritized, they can be sorted in the order of priority, to see which defects are next in line to be fixed. If they are classified into the three kinds of defects—design issues, software defects, and content errors—the list can be sorted to provide different individuals with appropriate information. You can even do custom searches; for example, you can find all the most important software defects for the programmers. Keeping track of what version of the software exhibited the defect is also important for regression testing purposes.

Isolating and Reproducing the Defect

In addition to simply finding a software defect and being able to reproduce it, you must give directions for another person to be able to reproduce it as well, with a minimum of time and effort. If it can't be duplicated, it's hard to know whether it really exists, not to mention whether it's been fixed. This is where software testing borders on being an art. It is better to be able to reproduce a defect in fewer steps, because it greatly assists the programmer in identifying the source of the defect. If

it takes five keystrokes to demonstrate the defect, the programmer has fewer variables and conditions to consider than if it takes six keystrokes. It takes experimentation, insight, and time for a tester to reproduce defects and demonstrate them with the fewest possible steps. The time necessary to identify, reproduce, and isolate defects accounts in large part for the unexpectedly long time and effort it always seems to take to get an application from gamma to final release. Yet this is the most efficient method, because if the tester doesn't do a thorough job and isolate defects to the minimum number of steps, a programmer will spend even more time doing the same thing before he or she even starts trying to fix the bug.

Test Plan

To adequately test a more complex multimedia application, such as a consumer CD-ROM, a test plan must be used. A test plan provides a checklist of all the functionality in the program. With such a checklist, testing can be performed in a consistent, detailed, and thorough manner by one or many testers. This test plan gives the testers an actual checklist of the features to try and often an order in which to try them, with clues as to areas that may exhibit defects, due to the complexity of the code. With such a test plan, all the testers can be sure of trying most, if not all, features and functions in the program. Without such a framework, testing is merely a hit-or-miss approach, relying on the skill and luck of individual testers. However, even with a test framework, the challenge in testing is to find defects that exhibit themselves only in certain situations, when combinations of features are used in a particular order.

For example, the word-search feature in an electronic encyclopedia may work fine when used alone, but if text is copied out of an article and then into a notepad, the word search may malfunction the next time it is used. In such a situation, the tester can start creating hypotheses to test and identify the fewest actions necessary to exhibit the defect. It may take a fixed number of cut-and-paste operations, or it may require a minimum amount of text being copied, or it may depend on the length of the word being searched for. This is where a structured testing method and a creative software tester can find a potentially serious problem and give valuable feedback and clues to programmers to help them figure out how to fix it. However, mere "trial-and-error" testing by someone with little software testing experience may not disclose the problem at all, and if such a person does happen to stumble across it they may not be able to reproduce it later, much less reproduce it in the fewest possible actions and provide an adequate defect report.

Once these software defects and errors are found, they are logged on bug report sheets. The sheets are then typically turned in to whoever is responsible for maintaining and updating the defect database. Without this approach, it is difficult to keep track of defects, make sure they have been fixed, and prioritize outstanding defects to make the best use of remaining programming time.

EXAMPLES

Electronic Slide Show

Performing testing for an electronic presentation is a relatively simple task. The presentation usually has a limited user base (just the presenter), without much to test. Most of the time, it simply presents a number of static slides in sequence. Features that can complicate the testing include accessing the slides out of order, advancing slides automatically, and running time-synchronized multimedia elements like video and audio. However, for most simple presentations, a test plan is not needed. The application can easily be tested by simply loading it up on the display machine and running it a few times.

The most significant form of testing, however, is when you actually try to run it in the real presentation environment on all the display equipment, such as the LCD panel or video projector. If you're pretty sure it will all work fine, it may seem pointless to run the application in the presentation environment ahead of time—pointless, that is, until you find yourself standing in the presentation room just minutes before the meeting with a malfunctioning system and no idea what's wrong.

Consumer Multimedia CD-ROM

Adequately testing a consumer CD-ROM requires hundreds, if not thousands, of hours of testing, including both hardware compatibility and software functionality testing. Generally, at least some of this testing is contracted for out-of-house, both because of the objectivity and because of the sheer quantity of testing. Testing is usually the limiting factor for when an application is released. For this reason, testing departments can come under extreme pressure to modify their assessments regarding the severity of defects found. Consumer software testing should start as early as possible and continue in force until the application ships, using every technique at the disposal of testing personnel.

Trade Show Kiosk

When a trade show kiosk is nearing completion, it is important to test it thoroughly, from a test plan, if possible. Because of the many users who will have access to the system, the application will be used in unexpected ways. However, testing is simplified by the limited number of hardware systems the application will run on and the limited interaction usually allowed. Often, the only input is through a touchscreen, which makes for a relatively simple set of functions to test.

Web Site

Performing QA testing on a Web site can be as time-consuming as testing any other software product of similar size and complexity. If the final site consists of only a

dozen HTML pages with some photos and text, all simply linked together, it probably wouldn't take more than a few days of testing. However, a site that relies on custom Java programming and back-end server programming and contains special databases and many external hyperlinks could take substantially longer to test. Such a site would require a full test plan and complete testing using a wide variety of browsers. The more complex the site, the earlier testing should start.

One advantage in testing a Web site is that since it is on-line, distribution problems are minimized. Instead of having to continually cut dozens of new CD-ROMs to parcel out to testers and keep various release versions separated and archived, you can have the site tested in a more fluid, ongoing way. As errors are fixed, the site nears completion.

For adequate QA testing, the site must be "live" and running on the actual host server where it will be launched and maintained, as if it were actually on-line, with only a password to prevent general access. This way, if the site is already up and running, once it has passed QA testing, it is a simple matter to remove (or change) the password and make the site available to the intended audience.

Finally, if a site contains links to other sites, those links must be tested in an ongoing, maintenance process, to make sure they are still valid and active, as long as the site is in operation.

Support and Maintenance: The Care and Feeding of Software

The support and maintenance of software is a large topic, to which many well-respected books have been devoted. The following discussion is meant as a simple overview and introduction to the topic for those who may be new to the full multimedia development cycle. Creating a means of supporting users is crucial to the success of a multimedia product, and if that product is to survive, the code must be maintained as well.

Once a multimedia application has been released, some people might assume that the development process is over and they can move on to other things. However, this is usually not the case. From the simplest electronic presentation to the most complex consumer CD-ROM to the latest World Wide Web site, if the application is put into use, the user has to be supported. In addition, the need to fix newly discovered defects, make design improvements, and update the application for new systems means that a successful application requires an ongoing investment of time and resources. In a sense, development never ends. Hopefully, the application is profitable enough or has enough strategic importance to justify such continued investment.

In some ways, releasing the application is just the first step in creating a successful multimedia application. A successful application will require support and maintenance by virtue of the fact that it is successful and in widespread use. An unsuccessful application, however, may not require this level of support (unless its lack of success is *caused* by inadequate support). Providing support is an essential ingredient in maintaining the success of a multimedia application.

The Final Phase

Support and maintenance of the application is the final phase in the development process. This is a real phase, one that must be planned for early. Otherwise, you will be unprepared for the responsibilities that become apparent once the product is released. After creating an in-house training application and releasing it to half

a dozen regional sites, questions from those sites must be answered. These questions will come from computer novices (who have trouble installing the application) to experts (who may be concerned, for example, about memory usage). Someone must be available to answer these questions, or the application will not be fully utilized, if at all. Likewise, electronic presentations often take on a life of their own; internal clients may want to use the same electronic presentation for other speaking engagements with "minor" revisions and on different display machines. Consumer titles require a significant help-desk infrastructure to deal with user support issues. In addition, if the program is to live into the future, the code must be maintained and even enhanced for new competitive versions. Web sites require continuous maintenance and updating and must be physically hosted on a file server as long as they are in use.

If these postdevelopment activities have not been anticipated and planned for, they will come as a rude awakening to those who thought the project was done and that they could move on to other things. Therefore this ongoing user support and product maintenance are best seen as the final phase of development, not merely as some cleanup work that may need to be taken care of as quickly as possible and dismissed.

Real Issues and Real Dollars

These support and maintenance issues are real concerns and cost real money, regardless of whether expenses are out-of-pocket or as time taken by salaried employees from their normal duties. Therefore, continued development must be planned for and budgeted. It may be rolled into the original product development expense or included as a part of the ongoing fixed cost of doing business.

If these support and maintenance costs are ignored, the need for them will quickly become obvious and may require an "executive decision" about how people spend their time. For example, if (in a non-software-producing company) a customer service department handles customer complaints, the support of a multimedia application may be viewed as a natural extension of its work. However, current skills of the staff may not include those needed for software technical support, so they may not have the resources to handle the task. Not only will it take nontechnical customer service personnel much longer to handle a support call than it would take a dedicated technical support person, but it will pull them away from their normal duties, which may not be appreciated by their direct supervisor. Resource contention like this is only the tip of the iceberg.

In some ways, developing software is more like building cars than like book or video publishing. In the book or video publishing business, once the product is created and manufactured, it is sold, with little need for maintenance or dealing with the end customer. A book or video is simply published and distributed. If it sells well, it is a success. Software, however, like automobiles, requires constant support for users, because they really are *users*. They actually use the product repeatedly and

may have questions about its proper use or problems operating it. Just as few people want to buy a car that has no support structure (dealers and mechanics), people also prefer not to purchase software for which no support is available. If the program does not install correctly or malfunctions during operation, the user needs someplace to go for help. Few of us have not experienced these kinds of problems with software. Having most likely been in this situation yourself, you can easily see how essential it is to have some sort of support structure in place for users. This applies to multimedia applications developed for in-house use as well, such as training and sales presentation applications.

Likewise, just as car models are updated and improved each year, software must also be continually updated and improved regularly. When buying a car, you are usually buying more than that particular automobile—you are buying a car that is part of an ongoing car model, which you hope is being continually improved from year to year. The many years of product evolution that have gone into the Ford Mustang, for example, give the buyer of that car a certain comfort and security that are not present when purchasing a brand new car model in its first year of production. Only the "early adopters" will buy a new model car in its first year of production. In this same way, a consumer multimedia product also needs to establish itself in the market as credible and ongoing for more potential users to feel secure enough to buy it.

For these reasons, support and maintenance can be seen as a normal part of the software development cycle. This cycle will continue as long as the software is actively used.

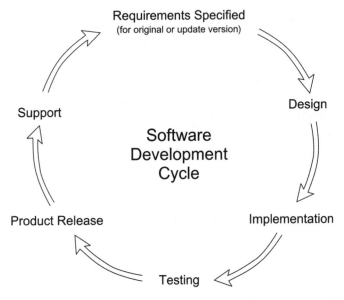

Figure 14.1 The software development cycle.

SUPPORT

If you are creating multimedia software for anyone else to use, you will most likely have product support issues. Users may discover defects and inquire about them. In addition, there is always the need to provide more instruction, guidance, or just plain encouragement to get someone to use a new piece of software. These needs may be minimal or resource-intensive, depending on the complexity of the software, the use to which it is put, and the skill level of users. However, the need to support users is certain as long as the application is in use. This may seem like an alien (and perhaps risky) proposition to those previously involved in video or print production, and rightly so. However, it is not as difficult as it might first appear and can even be simplified, for a price. The following discussion of user support is a brief overview; however, many fine works discuss user support in detail.

Purposes

Credibility

Supporting a multimedia application is essential to maintain its credibility among users. If users who have a problem can call and get polite, intelligent, and correct answers, it will enhance their satisfaction and their assessment of the application. On the other hand, if they call and get routed into a telephone maze, get connected with someone who can't answer the question, or, worse, if they cannot call at all (because no phone number is available), they will quickly become frustrated and lose faith in the product (and, by extension, the producers of that product). This applies equally to applications developed for in-house use. Some avenue of support must be available for those using multimedia applications. While in-house personnel may feel freer to call the developers or the project manager directly, that person may not know the necessary answers or may be under time or resource pressures that prevent satisfying the user's needs. If no mechanism for this support exists, the result will be disenchantment on the part of the end user. The inevitable result is that the application gets used less and less, if at all, and will most likely become an eventual failure. In addition, this unfortunate experience may have a negative effect on whether new multimedia projects are undertaken at the company. Therefore, creating the means of support is essential to the success of current and planned multimedia applications.

Feedback

Ongoing user support is also an essential source of feedback from users regarding design issues and outstanding product errors and defects. Users are one of the best sources of new design ideas and features. Only the end user has exactly the right perspective on using the product, and in doing so will notice things that can be improved and provide ideas for new features. In fact, in many successful ongoing applications, user suggestions comprise the bulk of new features added from one

version to the next. This is a valuable source of input for the product development team, and such users can be cultivated for surveys and focus groups. In addition, users will often have interesting ideas for new products.

Customer Contact

Support lines are also a great way to stay in contact with customers and help establish a satisfied customer base, which in turn is a strong defense in warding off threats from competitive products. Creating and maintaining a dialog with users has many benefits, ranging from allowing the development team to obtain a better user perspective to the public-relations value of showing users that the company cares about and is responsive to them. One especially good way to stay in contact with users is through a Web site, which allows visitors to the site to e-mail directly to the Webmaster or even to specific departments or individuals in the company.

Execution

Database

If the multimedia application is a consumer product or even a heavily used internal application, support personnel will probably need to record the calls received in some kind of database. It is important to log such calls, for several reasons. First, to know what kinds of problems users are having, so they can be fixed in future versions. Second, to have a record of the call, in case the problem was not resolved and the user must be recontacted after the answer is obtained through further research. Third, to help you learn more about the customer base and how customers are using the product. Finally, to perform measurements and analysis to help determine future courses of action, from determining whether it was worthwhile developing the product at all to gauging efficiency of support staff as measured in average time per call.

Interaction with Development

Since one of the main benefits of support is to gain insights into user response in preparation for future versions and updates, regular interaction between the support staff and the development team is important. This connection closes the loop in the development cycle. The development staff obtains fresh insights into the reactions of real users, while support personnel learn about the product and why it behaves as it does, which is invaluable when helping users. It is also helpful if this sort of information can be exchanged electronically (although this is no substitute for face-to-face meetings).

Revision to Manuals

Another area in which support calls can help is in highlighting desired modifications to the manuals or on-line help. Sometimes issues that cannot easily be solved

within the application itself can be dealt with in the manual. A classic case is installation problems. Various system configurations, like different sound boards or the need to close down other applications, that must be taken into account when installing the application may be easily solved in the manual. However, the manual should not be used as a dumping ground for all the problems and information that are better dealt with through a quality development process. If an application requires special consideration to get audio running, it is probably better to fix this problem within the application than to give elaborate instructions in the manual on how to get around the problem.

Many valuable suggestions can be obtained from users regarding the structure of the manual. If such changes are made, users may be able to find the information they need on their own, which can decrease the frequency and duration of support calls. This directly benefits the profitability of the application.

Alternate Support Methods

In addition to traditional telephone support, other methods may suit your needs. These include fax-back systems, computer bulletin boards, and World Wide Web sites. The primary advantages of these methods are cost and availability. Telephone support can become very expensive, especially if toll-free telephone support is offered, but even if the user pays for the call. Fax-back systems and other automated support systems provide relatively inexpensive support for both publishers and users. In addition, these systems are usually available to users twenty-four hours a day.

World Wide Web sites can offer a wide range of support services, ranging from FAQ (Frequently Asked Questions) files to indexed on-line help systems to allowing users to send e-mail messages to technical support personnel. The more users that need to be supported, the more appropriate it is to install an automated support system. Fax-back systems and Web sites are ideal for consumer applications that have mass distribution. A Web site might even be worthwhile for a widely distributed in-house application, such as one used by several hundred sales representatives. However, an electronic presentation used by one or two people probably doesn't warrant the investment of time and money to implement such a support system. If the application itself is a Web site, it is imperative to incorporate appropriate feedback mechanisms into its design.

Another option is to contract out-of-house with a professional software support organization. Several excellent support organizations specialize in providing such third-party technical support. They can be efficient in handling support calls, maintain detailed reports regarding customer calls and problems, and can be cost-competitive with in-house support. In fact, a number of large commercial software publishers outsource their technical support needs this way. The decision to use an out-of-house service will depend in large part on the number of users of the product. The more users, the more appropriate an out-of-house service may be.

MAINTENANCE

The term "maintenance" refers to any work done to the application after the first version has been released. While maintenance includes fixing defects, it also includes adding new features in updated versions and revisions to the user interface, if necessary. For those who imagine that software maintenance refers only to fixing problems, a natural assumption is that "properly written software" should not contain defects in the first place and therefore should not require maintenance. However, as previously discussed, this is almost never the case. If software is in use for any length of time, defects and content errors will be discovered, users will request new features, and the need for interface improvements will become glaringly obvious, all of which require software maintenance.

Maintenance is also required by the ongoing development of software platforms (new releases of operating systems, like Windows and Macintosh) and the increasingly powerful hardware available to end users at modest prices. Unless the developer can respond to this evolution through a regular maintenance cycle, the application will rapidly fall behind industry standards and have little chance of receiving ongoing use, much less continued success. Therefore, it is important to view maintenance as a broad category of ongoing development, not simply as fixing defects that slipped through the testing process.

Continually maintaining code is a trade secret of those who are successful in the software business, which also applies to multimedia applications. If a piece of software is to survive as a viable product, it must be kept reliable and up-to-date. This requires continual investment, which is often overlooked in the initial product-planning stages. This is one of the areas where experienced software publishers and developers have a strong advantage over new multimedia developers from industries where a product is developed once and then sold for years without revision, as in most book and video publishing.

Necessity of Design Documents

Your ability to maintain a software application depends in large part on being able to keep the original programmers available to work on the application and having them help and teach others how to maintain it as well (for the sake of redundancy and stability). In addition, maintaining and updating the application requires that the code be well documented, including a description of the development environment used to put the application together (hardware and software), fully commented source code, descriptions of the software architecture, and instructions on how to perform data preparation. In short, the documentation should contain as much information as possible to permit fully reconstructing the application, if necessary. Otherwise, there may be little chance of maintaining the application (aside from rewriting it from scratch) should the original programmer(s) leave or become unavailable for some other reason. For this reason, if the application is being

developed externally, it is important to ensure that the developer provides fully documented source code upon product delivery. In fact, in some ways, the source code is the end product, just as much as the compiled application is. This is absolutely essential, because the original programmers might not be available for maintenance work, because it may become necessary to convert the application to another platform, or because it might become necessary to temporarily move, delay, or even dismantle a project before starting on the next version. The more complete the documentation, the easier it will be to restart the project later.

The person responsible for maintaining the application needs the fully documented and commented source code, along with any additional software tools and libraries used to create the application and instructions on how they were used. This is where the completeness and currency of the design documents is most valuable. If the functional and technical design documents have been regularly updated during development and accurately reflect the final, released application, it will make maintaining the application much easier. Even a new programmer assigned to the project will at least have a good reference source to continue development work. However, if design documents have not been maintained accurately, they may be of little use to a new programmer, or worse, they may be misleading or inaccurate. For this reason, it can be seen that design documents are not a mere formality that, once approved, can be ignored. Rather, they represent a worthwhile investment in the future that will become absolutely necessary if the product is to have any life beyond the first version.

Continuity of Personnel

Finally, one of the most effective and cost-efficient ways to keep a product maintained is to keep the same development personnel working on the application, especially the programmers and data preparation personnel. These individuals become experts in the application and are great repositories of knowledge about the product. The learning curve for new development personnel (especially programmers) to get up to speed on an existing product can be steep. Retaining original personnel will greatly facilitate the maintenance cycle.

However, development personnel may not relish the thought of working on one product for the rest of their careers. They are typically creative individuals who like to work on new products, so some method must be employed to keep them interested. Hopefully, they can be cycled through projects over the long term, to provide them with variety while they train new personnel. This also helps widen the pool of knowledgeable individuals, as a safety factor in case one of them departs, and allows fresh ideas into old projects. Another way to keep an original staff member interested in a project is by increasing his or her level of responsibility as time goes on. Ideally, the lead programmer can move either into a project management position or to a different project and make room for a more junior programmer. This will keep the original lead programmer available for expert guidance.

EXAMPLES

Electronic Slide Show

The typically small scale of these applications and limited use they receive greatly lessens support and maintenance. Generally, a presentation used more than once requires minor changes from time to time. This usually includes changing text bullet points or graphics. Additional work needed to keep the program in use may include reinstalling it on various display machines and fixing any resulting technical glitches, as well as answering questions that may increase in frequency if additional people start using the presentation.

One major source of investment after a presentation has been released is the time and effort needed to ship the presentation hardware to an off-site location and, if necessary, to set it up there and even run it for the speaker. Even if you are simply responsible for shipping it out and receiving it when it is shipped back, you will usually have to check the machine upon its return, replace any lost cables or adapters, and so on. This shipping and maintaining the hardware system is a real cost in time that must be budgeted for in some way.

Consumer Multimedia CD-ROM

A consumer CD-ROM requires perhaps the highest level of support and maintenance. Not only is it in use by (hopefully) thousands of users, but it is subject to use on a wide spectrum of target platforms. The large number of users means many more calls regarding installation, operation, and design. The variety of hardware platforms means software defects will be exhibited more frequently, and the application will need to be in a virtually continuous maintenance cycle. In addition, competitive products in the market will drive the need to regularly incorporate new features and redesign the interface. As mentioned earlier, on-line and electronic support like Web sites, e-mail, and fax-back systems can substantially lower cost and time for support personnel.

Trade Show Kiosk

A trade show kiosk will require logistical support and hardware support as well as any end-user support. Since a trade show kiosk is usually in use on a very limited number of machines, it generally does not include supporting numerous users with widely varying needs and hardware. However, the physical demands of shipping such a system and exposing it to public use (and possible abuse) ensure that problems will be encountered with the equipment, especially at the beginning, when sales personnel are just learning how to set it up and operate it. For the application to maintain its timeliness, a regular maintenance cycle must be established, in which new content and/or data are added (such as information on new products or pricing) to keep the application current. In addition, if the kiosk is being used to

generate sales leads, this information must usually be extracted (or copied) from the system right after the trade show so it can be made use of by the sales staff.

Web Site

Support and maintenance is of prime importance for Web sites and is qualitatively different than for other kinds of multimedia applications. Not only must Web sites be hosted on "live" servers—which themselves require continual maintenance and support to ensure that they are stable, secure, and available twenty-four hours per day—but if the site itself is to be of value, it must be regularly updated with current information.

In addition to basic maintenance and updating, Web sites are usually under continual design changes, to which the medium lends itself. If the navigation structure is confusing, pages can often be changed easily in HTML, then uploaded to the server in minutes and become immediately active.

Finally, the explosive evolution of the Web and the capabilities it allows, through new programming languages and techniques, are continually upping the ante for companies to make their sites competitive and draw traffic. Most companies with Web sites also have long lists of new features they'd like to implement and existing features they'd like to enhance. These features are usually developed as subprojects and phased in as they are completed, in an ongoing process. For this reason, a successful Web site requires an ongoing investment.

The benefits of the Web site must be sufficient to warrant such an ongoing investment. Web sites need clearly established and (hopefully) measurable goals. Otherwise, the investment may be viewed simply as a nonretrievable cost, and support for the project can easily be removed.

Several factors will determine the ongoing cost of maintaining a Web site, including the size of the site, the level of interaction supported, and the quantity and volatility of the data that can be accessed at the site. The bigger (more pages and data) the site, the larger the amount of hard disk storage space it will require and the greater the expense. The more intricate and customized interaction allowed, the higher the cost for system programming and data preparation to support such interaction. If the site contains large amounts of data to support such interactions and that data changes frequently, the cost to obtain and prepare the data on a regular basis will be significant.

Web sites usually require a much higher and qualitatively different level of support than most other kinds of multimedia applications. However, this higher level of support is hopefully warranted by the benefits gained from the site, including extensive use-value by users and increased communication with and feedback from users for marketing and planning purposes. In addition, the ability to actually generate revenue directly from a site by selling advertising space or letting users order products on-line can help defray Web site maintenance and support costs.

Appendix A

*The Perils of Partnership:** *

Contracting for Multimedia Development

At least one developer has remarked that doing a multimedia project without a contract is like bungee jumping without a cord. While some large software development companies can do virtually all their multimedia development and publishing in-house, most companies need to work with a development or publishing partner. And with the fluid nature of multimedia development, the temptation for mid-course design changes, and the get-rich-quick expectations of many entrants in the multimedia CD-ROM field, signed legal contracts between partnering developers and publishers are as necessary as the partnerships themselves. One of the long-term advantages of drafting full-fledged contracts is precisely the short-term hassles their negotiations create. The ups and downs of hashing out contractual minutiae can prove a harbinger of how the partnership itself will play out as the title is developed. The process of discussing, negotiating, and ultimately agreeing on contract terms forces the partners to consider details of the arrangement that may not be obviously apparent. It also helps them check assumptions and account for tasks and decisions that may have been ignored or tabled during initial discussions. It can be quite disappointing for a developer to realize that the publisher expected him to handle technical support or for a publisher to realize the developer had no intention of turning over source code at the end of the project. Multimedia development partners are much better off settling such issues before the project gets started. Therefore, the process of negotiating the contract can be as important as signing it.

In addition, the process of negotiating a contract can give you valuable insight into the personalities, attitudes, and priorities of your partner. As you negotiate the contract, you must converse and communicate in much the same way you will have to on the project you jointly undertake. If you find it difficult to negotiate with this partner on the contract, chances are you will find the project itself similarly trying—a good reason to start looking for another partner before the contract is ever penned.

*Originally published by *CD-ROM Professional*, now called *EMedia Professional*. Vol. 8, No. 12, 1995.

PRELIMINARY ISSUES

Negotiation Know-How, Step One: Know What You Want

The best strategy for drafting a serviceable contract is to know what you really want before entering into negotiations. For example, as a developer, whether you want a royalty arrangement or would prefer to sign on as a job-for-hire to bring in some immediate revenue obviously has a tremendous effect on what you will look for in negotiations. Often, what publishers want and what developers want are different things. The primary criteria developers seek in a satisfying contract negotiation may include the following:

- a steady income during development that, at minimum, covers incurred costs
- a royalty interest in the product
- visibility that comes from being associated with successful products
- creative flexibility

The expectations publishers bring to negotiations may include the following:

- a reliable project schedule that allows close monitoring of title development
- a responsive developer who will listen to and accommodate their needs within reason
- relief from overseeing the day-to-day details of developing a multimedia application
- leveraging their assets (content material)
- establishing and maintaining a strategic market position
- technical expertise

Negotiations should proceed more predictably and fruitfully if expectations like these are clearly determined and stated early in the process.

Partnership Problems: Contract as Crutch?

One of the most important things a company can do to ensure a successful development contract is to choose a good partner. Any significant project will involve a long-term partnership with potential long-term consequences. A contract will not protect you fully from dishonest partners; despite whatever legal recourse it may provide, it will not restore the lost time, opportunity costs, or pure aggravation associated with dealing with an ill-chosen partner who, as the project drags on, may try to manipulate the contract's terms to promote a self-serving agenda.

Companies have been known to enter into contracts with ulterior motives. For example, some developers have been known to sign contracts with a famous company for publicity purposes, in order to have a well-known name on their client list. Some publishing companies have signed contracts with a development company to learn the secrets of its development strategy. Once a contract is signed under false pretenses, it may prove nearly useless to repair the damage, because few contracts are in fact enforced to their full extent. What good contracts can do is help maintain favorable working relationships by establishing mutually agreed-upon roles and a delineation of responsibilities. For instance, if the contract states that testing and quality assurance will be handled by the publisher, the

Contracts versus Letters of Agreement

Some multimedia development partnerships don't necessarily require a full-blown contract; in many situations, something significantly simpler will suffice. One frequently viable alternative is a Letter of Agreement (LOA). LOAs are often used when a project involves working with an individual on an hourly basis; they also serve well in situations when you need work to begin while the final terms of the formal contract are still being negotiated.

LOAs typically specify an hourly rate, the job to be performed, and a duration or length for the agreement, and are particularly appropriate to projects that require working with an individual programmer, artist, or tester. Contracts are usually signed and negotiated between companies and specify many parameters about the project and define the working relationship on an LOA.

developer can relax on that issue, knowing that the publisher is responsible. Most important, developing a worthwhile contract should not be regarded as a goal in itself, but rather a means to an end. The contract does not need to be a work of art, incorporating the finest legalese, anticipating every imaginable complication, and formatted with the care and elegance of the Magna Carta. If one party really wants to get out of a contract, they will find a way, legal or not, and if they are in a breach of contract, the other party is likely to find it too expensive and inconvenient to prosecute. The best contract is one that the parties never have to refer to. Conversely, if you find yourself frequently arguing with your partner and referring to the contract, you'll be glad you drafted a good one; however, you'll probably be loath to work with that publisher or developer again.

Participation by a Lawyer: An Intelligent Investment

Just as it is foolhardy to start developing a multimedia title without a contract or to contract with a partner whose motives are suspect, it is also unwise to write a contract without having it reviewed by a lawyer. However, more projects have been stalled in the hands of lawyers than for probably any other reason, yet the blame tends to reside less with the lawyers themselves than with the misuse of their services. There are various schools of thought on when to involve lawyers in multimedia contracting and to what extent, ranging from having them present from the initial discussions through the end signing—to asking them only for a rubber stamp of approval on a contract that's already been negotiated and written. A more moderate method that seems to work well: start with a boilerplate contract the lawyer has previously approved, keep him or her apprised of the negotiations as they proceed, and then ask the lawyer to review the final contract before signing. This approach allows the contracting parties to be each other's primary contact through initial discussions and substantive issues. Finally, a draft contract may be submitted to the lawyer for review and comment on any issues that may have been overlooked. A lawyer can also be an invaluable resource when negotiations have stalled over a particular issue. Sometimes, when two positions appear mutually exclusive and it seems

as though the whole deal will break down over some seemingly trivial detail, a lawyer can suggest an alternative acceptable to both parties.

Deciding the Big Issues Up Front: Initial Conversations

One of the most important stages of a successful contract for multimedia development is determining exactly which services the contract will stipulate. Design, development, testing, and documentation can each be contracted for separately, if necessary; for example, if a publisher can use its own internal resources to generate software documentation, then perhaps the user manuals don't need to be included in the developer's contract. The mix of services contracted for, however, will depend on issues like the core competencies of the individual companies. And what about the terms and nature of the agreement? Will the publisher contract the developer's services on a work-for-hire or royalty basis? And the payment question itself can't be answered satisfactorily without considering who will own the rights to the raw material or source code of the title following its development cycle and initial market run. All these questions cut to the heart of the development process when a partnership is involved and must be discussed early in contract negotiations to lay groundwork for the finer details to be ironed out later.

Royalty versus Work for Hire

One of the bedrock issues of multimedia development contracting is whether the developer will receive a royalty from sales of the product or if the job is strictly a work-for-hire arrangement in which the developer will be compensated in individual fixed payments. The royalty approach has distinct advantages for both parties, since the monetary interest the developer may take in the continued success of the product will help the publisher by adding incentive to develop a superior product. In addition, development costs assessed tend to be lower, because the developer expects to make more money in the long run through royalty payments, and the publisher will still tend—in spite of the developer's continued stake in the returns—to retain control of the product's marketing and sales strategy. The disadvantages to publishers of paying royalties are twofold: besides making sales income less lucrative, the administrative overhead incurred to process developer payments can add costs. Work-for-hire arrangements, in which payments to the developer are made on a flat-fee basis, with no proceeds from the title's sales, are generally more lucrative—in terms of profits and control—for publishers of successful titles than contracts calling for royalty payments to developers. However, when contracted on a work-for-hire basis, the developer is usually less committed to supporting and maintaining the title following its release, which may leave the publisher holding the bag should complications arise. Of course, such a work-for-hire arrangement does leave a publisher who is dissatisfied with the initial partnership free to seek subsequent help elsewhere. And the up-front costs charged for development are, of course, significantly higher, since they represent the developer's entire compensation for work on the title.

Product Ownership: Key to the Kingdom

Another key issue in contract negotiations is who owns the product upon completion and what that ownership means. Generally, owning the product means owning the source code and data, as well as legal rights to their unrestricted use. If the developer "owns" the product, the publisher is contracted primarily for marketing, duplication, and distribution of the

developer's work. Ownership also includes the responsibility to update and modify the program. If the publisher owns the product, then it will need to understand and have complete access to the source code and development environment and must own any relevant copyrights. The owner also handles liability in the case of misused data or code. If the product is developed on a work-for-hire basis, the code will generally belong to the publisher. Otherwise, the publisher is less likely to own the application upon its completion.

Who Writes the Contract?

Finally, one of the most important issues to settle is who will actually write the contract; that is, which party is responsible for creating and maintaining the physical document that gets negotiated. One party will be responsible for filling in the details, making changes, and preparing the document for signatures. The physical document is then submitted to the other party for review and comments. It doesn't matter whether the developer or publisher handles the document, but whoever does, it is paramount that the drafting process allow quick modifications by experienced people. Otherwise, delays in preparing the physical document can slow the process, and by the time the new version has been prepared, memories may have faded regarding which details were to be altered and why. In addition, one party often has more experience in contract preparation and may even have a standard contract template or "boilerplate" to use.

THE CONTRACT

Precontracting: Making a List, Checking It Twice

Once the big issues have been sorted out, one way to ensure that matters proceed "according to Hoyle," so to speak, is to draw up a checklist or "precontract" that ties both parties to a common understanding about the project. This forces the parties to inventory and discuss their positions on significant issues early in the process and thereby avoid much potentially wasted time and aggravation. The checklist is a short list of the most important items, which may allow negotiations to start before the actual contract is written. In a sense, the contract itself should just spell out in legal language what has already been agreed to by the two parties. The items in the checklist can be discussed amicably in a series of meetings or even over the phone. In the course of these meetings, the two parties should settle most of the nitty-gritty details of the project before entering them into the physical contract, because once these items are written into the contract, they are more difficult to change or negotiate. Once the terms are in writing, people feel wedded to the positions they have taken, and such "physical" modifications can have a ripple effect on other places in the contract. While changes are certainly negotiated in the contract itself, it is best to try to keep those changes to a minimum, so that the party who is not preparing the contract feels it has some control over the process.

Seeking and Tweaking the Boilerplate

Once preliminary negotiations have been completed using the checklist, the designated drafting party can then start writing the contract, which usually entails filling in the details of an existing standard contract boilerplate. Writing a software development contract from scratch is a huge effort and a sizable project for a qualified attorney. However, software

A Sample Precontracting Checklist

Although the details may vary, most multimedia development precontracting checklists contain several common items that represent an informal record of preliminary negotiations resolved before the drafting of the actual contract has begun. As well as establishing a rough schedule for product development, testing, review, and release, the checklist items typically include answers to the following questions:

- Who owns the source code?
- Does the developer retain rights to use and modify the code?
- Who provides technical support for the title's users?
- Does the developer handle technical support for product maintenance?
- Who does testing and how much is done?
- Who owns the final product?
- Who distributes the final product?
- What development environment will be used?

development contract boilerplates are readily available for customization to the details of particular projects. Sources for contract boilerplates include the Software Publishers Association and various law handbooks about multimedia. Ideally, the boilerplate should be reviewed by an attorney, to make sure it suits the needs of the project. Contracts can vary in length and detail from short one-page letters of agreement for the services of an hourly programmer to fifty-page documents detailing payment and proprietary arrangements with an established software development house. Finally, it is important that whoever is negotiating and preparing the contract understand the contract and the language it contains. Most boilerplates contain a great deal of legalese, of which the contracting parties—not just the attorneys—should have a working grasp. Many questions arise that the affected parties need to answer, and the legalese within the contract should not impede this negotiation process.

Negotiating the Contract

Normally, one of the parties is responsible for modifying and maintaining the contract during the negotiation phase. To have both parties modifying the contract simultaneously through this revision phase can prove extremely awkward; the process seems to go best with a series of back-and-forth review phases with documented edits, commentary, and discussions of outstanding issues. During the review process, it is important that the contract include an escape clause, commonly called a "termination clause," in case the project goes awry. Some penalty payment may be incurred, or the loss of content material or of rights to work done to that point, but the clause will greatly reduce the possibility of a breach-of-contract conflict. Once both parties have agreed on the contracted project terms, the respective lawyers can then review and—in the best case—approve it without too many changes. Several situations may occur in contract negotiations that create unexpected snags. For instance, items occasionally

need to be specified in detail in the contract, but the details have not been worked out by the contract's signing. This usually occurs in the section describing the application envisioned. For example, the major features of the application have been discussed and agreed to, but many of the details may still be outstanding. In such a situation, it is sometimes appropriate to incorporate a clause like "to be mutually agreed upon during the design phase," which allows the contract to be signed with unresolvable issues temporarily tabled. Another situation that can cause considerable inconvenience but can be easily fixed is the projected dates of the "milestones" that highlight the development process. For example, if the parties plan to sign the contract on January 1—with the signing date considered the first milestone—and the design specification is due one month later, which would seem to be February 1, then if the contract isn't signed until the middle of January, the milestone will be cast askew and continue to change as the contract undergoes subsequent revisions. A more fluid contract would designate the dates in "project weeks," like "Design document—Week 4," and "Alpha version—Week 10." This approach leaves the milestones untouched once they are agreed upon, regardless of how many revisions take place. The actual dates can then be filled in for project management purposes once the contract has been signed. A healthy contract will also be designed to provide significant motivation for the developer to finish the project on schedule by including a bonus for finishing a project early or on time. Bonuses can be administered as lump sums upon completion of the project, an extra percentage point in the royalty payment, or even as a sum for each day or week the project is finished before its expected time.

Details, Details: The Case for Contract Specificity

Contracts must be as specific and detailed as possible. One test of a good contract is whether someone besides the person who negotiated it could pick it up and use it to manage the project; that is a good guideline to use when checking a contract for specificity and phrasing. Deliverables should also be defined carefully, including exactly what is meant by the "Design Specification" (how long, what format, what kind of information or drawings, and the like); "Alpha" (what kinds of bugs are permissible, how much content, what media will it be delivered on, and such) and the other specified milestones. A clear definition of these milestones can prevent many disagreements when the developer presents the deliverable for approval and payment. Another item that should be specified in detail is any equipment, content, or services to be provided by the publisher to the developer, and in which format and media. These responsibilities should be well defined, so that neither party expects something from the other party to which the other party has not agreed. For example, if the developer is to provide a certain level of testing, items such as how many hours of testing are required, by whom, and under what conditions should be clearly spelled out, as well as who will pay for additional testing if it is needed. Finally, remedies for breach of contract by each party should be defined, as well as exactly what constitutes a breach of contract within the particular arrangement.

Payments and Approval Dependencies

Usually, contract payments to developers correspond to milestones, and developers plan and budget for staff and expenses according to these anticipated payments. Frequently,

however, developers must receive materials (such as content) from publishers to reach these milestones. If the publisher is late supplying materials to the developer, the developer will be late reaching the milestone. This means the developer will be late receiving payments through no fault of its own—due, in fact, to the negligence of the party bound by contract to pay the developer. When this happens, the developer begins to incur the additional costs of keeping staff employed while awaiting payment, particularly during the approval process, when a developer has submitted an alpha version to the publisher and is expecting a sizable payment linked to that early milestone. Say, however, that the publisher needs four weeks to approve it, rather than the two weeks specified in the contract. When situations like this arise, it is not unusual for the contract to call for a partial payment if the fault for the delay lies with the publisher. The intent here is not to punish the publisher but rather to keep the developer solvent and advancing the project while the publisher takes whatever time is necessary to evaluate the work. On the other hand, there are times when a developer is chronically late or perhaps even incapable of completing the project satisfactorily. In these cases, it may not be a matter of rescheduling milestones, renegotiating payments, or adding resources. Instead, the contract should include some mechanism for the publisher to take control of the project. This scenario happens more frequently than one might suppose, and for this reason, it is important that the development environment be fully documented, the code turned over in usable form, and that the publisher face no restrictions regarding selecting and hiring a new developer to complete the project. This scenario should also be foreseen and addressed within the contract. One "perk" for which developers often negotiate is the "right of first refusal" to do a future version of the application that may involve, for instance, adapting a Windows program to the Macintosh, or developing a sequel. However, right of first refusal is difficult to enforce, and if the publisher does not want to work with a developer again, the developer has little chance of forcing the company to do so. Actually, such a forced relationship would be disastrous for product development. Projects can be bid out in myriad ways, and first refusal rights may amount to nothing more than an assurance that the publisher will consider the developer's bid on doing future versions—a reasonable assumption with or without the written clause.

Opting to outsource the development of a multimedia CD-ROM can be as demanding a proposition for a publisher as budgeting, building, and managing an in-house development staff. What's demanding about hiring an outside developer is the risk that comes with investment and partnership. Developers also face risk, in that they virtually put their businesses on the line when they enter into agreements with publishers. Consequently, development contracts should be drafted in such a way that they protect both parties and reflect an equitable arrangement. However, with the security and predictability that result from cultivating a partnership and sealing it with more than a handshake come contracting complications that should be taken no less seriously than developing the title itself.

Resources for Multimedia Contracting

The February 1995 installment of Richard A. Bowers' THE RESOURCE DIRECTORY, "Courting Legal Resources for CD-ROM and Multimedia," included several entries that may provide useful resources for partnering multimedia developers and publishers seeking sample boilerplate contracts, road maps to the intricacies of the development contracting process, and much in between. The following are excerpts from that Directory, including titles relevant to the contracting process, plus contact information and Bowers' commentary.

Multimedia Law Handbook
By Dianne Brinson and Mark Radcliffe
Ladera Press
3130 Alpine Road, Suite 200-9002
Menlo Park, CA 94025
415/854-0642

Softcover, 1994, 340 pages, $74.95 ($99.95, with optional PC disk)
Designed for the nonlawyer, the *Multimedia Law Handbook* is a comprehensive practical guide to the legal issues involved in developing, publishing, and protecting your multimedia products. Covers a wide range of legal issues including contracting with employees and independent contractors, licensing content, contracting for sale or distribution of your work, and protecting your intellectual property rights. Includes a PC diskette with forms and ready-to-use contracts.

The Multimedia Producer's Legal Survival Guide
Stephen McIntosh
Multimedia Computing Corp.
SIMBA Information Inc.
213 Danbury Road, Box 7430
Wilton, CT 06897
203/834-0033
Fax 203/834-1771

Looseleaf binder, $299 including floppy disk
The current availability of this publication is unknown as the original publisher was acquired and the current owner is uncertain of its status. This is a valuable resource, if it can be found.
The currency of the language has been superseded by the *Multimedia Law Handbook* from Ladera Press, but the *Survival Guide* contains contracts not sampled in other publications, including nondisclosures, employment agreements, and joint venture agreements.

Negotiating Contracts in the Entertainment Industry—Audio Tape Seminar
Michael I. Rudell, Chair
The New York Law Publishing Company
345 Park Avenue South
New York, NY 10010
800/888-8300, Ext. 6000; 212/545-6000
Fax 212/481-8110

Audio tapes and course book, $295 (tapes), $55 (book)

 Recorded sessions and print matter from a three-day seminar held in October 1993. Covers key issues to be addressed in developing properties in book publishing, television, film, theater, and music.

Entertainment Law & Finance
Stan Soocher, Editor
Leader Publications
345 Park Avenue South
New York, NY 10010
800/888-8300, Ext. 6170; 212/545-6170
Fax 212/696-1848

Monthly newsletter, $185/year

 "Entertainment" covers a wide spectrum of activities, including theatrical events and sports, but many of the principles—reflecting the cultures from which these industries grow—can play crucial roles in negotiating contracts that can coexist with more traditional media ventures.

Multimedia Law: Forms and Analysis
Richard Raysman, Peter Brown, and Jeffrey D. Neuberger
Law Journal Seminars Press
345 Park Avenue South
New York, NY 10010
800/888-8300, Ext. 6000; 212/545-6000
Fax 212/481-8110

Looseleaf, 1994, $85

 This looseleaf service contains 46 forms designed to step through negotiations and deal-making for multimedia productions, as well as substantial background in the patent, copyright, and trademark arenas—plus established contract law. Updates will be provided as needed.

Software Publishers Association Legal Guide to Multimedia
Thomas J. Smedinghoff
Addison-Wesley Publishing Company
One Jacob Way
Reading, MA 01867
617/944-3700, Ext. 2278

ISBN: 0-201-40931-3, 1994, Softcover, 672 pages, $44.95, includes PC disk

 The Software Publishers Association is responsible for this book, which adds to their other related book, *SPA Guide to Contracts and Legal Protection of Software* (1993), also written by Smedinghoff, the intellectual property counsel for SPA and a partner at the Chicago law firm of McBride Baker & Coles. This book addresses such issues as licensing content of all kinds, contracts with independent developers, ensuring ownership of rights, and protection for copyright, trademark, trade secret, and patent rights in multimedia works. According to SPA's executive director Ken Wasch, in the book's foreword, "If you are serious about the issues involved in merging code and content, you will want this guide to be nearby." The floppy disk contains checklists, templates, and other forms and guidelines that correspond to coverage of the book.

Appendix B

The Development Tool Fandango: *

Deciding the Authoring-System-versus-Programming-Language Question

When developing a multimedia CD-ROM, one of the most important decisions is the choice of a software development tool. While there are many other issues to wrestle with—determining the target platform and understanding distribution methods, to name just a couple—the choice of development tool will have a major impact on the timely development, feature selection, and maintenance of the title. When it comes to creating multimedia titles, development tools fall into two camps: authoring systems and programming languages. An authoring system is a special software program that attempts to eliminate programming from the development process, so that "nonprogrammers" can create multimedia applications. A training instructor might use an authoring system to create instructional presentations that contain menus and display graphics, text screens, and animation. One of the earliest interactive authoring systems, "The Instructor" (BCD Associates), was designed to let teachers create interactive videotape programs for use by the students in their classes. Programming languages like C, C++, and Delphi are used by computer programmers to custom-develop applications. These programming languages are flexible, powerful tools for developing a wide range of computer software, including multimedia applications. For instance, one of the best-selling CD-ROMs, *Compton's Multimedia Encyclopedia*, is written in C++. To create a title using a programming language involves writing many lines of computer code, which is generally unintelligible to nontechnical persons. This source code is then compiled into executable programs. Some types of applications tend to be developed using authoring systems, others using programming languages. In general, applications that have unique features, especially consumer titles, tend to be developed with programming languages. In-house training and educational applications, prototypes, museum displays, kiosks, and presentations tend to be developed with authoring systems. Established software development houses like Electronic Arts and Brøderbund generally use programming languages, because they need to create new, compelling features that help users decide to purchase their products. In other environments, such as in-house training and

*Originally published by *CD-ROM Professional*, now called *EMedia Professional*. Vol. 8, No. 2, 1995.

presentations, these sorts of competitive pressures do not exist. Other pressures, however, such as how quickly a simple application can be put together, favor the use of authoring systems. While authoring systems and programming languages offer fundamentally different approaches to development, they are not mutually exclusive, and a gray area, or a continuum, exists between the two extremes. Macromedia Director is an authoring system that provides a background scripting (programming) language named "Lingo" to let the developer accomplish functions not supported in the general authoring environment. Some developers even use authoring systems as a sort of "glue" to hold together specialized modules written in programming languages.

AUTHORING SYSTEMS: THE ARGUMENT

Authoring systems range from simple, easy-to-learn presentation tools like Microsoft PowerPoint to more complex programs like Director (Macromedia) or Asymetrix Corporation's Toolbook. Authoring systems try to shield the user from the task of "programming" by letting the user tell the computer what to do in some graphical way, such as manipulating a flowchart, placing "cards in stacks," or constructing a timeline. Flowcharting is one of the most popular metaphors among authoring systems. With a flowcharting system, the user can construct a flowchart of the intended program from a collection of provided icons,

Figure B.1 Microsoft's PowerPoint is an easy to learn presentation tool, with templates and directions on screen so the casual user can quickly create attractive multimedia presentations.

then run the application right from the flowchart. With Macromedia Authorware, the user merely drags icons (such as a "Screen Display" icon) to the appropriate spot in the flowchart, then double-clicks on the icon to open it and choose options that specify that icon's function within the program; a "Try It" pull-down menu makes the program test-run. The icons can easily be repositioned and their behavior modified until the program operates as the user intends. The timeline approach in an authoring system lets users construct a program by placing items on a timeline. One can set the program so it branches between various spots in the timeline. A good example of this is Director, in which the timeline (called a "score") is segmented into "frames." Interactive objects called "cast members" (such as buttons) are programmed to perform their respective actions, including branching between various spots on the timeline. Such a timeline approach allows the user to construct a program with multiple tracks so that simultaneous effects can be achieved, like playing an audio file while running an animation. These authoring systems' graphical interfaces, while easy to learn and use, are composed of predetermined program modules and have inherent limitations in the flexibility they allow. To make up for these limitations, many authoring systems allow the knowledgeable technical user—often called a "power user"—to access some sort of scripting (programming) language to make more sophisticated modifications. Some authoring systems even allow sophisticated users to incorporate their own custom-coded program modules, thereby achieving results not specifically supported by the authoring system. In this way, they try to provide the ease of use of a graphical interface and the power and flexibility of a programming language.

Advantages

Authoring systems offer some significant advantages. The main benefit is that they are usually relatively quick and easy to learn, with easy interfaces and built-in features, and offer quick prototyping of applications. One can often start using an authoring system within a week or even a few days. Some authoring systems come with their own tutorial overview program that lets the user get started authoring quickly, sometimes even in a matter of hours. The graphical interface provided by most authoring systems is a convenient way to visualize the underlying flow of the program and handles many of the detailed programming instructions automatically. Authoring systems usually contain dozens of features, each of which could take many hours to program from scratch. To display an animation may require a programmer to write dozens of lines of code in C. However, the programmers who wrote AimTech's IconAuthor have already written the code to display several kinds of animation files, like FLI and AWI, within the authoring system. To include such animation, the user simply provides the animation's filename. One area in which authoring systems excel is prototyping. They are handy for quickly mocking up an application, showing it for feedback, and making changes before committing to a final design. Authoring systems are often used by designers to test out ideas and refine the interface before turning the application over to a programmer for actual coding.

Disadvantages

Authoring systems have some significant limitations and disadvantages, such as slower execution, limited target machines, higher cost, and dependence on the company that produces the authoring system.

Figure B.2 Macromedia Director is an authoring system that uses the metaphor of a musical "score," which allows the author to specify the actions of various "cast members" (listed vertically) against a horizontal axis timeline. Notice the Lingo script window that can be used to add functionality not included in the basic authoring system.

Applications created using authoring systems generally run slower than those developed with a programming language. The authoring system itself represents an extra layer of programming that the computer must process at run time, thereby slowing down the program. Applications created in authoring systems generally require that the authoring system itself, or a run-time version (often called a "player" program), be present on the user's machine. This requires more memory and more resources and thus limits the machines on which the finished application can run. For this reason, applications created with an authoring system are generally more successful when one has some control over the target hardware. Examples include in-house training situations, where machines are purchased specifically for a particular application, or kiosks, where only one or two delivery systems are installed and are configured specifically for that application. Authoring systems can be much more expensive than programming languages. Currently, Authorware retails for approximately $5000, compared to $500 (or less) for some sophisticated programming language compilers, like Java or C++. And for a significant project, several people may be authoring simultaneously, requiring the purchase of several copies or a site license, thus increasing development costs. Authoring systems are themselves software programs requiring support and maintenance. They are certainly not immune to having bugs, which may manifest themselves in your application. However, since you cannot fix these bugs yourself, you may have to redesign your application to avoid them, or worse,

wait until the authoring system company gets around to fixing them. Likewise, new features you may want must await development by the authoring system company at some future date, if at all. Since authoring systems provide a predetermined and therefore limited set of functions, some authoring systems allow the "power" user to incorporate custom-coded programming. However, the method for doing this varies, depending on the authoring system, and the degree of incorporation also varies. Authorware merely allows the user to temporarily exit the application and run a separate software program; when the external program is finished, it reloads Authorware and returns control. Other authoring systems allow the secondary custom code to be integrated completely into the main application; for example, Allen Communication's "Quest" lets users write their own C code directly into the authoring environment, where it gets compiled into the final authored program. The various methods for increasing the functionality of authoring programs may or may not be suitable for your particular application, however. An authoring system that lets you exit to run a separate program may be fine for an educational application that simply needs to branch off and run a freestanding game, for instance, but that same authoring system might not suffice for an electronic encyclopedia that uses simultaneous interdependent controls to index and search text, query a database for filenames, and provide bookmarks to backtrack the user's actions. Indeed, some users liken authoring systems to being on a bus: you get the convenience of letting others drive, but you are on their schedule and can only get off at designated stops. The designers of authoring systems must make tough choices about which features to include, based on assumptions about what the users are going to want to do with the system. The choices they make impose limits on what the authoring system can do and how to do it. This means that sometimes features you want in your application are not included in a particular authoring system.

PROGRAMMING LANGUAGES: THE ARGUMENT

Programming languages are not very much like taking the bus; instead, the analogy might be the high-performance sports car: anyone with a driver's license can drive it, in theory, but the reality is that it takes skill and experience to go fast and handle the curves. Programming languages hold many advantages for title developers, but there are some significant disadvantages too, especially for certain types of titles and title developers.

Advantages

The power, flexibility, and fast execution of programming languages can have a significant effect on the final application. In addition, programming languages can be used by programmers without special "multimedia" knowledge or particular authoring-system training. Power and flexibility remain the main benefits of using a programming language. One can write an application with unique user interface controls and features that will run on target computers with minimal memory requirements. Speed of execution is a close second in the benefits column for programming languages. Applications created in most programming languages get compiled and linked, and as a direct result, run much faster than the interpreted applications created by most authoring systems. The difference between waiting a quarter of a second for a compiled program to display a screen and waiting up to five seconds for an authoring system to do the same thing can be extremely significant

Figure B.3 Microsoft Visual C++ is an object-oriented programming language. It makes use of a predominantly text-based interface, and requires a significant learning curve for users to become proficient enough to develop multimedia applications.

to the end user and may ultimately spell the difference between an application's success and failure. Another advantage to using a programming language is the many competent programmers available. While they are not inexpensive to hire and may not have multimedia experience, competent C programmers are much more plentiful than the rare, expert user of a particular authoring system. One practical benefit can be that if an application being developed in a programming language falls behind schedule, it is easier to find a decent general-purpose programmer to help make up time. However, it is important to note that the skills of programmers are usually different from those of "authors," and this will affect the organization of a development team. Programmers are rarely well versed in the field of instructional design, which can require that other members of the team perform instructional design tasks. Another important consideration is the potential dependability of the application. Programming languages are held to strict quality assurance standards; they provide programmers with dependable commands and small building blocks with which to construct the application. Nearly every problem that surfaces in a programmed application can be traced back to how that specific application was written and can (hopefully) be fixed by the application programmer. Authoring systems, on the other hand, since they are themselves built from programming languages, are more likely to contain their own bugs, which in turn may decrease the dependability of the final applications they are used to develop.

Disadvantages

Programming languages, however, are not without disadvantages, such as higher personnel costs and, generally, longer development time. Although the benefits in power and flexibility may be well worth it, experienced programmers are, in most instances, higher paid than "authors," since they have significant technical skills. In addition, programmed applications usually take longer to create, thus raising costs even further. In contrast, a small, in-house training presentation may be easily created in an authoring system by a less technically skilled person and may not require the expertise of a top-flight C programmer. It may well take longer to program a simple application than it would to develop it with an authoring system. It generally takes longer to build a product using a programming language, since one must create more of it from scratch and work with smaller "building blocks."

AUTHORING SYSTEM/PROGRAMMING LANGUAGE CONTINUUM

Authoring systems and programming languages both provide the means to create multimedia applications and can be seen as opposite ends of a spectrum. At one end are basic authoring systems and even presentation tools that provide limited functionality in exchange for simplicity and ease of use. At the other end are programming languages that rely entirely on written source code. However, many products fall somewhere between these two poles. Examples follow:

> *PowerPoint (Microsoft):* An electronic slide show program that lets the user create screens and display them individually or as part of an automated presentation. PowerPoint provides a single, menu-driven interface, with a simple paintbox/graphic layout tool to create those screens. It supports minimal interactivity.
> *IconAuthor (AimTech):* An authoring system that lets the user create a visual flowchart of an application, using icons that are provided. No background scripting or programming language is supported within the authoring system.
> *Director (Macromedia):* This authoring system allows the user to arrange interactive objects on a timeline and, for most applications, requires the use of its proprietary "scripting" (programming) language, named "Lingo." The more sophisticated the application, the more complex is the use of Lingo, which means that Director is a good example of an authoring system well down the road toward programming language.
> *Visual Basic (Microsoft):* Visual Basic lets the user easily "drag and drop" user interface objects onto the screen, then program their behavior with the Basic-like programming language. In addition, Visual Basic allows freestanding code modules to be integrated within the application and compiled into executable program files, and so stands in as an authoring-software-like programming language.
> *C and C++:* These programming languages require a programmer to write code for user interfaces and programming routines in a sophisticated, script-based language. They are not usually represented with any graphical metaphor, and are unintelligible to nonprogrammers.

As one uses an authoring system more and more, it quickly becomes apparent that authoring systems can become quite complex. To do anything but the most trivial application requires many of the same techniques used by actual programmers, including loops, "if/then" and "case" statements, and handling variables. By the time one does a significant application with an authoring system, the developer is often essentially doing programming anyway, as evidenced by the need for background scripting languages in many of the authoring systems. To really use most authoring systems to their full potential requires a programmer. This can make authoring a much more technical process than is commonly described in marketing brochures.

THE KEY: SELECTING THE APPROPRIATE TOOL

A key to developing a timely, high-quality, maintainable multimedia application is to select the right development tool. In selecting the appropriate development tool, at least five factors must be taken into account: development time, distribution, uniqueness of features, technical resources, and target hardware. Generally speaking, it takes longer to develop an application using a programming language. If one needs to get a project or prototype done quickly (within a matter of weeks), an authoring system might be preferred. To put together a presentation for an in-house training session, one might spend only a few days using Authorware or PowerPoint but several weeks trying to write it from scratch in C. If the application will be distributed in volume, such as a retail product, it is well worth considering a programming language, to avoid the expense and/or inconvenience of any run-time licenses required by authoring system companies. Macromedia requires that applications created with Authorware display the Authorware logo on the packaging. It may also be faster to accommodate new hardware devices (CD-ROM drives, audio cards) by using a programming language than to wait for an authoring system company to update its system. If the application requires some unique new features or a combination of unusual features, the power and flexibility of a programming language may be important. SimCity (Maxis), a program that lets the user design and run a simulated urban environment, was custom programmed. No authoring systems are available with which one could duplicate such an application. If the developer or development company has limited technical resources (no MIS department or technical support), an authoring system may prove a safer approach. Once one releases an application developed in a programming language, the developer is committed to resolving technical issues that may arise. This can sap significant resources from a company without the necessary infrastructure. If the number of target machines is limited, and especially if one has some control over what kind of machines they are, an authoring system might be the ideal development tool. However, if the application is intended for a wide audience with potentially diverse target hardware, the power and flexibility of a programming language has strong advantages. If a kiosk is to be placed in a few of a company's regional field offices, and identical new machines will be purchased to run the program, the display might well be authored, since every machine will be the same. On the other hand, a consumer application developed in a programming language can be written to run on some minimum target hardware platform yet take advantage of the capabilities of more robust systems (for example, if the computer has a sound board, audio can be played). In general, authoring systems are useful for prototyping, in-house uses, and presentations—situations where one does

not envision distributing many copies of the program or a long life span for the product. Programming languages tend to be better for applications that will be sold off the shelf or require some special new features or capabilities. When deciding on a development tool, it is worthwhile to consider tools that exceed the initial program design. Software applications have a way of accumulating new features and functions as they develop, through feature creep. Many projects have gotten into trouble midway through, when the development tool, originally selected for its ease of use, proves inadequate to accommodate the final design. And finally, there is always something new. Development tools continue to evolve. Programming languages like Visual Basic and Visual C++ are making increasing use of graphical interfaces, previously the domain of authoring systems, and authoring systems are adding more support for custom coding. While some tools converge toward the middle of the spectrum, the spectrum itself is widening as new, extra-simplified presentation tools and ultrasophisticated object-oriented programming languages (such as Java) are released. While this gives developers a greater selection of development tools, it also makes it more difficult to find the ideal needle in the ever-growing haystack.

Bibliography

Alessandra, Tony, PhD., Phil Wexler, and Rick Barrera. *Non-Manipulative Selling*. A Fireside Book, Simon & Schuster, New York, NY, 1987, second edition, 1992.

Anderson, Carol J., and Mark Veljkov. *Creating Interactive Multimedia: A Practical Guide*. Glenview, IL: Scott Foresman, 1990.

Bauersfeld, Penny. *Software by Design: Creating People-Friendly Software for the Macintosh*. New York, NY: MIS Books, 1994.

Blattner, Meera M., and Roger B. Dannenberg, eds. *Multimedia Interface Design*. New York, NY: ACM Press, 1992.

Brinson, Dianne, and Mark Radcliffe. *Multimedia Law Handbook*. Menlo Park, Calif.: Ladera Press, 1994.

Brooks, Frederick P., Jr. *The Mythical Man-Month: Essays on Software Engineering*. Reading, Mass.: Addison-Wesley, 1975.

Brown, Marlin. *Human-Computer Interface Design Guidelines*. Norwood, NJ: Ablex Publishing Corporation, 1989.

Demarco, Tom. *Controlling Software Projects: Management, Measurement and Estimation*. Englewood Cliffs, NJ: Yourdon Press, 1982.

Entertainment Law & Finance. New York: Leader Publications. Monthly newsletter.

Heckel, Paul. *The Elements of Friendly Software Design*. New York: Warner Books, 1984.

Humphrey, Watts S. *Managing the Software Process*. Reading, Mass.: Addison-Wesley, 1989.

Katzenbach, Jon R., and Douglas K. Smith. *The Wisdom of Teams: Creating the High-Performance Organization*. New York: HarperBusiness, 1994.

Kristoff, Ray, and Amy Satran. *Interactivity by Design: Creating and Communicating with New Media*. Mountain View, CA: Adobe Press, 1995.

Lewis, James. *How to Build and Manage a Winning Project Team*. New York : AMACOM-American Management Association, 1993.

Lewis, James. *The Project Manager's Desk Reference*. Chicago: Probus Publishing, 1993.

Maguire, Steve. *Debugging the Development Process*. Redmond, WA: Microsoft Press, 1994.

McCarthy, Jim. *Dynamics of Software Development*. Redmond, WA: Microsoft Press, 1995.

McConnell, Steve. *Rapid Development*. Redmond, WA: Microsoft Press, 1996.

Peters, Thomas J., and Robert H. Waterman, Jr. *In Search of Excellence: Lessons from America's Best-Run Companies*. New York: Warner Books, 1982.

Raysman, Richard, Peter Brown, and Jeffrey D. Neuberger. *Multimedia Law: Forms and Analysis*. New York: Law Journal Seminars Press, 1994. Loose-leaf.

Rosenthal, Stephen R. *Effective Product Design and Development: How to Cut Lead Time and Increase Customer Satisfaction*. Burr Ridge, IL: Irwin Professional Publishing, 1992.

Rudell, Michael I. *Negotiating Contracts in the Entertainment Industry*. New York: New York Law Publishing Co., 1996. Audiotape seminar.

Shneiderman, Ben. *Designing the User Interface: Strategies for Effective Human-Computer Interaction*. Reading, Mass.: Addison-Wesley, 1987.

Smedinghoff, Thomas J. *Software Publishers Association Legal Guide to Multimedia.* Reading, Mass.: Addison-Wesley, 1994.

Smith, Preston G., and Donald B. Reinertsen. *Developing Products in Half the Time.* New York: Van Nostrand Reinhold, 1991.

Strauss, Roy. "Defeating the Demo Demons." *AV Video.* May 1993.

———. "The Development Tool Fandango." *CD-ROM Professional.* February 1995.

———. "The Perils of Partnership: Contracting for Multimedia Development." *CD-ROM Professional.* December 1995.

Whitaker, Ken. *Managing Software Maniacs: Finding, Managing, and Rewarding a Winning Development Team.* New York: John Wiley & Sons, 1994.

Index